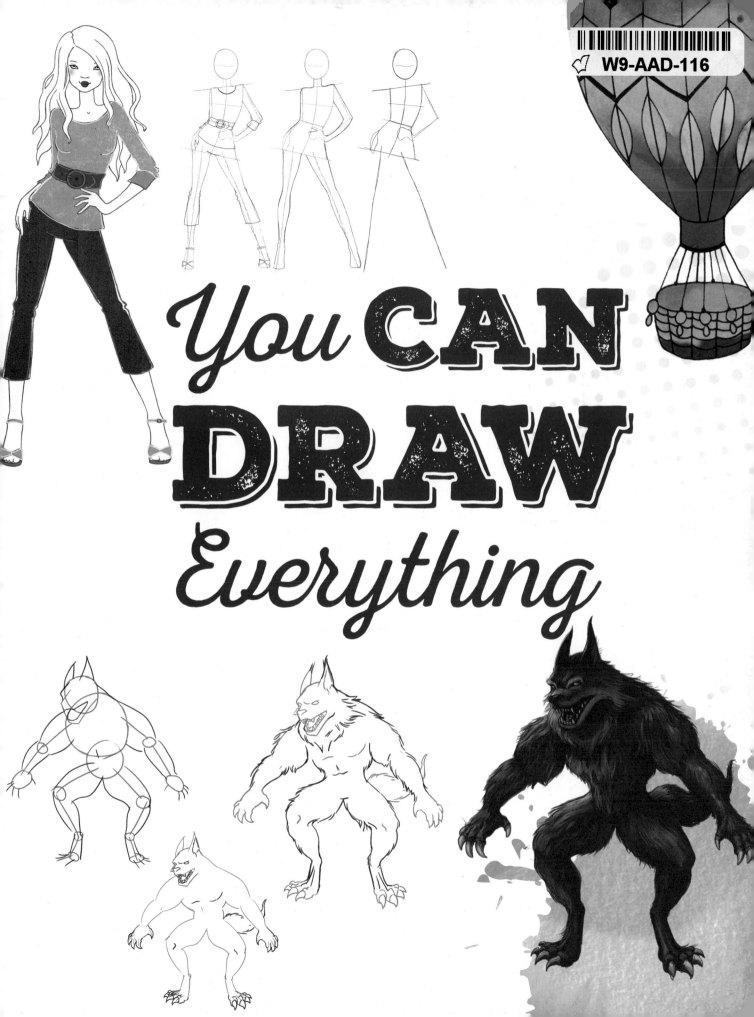

You CAN DRAW Everything

grab a pencil, and make your mark on the world of art!

Flick through the pages of this book to find the things you want to draw, then follow the steps to transform simple shapes into magical masterpieces.

But don't just stop there! Be inspired to draw everything around you, using the tips and techniques you pick up along the way.

And remember, the more you practice, the more your confidence will grow, and the more you'll be ready to draw EVERYTHING!

This edition published by Parragon Books Ltd in 2015 and distributed by

Parragon Inc.
440 Park Avenue South, 13th Floor
New York, NY 10016
www.parragon.com

Illustrated by Tom McGrath, Steve Horrocks, Sophie Burrows, Julie Ingham, Yasuko Yasuko, Alex Hedworth, Jessica Knight, David Shephard, Paula Franco, Luciano Locenzo, Steve Stone, Maddy McClellan, Si Clark and Adam Fisher. Photographs from Shutterstock, Inc.

ISBN 978-1-4748-2101-8

Printed in China

You CAN DRAW Everything

PaRragon

Bath · New York · Cologne · Melbourne · Delhi
Hong Kong · Shenzhen · Singapore · Amsterdam

CONTENTS

MATERIALS

ALL YOU REALLY NEED TO DRAW IS A PENCIL AND SOME PAPER, BUT OTHER MATERIALS CAN HELP TRANSFORM YOUR WORK INTO A MASTERPIECE!

PAPER AND PENCILS

Different kinds of paper and pencils can dramatically alter the appearance of your drawing.

Pencils come in numbered degrees of hard and soft. For thin, fine lines, choose an H (hard) pencil, or an HB (medium) pencil. For shading and blending, use a B (soft) pencil.

Copy paper is smooth and great for sharp pencil lines; cartridge paper is thicker and more textured, giving a softer effect; and watercolor paper keeps the color of ink and watercolor paints vibrant. Use transparent paper (trace) to copy images.

ERASER

Rub away mistakes or unwanted guidelines with an eraser. Also use it to create highlights by sweeping it across your drawing.

PEN AND INK

For line art, to go over outlines, or to make objects stand out from their backgrounds, try a cartridge pen, dip pen and ink, or even a fine-tipped brush and ink.

WATERCOLOR AND COLORED PENCILS

Regular colored pencils are great for creating animal fur and feathery textures. Watercolor pencils work like regular colored pencils, but can be blended together with a wet brush to create different colors and shades.

PAINTS

For a soft, translucent effect, try watercolor, and for a heavier, more opaque finish, try gouache. For a thick, vibrant appearance and smooth, solid areas of color, try acrylic or opaque paint. You can also create these painting techniques digitally.

BRUSHES

Experiment with round brushes for washes and general painting, pointed brushes for fine detail, and flat brushes to sweep an even amount of color on bigger areas.

CRAYONS AND PENS

Crayons are great for adding texture to your picture ...

... and felt-tip pens make objects pop from their backgrounds. You can also use marker pens to outline your work and draw attention to individual elements of your drawing.

TECHNIQUES

EXPERIMENT WITH DIFFERENT DRAWING TECHNIQUES TO FIND THE RIGHT APPROACH FOR YOU AND YOUR WORK OF ART!

SHAPES AND SYMMETRY

Break objects down into simple shapes to help get the proportions right from the start. Then draw around the shapes to join them together for the object's outline.

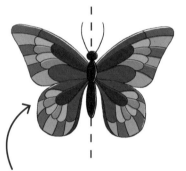

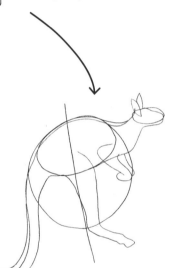

Add a center guideline for symmetrical objects, and mirror what you draw on each side.

DEPTH, DISTANCE, AND DIMENSION

Make your drawing appear realistic by turning basic shapes into 3D objects and using perspective to provide a clear foreground and background in your picture. Objects in the foreground are bigger and normally brighter.

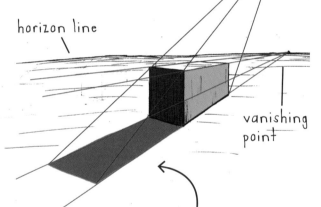

light source

horizon line

vanishing point

Shadows also suggest depth and distance. The higher the light source, the shorter the shadow. Use a light source and vanishing point for accurate shadows.

LINES AND SHADING

For shaded areas, rub the side of a pencil on paper with varied pressure, or use the tip of the pencil to draw lines—the closer the lines, the darker the shading.

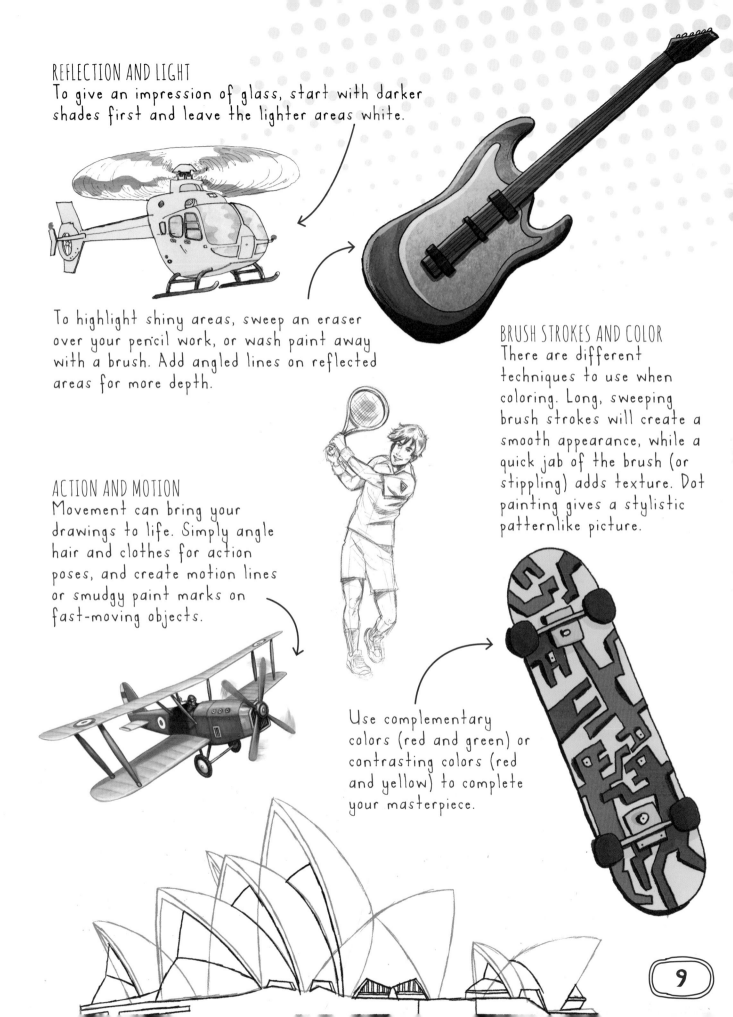

REFLECTION AND LIGHT
To give an impression of glass, start with darker shades first and leave the lighter areas white.

To highlight shiny areas, sweep an eraser over your pencil work, or wash paint away with a brush. Add angled lines on reflected areas for more depth.

BRUSH STROKES AND COLOR
There are different techniques to use when coloring. Long, sweeping brush strokes will create a smooth appearance, while a quick jab of the brush (or stippling) adds texture. Dot painting gives a stylistic patternlike picture.

ACTION AND MOTION
Movement can bring your drawings to life. Simply angle hair and clothes for action poses, and create motion lines or smudgy paint marks on fast-moving objects.

Use complementary colors (red and green) or contrasting colors (red and yellow) to complete your masterpiece.

9

GREEN IGUANA

1

START WITH A BASELINE FOR THE BRANCH. SKETCH A SQUASHED OVAL FOR THE IGUANA'S HEAD. ADD A LINE FOR THE BODY AND TAIL, AND LINES FOR LEGS.

2

USE A SOFT PENCIL TO GO AROUND THE SHAPES AND DRAW THE OVERALL OUTLINE. ADD SMALL HANDS, FINGERS, TWO EYELIDS, AND AN EYE.

If caught by a predator, iguanas can shed their tails to escape and regenerate a new one!

3

DRAW A ROUGH LINE DOWN THE SPINE TO USE AS A GUIDE FOR THE SPIKED RIDGE. ADD A CREST ON THE HEAD, A MOUTH LINE, AND A NOSTRIL.

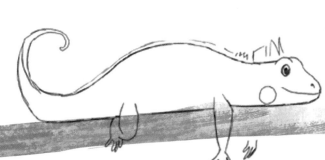

4

ADD MORE DETAIL TO YOUR DRAWING, INCLUDING INDIVIDUAL SCALES, SKIN TEXTURE, CLAWS, AND LOTS OF SMALL SPIKES ON ITS BACK.

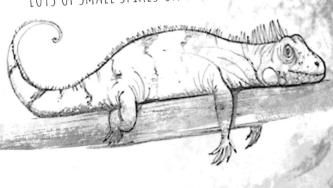

The green iguana is the largest species in the iguana family. They can be around 6 ft long from head to tail!

5

USE A GREEN WASH BASE, THEN GO OVER IT WITH GREEN FELT-TIP PENS. USE GREEN AND BROWN CRAYONS TO ADD SCALES. USE A YELLOW CRAYON FOR THE EYE.

WIZARD

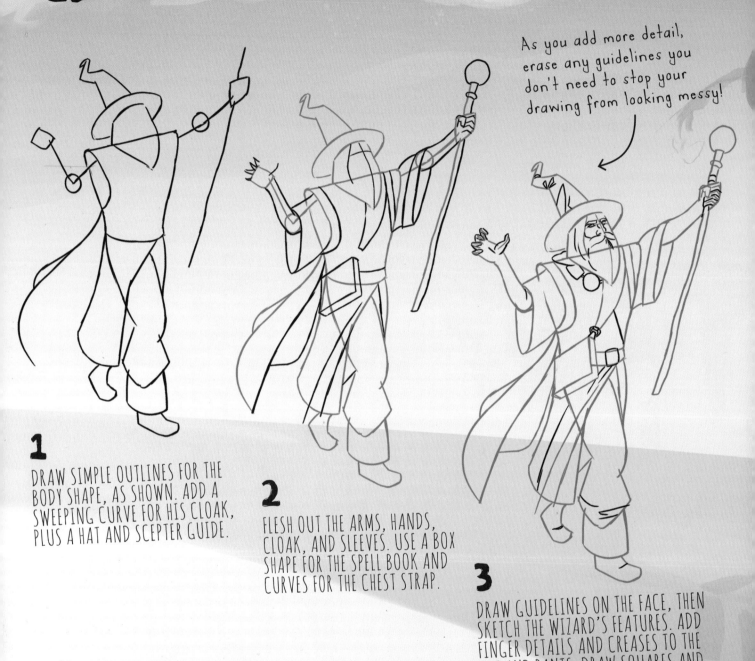

As you add more detail, erase any guidelines you don't need to stop your drawing from looking messy!

1

DRAW SIMPLE OUTLINES FOR THE BODY SHAPE, AS SHOWN. ADD A SWEEPING CURVE FOR HIS CLOAK, PLUS A HAT AND SCEPTER GUIDE.

2

FLESH OUT THE ARMS, HANDS, CLOAK, AND SLEEVES. USE A BOX SHAPE FOR THE SPELL BOOK AND CURVES FOR THE CHEST STRAP.

3

DRAW GUIDELINES ON THE FACE, THEN SKETCH THE WIZARD'S FEATURES. ADD FINGER DETAILS AND CREASES TO THE HAT AND PANTS. DRAW SQUARES AND CIRCLES FOR THE JEWELRY.

If you're not sure how to draw something in detail, it's a good idea to sketch simple guidelines and rough shapes first to help you!

4

CONCENTRATE ON THE FINE DETAILS, DRAWING SQUARES AND ZIGZAG PATTERNS ON THE WIZARD'S CLOTHES. ADD MORE LINES TO THE BOOK, AND DRAW AN EXTRA OVAL SHAPE UNDER THE HAT BRIM.

Paint lots of swirling, colorful flamelike shapes to create magic!

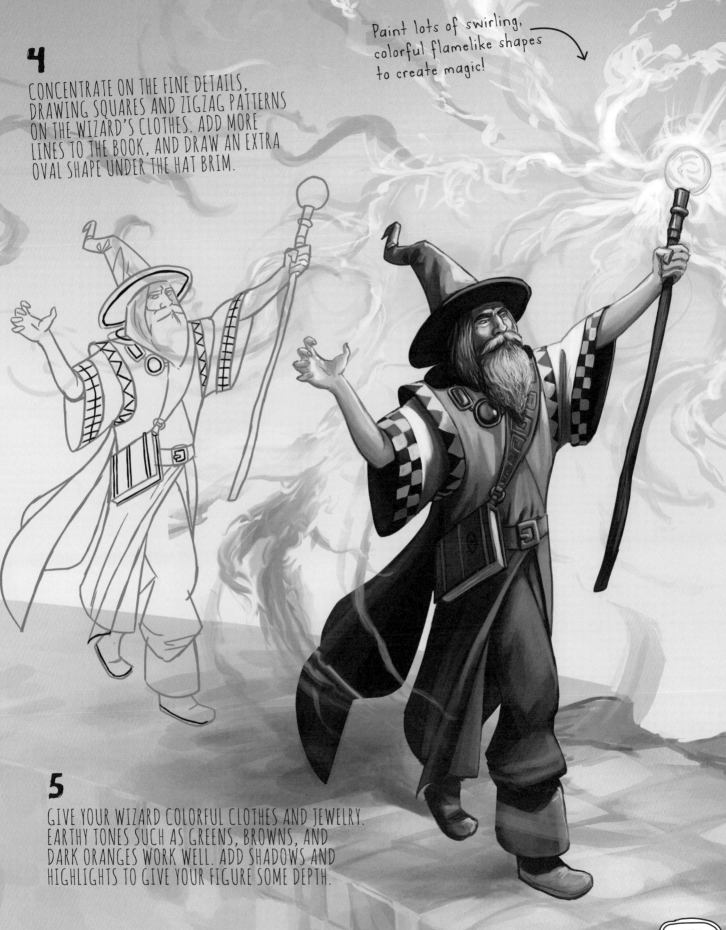

5

GIVE YOUR WIZARD COLORFUL CLOTHES AND JEWELRY. EARTHY TONES SUCH AS GREENS, BROWNS, AND DARK ORANGES WORK WELL. ADD SHADOWS AND HIGHLIGHTS TO GIVE YOUR FIGURE SOME DEPTH.

Hot-Air Balloons

Drawing faint guidelines helps you with the symmetry and proportions of your balloons. Use a compass if you want a perfect circle guide.

1

USING A PENCIL, DRAW A CIRCLE FOR THE BALLOON, THEN DIVIDE IT IN HALF WITH A FAINT VERTICAL LINE. ATTACH A BIG V SHAPE, STARTING ABOUT THREE-QUARTERS OF THE WAY DOWN THE CIRCLE. ADD A HORIZONTAL GUIDE WHERE THE TWO SHAPES MEET, PLUS A PARALLEL GUIDELINE BELOW THAT.

2

USING THE BASIC SHAPES AS A GUIDE, DRAW A LARGER BALLOON OUTLINE. ADD A CYLINDER SHAPE AT THE BOTTOM AND A BASKET BELOW. WHEN YOU'RE HAPPY WITH YOUR SHAPES, TRACE OVER THE OUTLINES WITH WATERPROOF INK.

3

USING YOUR INK PEN, ADD CURVED, VERTICAL LINES TO YOUR BALLOON. THESE WILL HELP YOU DESIGN THE BALLOON'S PATTERN. DRAW MORE LINES CONNECTING THE CYLINDER SHAPE TO THE TOP EDGE OF THE BASKET.

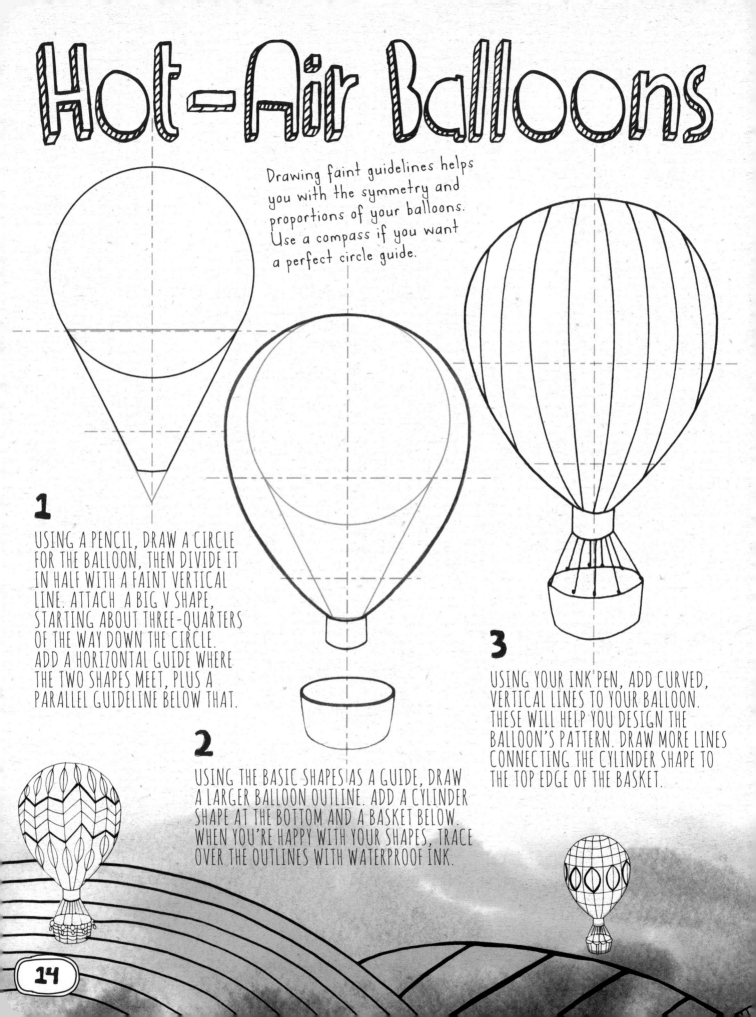

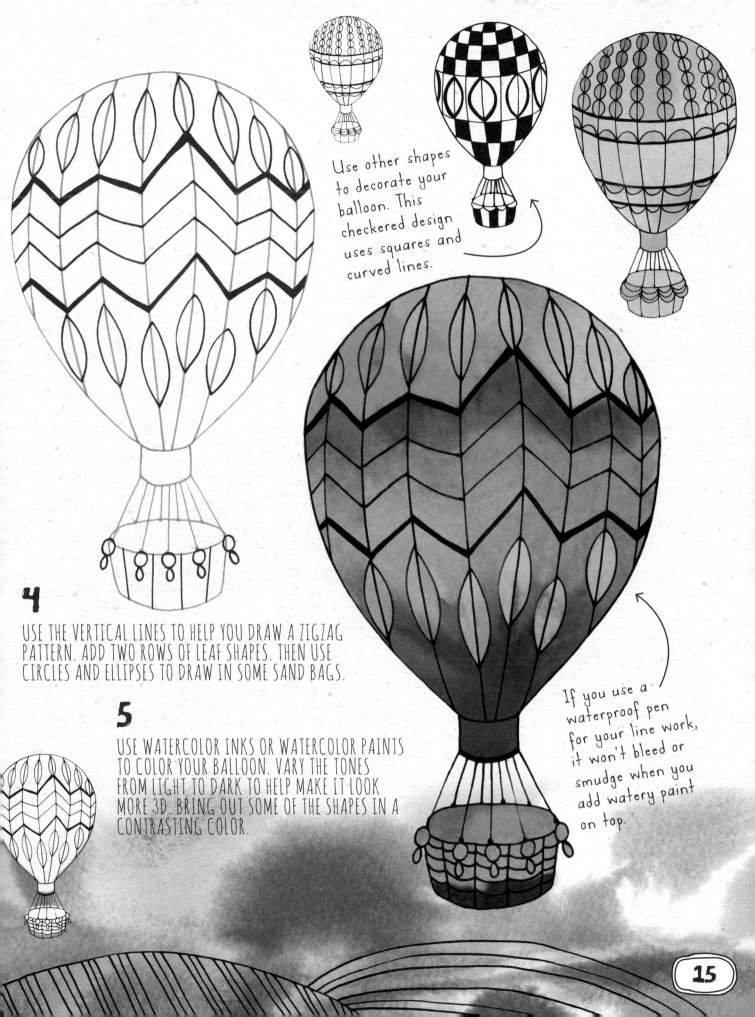

Use other shapes to decorate your balloon. This checkered design uses squares and curved lines.

4

USE THE VERTICAL LINES TO HELP YOU DRAW A ZIGZAG PATTERN. ADD TWO ROWS OF LEAF SHAPES. THEN USE CIRCLES AND ELLIPSES TO DRAW IN SOME SAND BAGS.

5

USE WATERCOLOR INKS OR WATERCOLOR PAINTS TO COLOR YOUR BALLOON. VARY THE TONES FROM LIGHT TO DARK TO HELP MAKE IT LOOK MORE 3D. BRING OUT SOME OF THE SHAPES IN A CONTRASTING COLOR.

If you use a waterproof pen for your line work, it won't bleed or smudge when you add watery paint on top.

BALD EAGLE

1 SKETCH AN OVAL BODY WITH A SMALL ROUND HEAD AND HOOKED BEAK. ADD TWO LARGER OVALS FOR THE WINGS AND A FIVE-SIDED SHAPE FOR THE TAIL.

Bald eagles are not actually bald. Their name originates from an older meaning of the words "white-headed!"

2 WITH A SOFT PENCIL, ADD A ROUGH FEATHERY OUTLINE ALL AROUND THE SHAPES, ESPECIALLY AROUND THE WINGS, TAIL, AND NECK.

3 NOW FILL IN THE BODY WITH PLENTY OF FEATHERS. USE SHORT CIRCULAR ONES FOR THE MAIN BODY AND LONGER ONES FOR THE WINGS. ADD A DOT EYE.

4 USE A SHARP PENCIL TO FURTHER DEFINE THE EAGLE. SHADE DARK AREAS UNDER THE NECK AND AROUND THE WINGS. ADD SOFT STROKES TO SHOW ITS HEAD FEATHERS.

5 PAINT THE WINGS BROWN, GRAY, AND BLACK. ADD A TOUCH OF WHITE TO THE FACE, WITH GRAY HIGHLIGHTS. USE YELLOW AND ORANGE FOR THE BEAK AND TALONS.

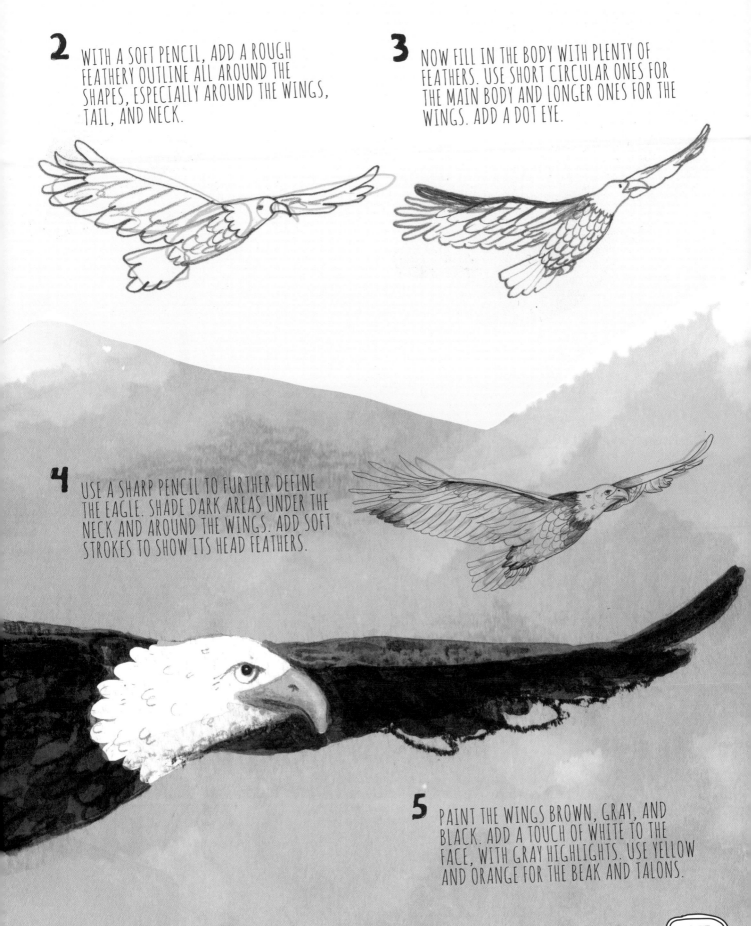

CIRCUS

Larger elements at the top of the tent give the scene a sense of scale and depth.

1

TO DRAW A BASIC CIRCUS RING, SKETCH TWO OVERLAPPING OVAL SHAPES USING SIMPLE PERSPECTIVE, AS SHOWN.

2

CREATE PEOPLE IN THE AUDIENCE USING CIRCLES AND SEMICIRCLES. DRAW CURVED LINES FOR THE TOP OF THE TENT, AND ADD A STAR IN THE RING.

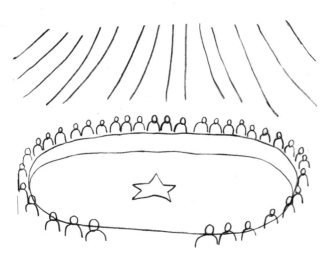

3

SKETCH LOOSER LINES AROUND EACH AUDIENCE MEMBER, AND ADD MORE PEOPLE! DRAW ROUNDED SEMIRECTANGLES AT THE BACK OF THE AUDIENCE FOR SEATING.

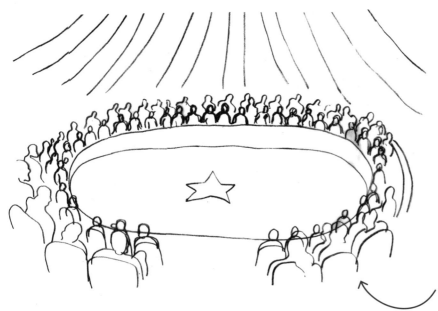

Make the audience members in the foreground bigger than those in the background to add to the perspective.

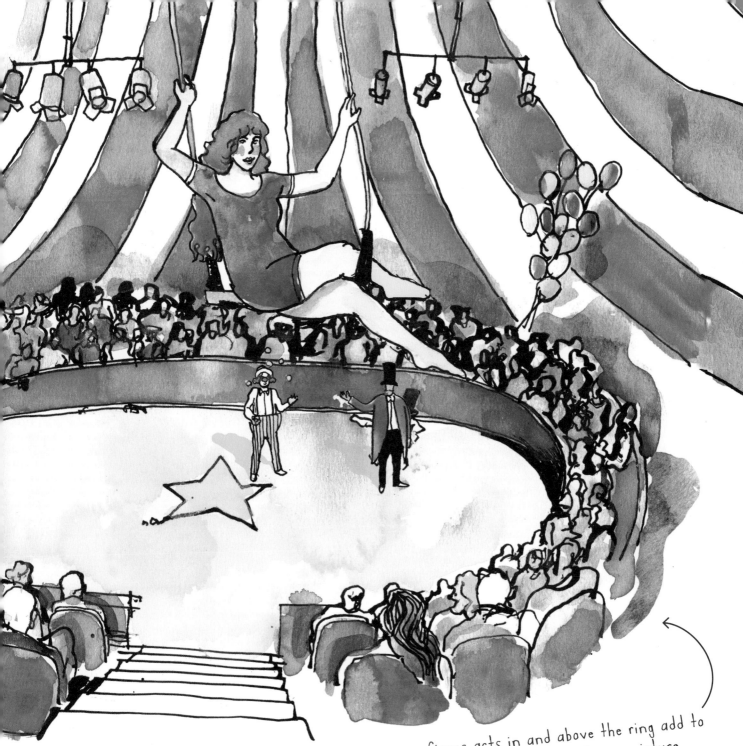

To build up the audience, draw overlapping people, like this. Give each person a different hairstyle for individuality.

Circus acts in and above the ring add to the action and story of your picture.

4

DRAW EVEN MORE PEOPLE IN THE AUDIENCE, AND ADD THE RINGMASTER, CLOWN, AND TRAPEZE ARTIST. DRAW SOME LIGHTS AT THE TOP OF THE TENT AND BALLOONS IN THE CROWD. USE WATERCOLOR PAINTS TO FINISH.

Fashion Girls

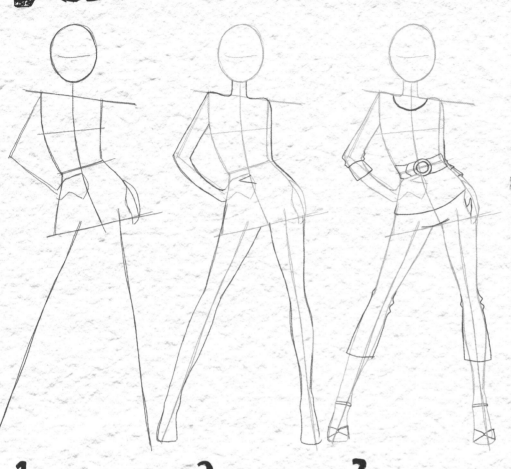

1

SKETCH A ROUND SHAPE FOR THE HEAD AND THEN GUIDELINES FOR THE TORSO, ARMS, AND LEGS.

2

DRAW ROUGH ARM AND LEG SHAPES AROUND YOUR GUIDELINES.

3

SKETCH A TOP, BELT, PANTS, AND SHOES TO ADD CLOTHES.

4

FINISH THE HANDS, AND SKETCH LONG HAIR AND A FACE. ERASE ANY ROUGH GUIDELINES. NOW ADD COLOR! USE ONLY ACCENTS TO KEEP THE DRAWING SOPHISTICATED.

Find inspiration for patterns and colors from magazines. You could even cut out some samples and glue them onto your model to make a collage effect.

OUT AND ABOUT

Use the technique on the opposite page to create a basic body, then change the outfits for different occasions.

Try drawing the girl standing side-on, and add accessories, such as an umbrella!

Add beachwear for a sunny-day pose!

Experiment with color combinations before you color in the outfits.

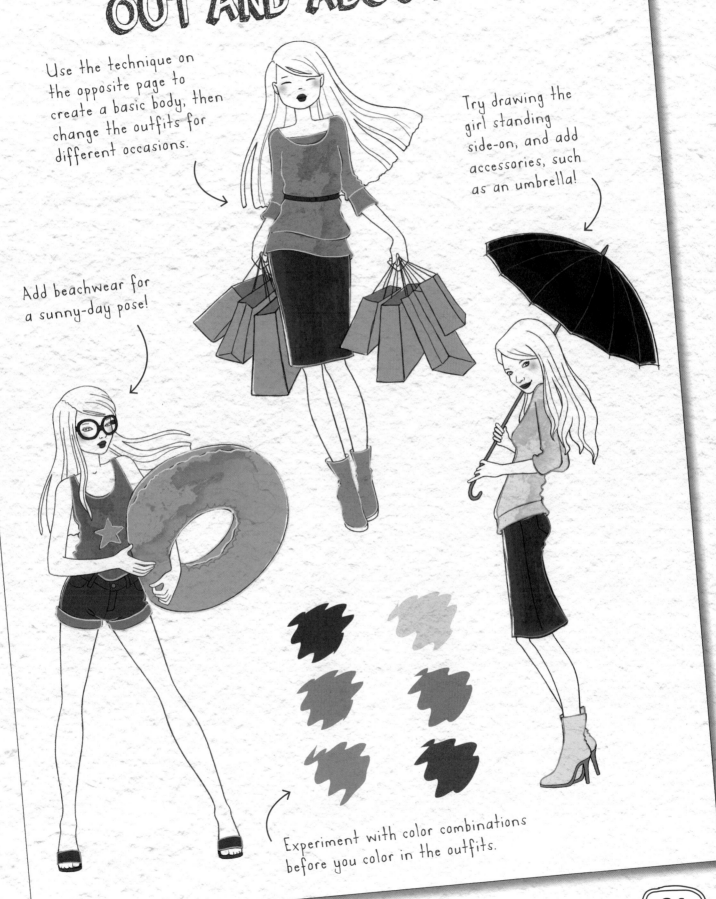

HUMPBACK WHALE

1

START WITH A BASIC GRID, FIVE SQUARES WIDE AND THREE SQUARES HIGH. USE THE GRID TO HELP YOU SKETCH LINES FOR THE BODY, FINS, AND TAIL.

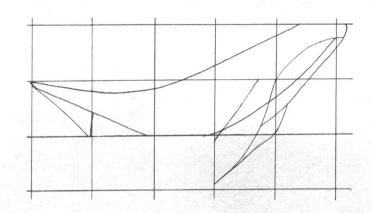

2

NEXT, USE A SOFT PENCIL TO SKETCH THE ROUGH OUTLINE. DRAW LINES TO SHOW THE SHAPE OF THE MOUTH AND THROAT, AND ADD A CIRCLE FOR THE EYE.

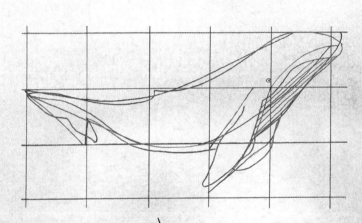

3

USE GRAY AND BLUE WATERCOLOR. THEN ADD HIGHLIGHTS WITH GRAY AND BLUE PENCILS. USE BLACK FOR DETAILS, SUCH AS THE EYE AND BUMPS ON THE HEAD.

A humpback's head and lower jaw are covered with bumps, called tubercles, which are hair follicles!

KILLER WHALE

1

DRAW A GRID, THREE SQUARES WIDE AND FIVE SQUARES HIGH. USING IT AS A GUIDE, ADD LINES FOR THE BODY, FINS, AND TAIL.

Killer whale calves are born with a yellowish tinge to their skin, which fades to white over time!

2

FIRM UP THE OUTLINE. ADD LINES TO SHOW WHERE THE WHITE AREAS WILL BE. DRAW AN EYE BETWEEN THE WHITE MARKINGS ON THE FACE.

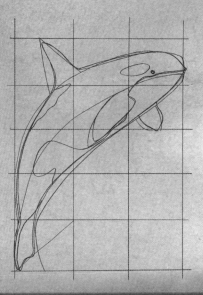

3

COLOR USING BLACK AND WHITE PAINT FOR THE BODY, WITH GRAY AND WHITE FOR HIGHLIGHTS, SHADING, AND SPLASHES OF WATER!

WEIGHTLIFTER

1
USING A LIGHT PENCIL, SKETCH A STICK MAN TO SET YOUR BASIC WEIGHTLIFTING POSE. MAKE THE KNEES SLIGHTLY BENT.

2
DRAW THE WEIGHTLIFTER'S OUTLINE AROUND YOUR GUIDE. MAKE HIS MUSCULAR LEGS AND BICEPS EXTRA CHUNKY.

3
SKETCH CURVED LINES TO DEFINE THE MUSCLE TONE. OUTLINE THE CLOTHING, ROUGH FACIAL FEATURES, AND THE BARBELLS.

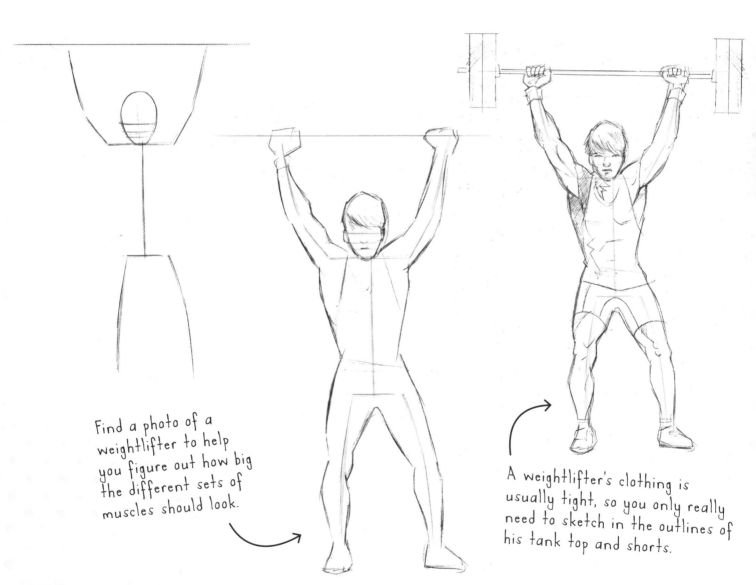

Find a photo of a weightlifter to help you figure out how big the different sets of muscles should look.

A weightlifter's clothing is usually tight, so you only really need to sketch in the outlines of his tank top and shorts.

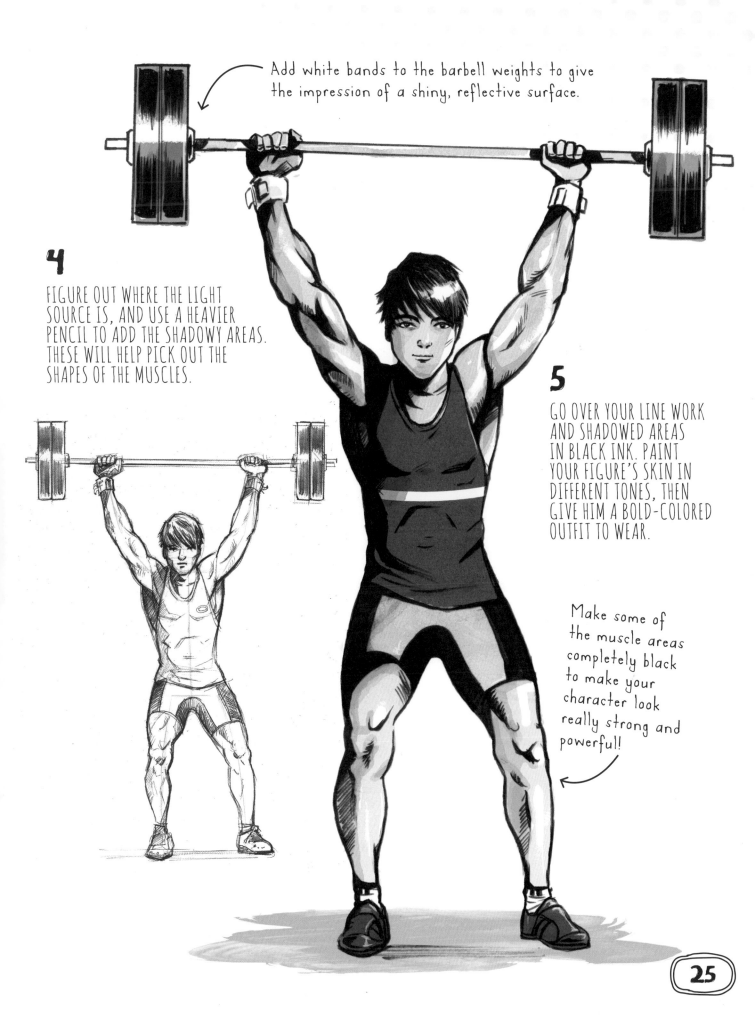

Add white bands to the barbell weights to give the impression of a shiny, reflective surface.

4

FIGURE OUT WHERE THE LIGHT SOURCE IS, AND USE A HEAVIER PENCIL TO ADD THE SHADOWY AREAS. THESE WILL HELP PICK OUT THE SHAPES OF THE MUSCLES.

5

GO OVER YOUR LINE WORK AND SHADOWED AREAS IN BLACK INK. PAINT YOUR FIGURE'S SKIN IN DIFFERENT TONES, THEN GIVE HIM A BOLD-COLORED OUTFIT TO WEAR.

Make some of the muscle areas completely black to make your character look really strong and powerful!

STATUE OF LIBERTY

1

USING A LIGHT PENCIL, SKETCH BASIC SHAPES. DRAW CIRCLES FOR THE HEAD AND FLAME AND LOOSE RECTANGLES FOR THE BODY, FOLLOWING THE LINE OF MOVEMENT OF THE STATUE.

2

ADD GUIDELINES TO PLAN THE FACE OF THE STATUE IN YOUR DRAWING. ADD THE CROWN OF RAYS FROM THE HEAD AND OUTLINE THE GOWN.

Find a photo of the Statue of Liberty for inspiration. This will help you decide which details are important to capture in your drawing.

Using darker colors on one side and lighter colors on the other gives the statue some dimension. White highlights in the center add form, too.

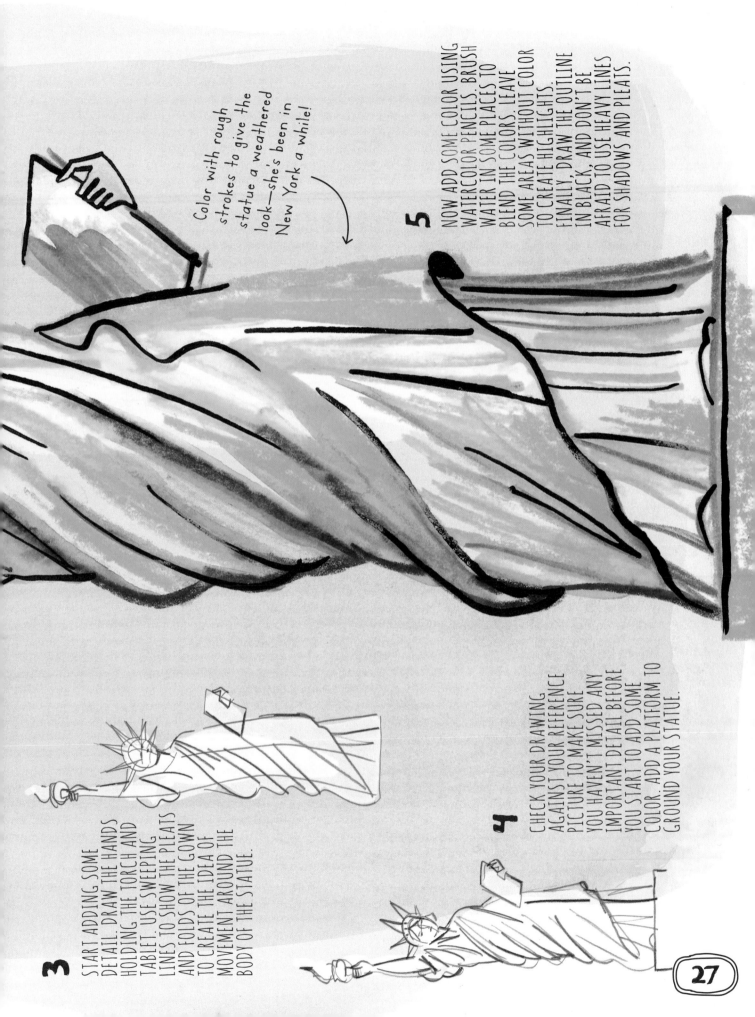

3

START ADDING SOME DETAIL. DRAW THE HANDS HOLDING THE TORCH AND TABLET. USE SWEEPING LINES TO SHOW THE PLEATS AND FOLDS OF THE GOWN TO CREATE THE IDEA OF MOVEMENT AROUND THE BODY OF THE STATUE.

Color with rough strokes to give the statue a weathered look—she's been in New York a while!

5

NOW ADD SOME COLOR USING WATERCOLOR PENCILS. BRUSH WATER IN SOME PLACES TO BLEND THE COLORS. LEAVE SOME AREAS WITHOUT COLOR TO CREATE HIGHLIGHTS. FINALLY, DRAW THE OUTLINE IN BLACK, AND DON'T BE AFRAID TO USE HEAVY LINES FOR SHADOWS AND PLEATS.

4

CHECK YOUR DRAWING AGAINST YOUR REFERENCE PICTURE TO MAKE SURE YOU HAVEN'T MISSED ANY IMPORTANT DETAIL BEFORE YOU START TO ADD SOME COLOR. ADD A PLATFORM TO GROUND YOUR STATUE.

PANDA

GIANT PANDAS LOVE BAMBOO! THEY CAN SPEND UP TO 12 HOURS A DAY EATING THE STUFF. DRAW YOUR OWN PANDA MUNCHING ON ITS FAVORITE FOOD!

1

DRAW A CIRCLE FOR THE HEAD, WITH TWO EYE PATCHES AND A NOSE. ADD A U-SHAPED BODY AND GUIDELINES FOR THE LEGS.

2

SKETCH UPSIDE-DOWN U-SHAPED LINES FOR THE EARS. THEN WORK UP THE EYES AND NOSE. CREATE THE ARMS AND PAWS.

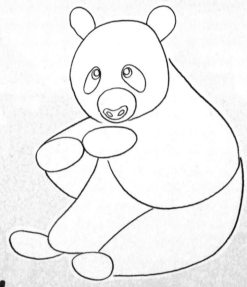

3

USING THE GUIDES, BREAK THE LINES UP TO ILLUSTRATE FUR. ADD SOME TUFTS OF GRASS UNDERNEATH THE PANDA.

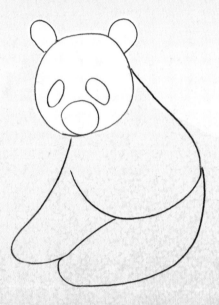

4

ADD A FEW BRANCHES OF BAMBOO COMING OUT OF ITS MOUTH AND SOME IN ITS PAWS AND LAP. THEN BEGIN SHADING.

5

USE A LIGHT GRAY WATERCOLOR WASH ON THE MAIN BODY, WITH LIGHTER GRAY AND WHITE HIGHLIGHTS. USE A BLACK PENCIL TO CREATE FUR TEXTURE ALL OVER.

Pandas eat 18-36 lb of bamboo every day, while sitting upright!

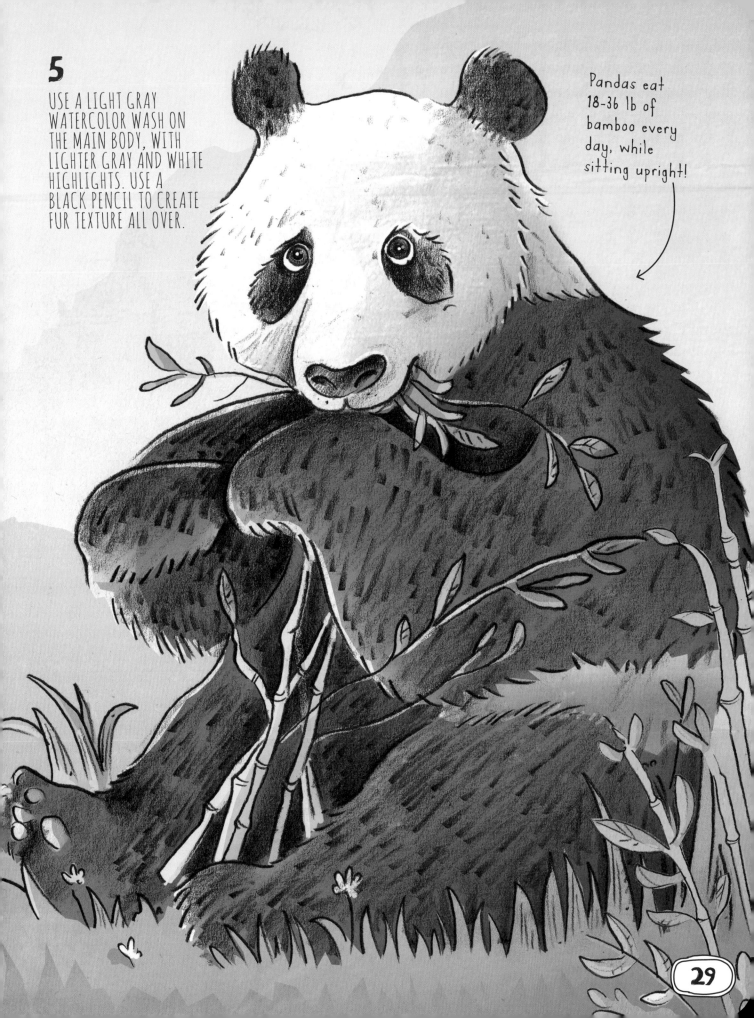

FRUIT BOWL

A MUST-LEARN FOR ANY BUDDING ARTIST!

1 USING A PENCIL, DRAW A SIMPLE BOWL SHAPE SIDE ON. GIVE IT A ROUNDED BRIM WITH A SHALLOW BASE AT THE BOTTOM.

2 LOOSELY SKETCH THE SHAPES OF DIFFERENT FRUITS.

Pick a single color for the bowl, with a darker shade for the areas in shadow. Or make up your own design!

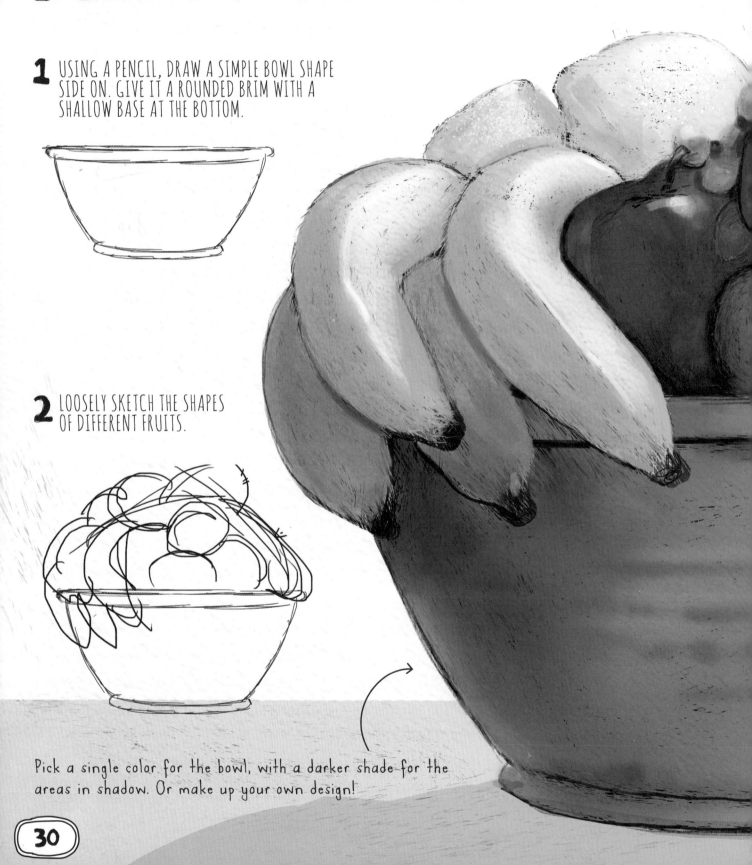

3

START REFINING YOUR OUTLINES, ADDING SMALLER FRUIT SHAPES HERE AND THERE, TOO. ERASE YOUR ROUGH GUIDELINES.

4

DECIDE WHERE THE LIGHT IS COMING FROM IN YOUR DRAWING, THEN ADD SOME SHADING TO THE AREAS THAT ARE IN SHADOW.

Light source

6

WHEN COLORING YOUR DRAWING, THINK ABOUT HOW THE SHINY FRUIT PEEL WILL REFLECT THE LIGHT. CREATE HIGHLIGHTS BY LEAVING SOME AREAS WHITE.

Shiny objects will slightly reflect the color of whatever is near them. So, add a red tinge to the fruit that's next to the bright red apple.

5

REALLY WORK UP THE FRUIT SHAPES, AND FOCUS ON MORE SUBTLE SHADING TO MAKE THE FRUIT LOOK MORE ROUNDED. THIS WILL ALSO HELP ADD DEPTH TO YOUR PICTURE.

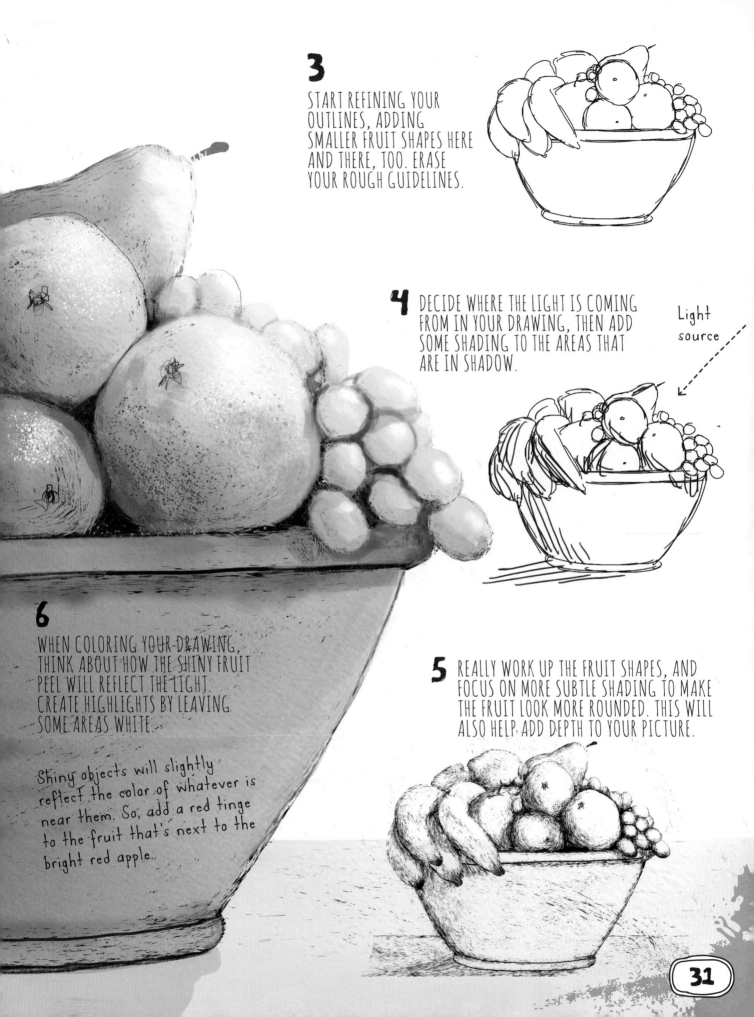

RACE CAR

Draw light guidelines to help with the shape.

1 START WITH A SIMPLE OUTLINE. DON'T WORRY IF THERE ARE A FEW WOBBLES HERE AND THERE. IT ALL ADDS TO THE CHARACTER!

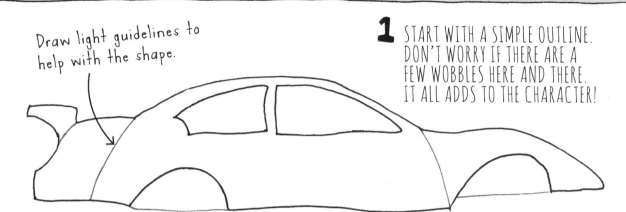

2 ADD A BUMPER AND SOME WHEELS. TRY SLOPING THEM TO GIVE THE IMPRESSION OF MOVEMENT.

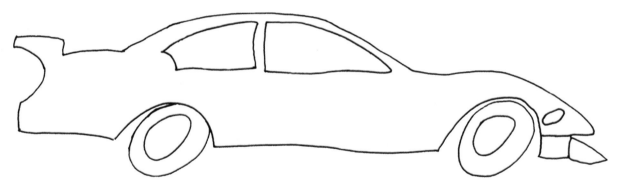

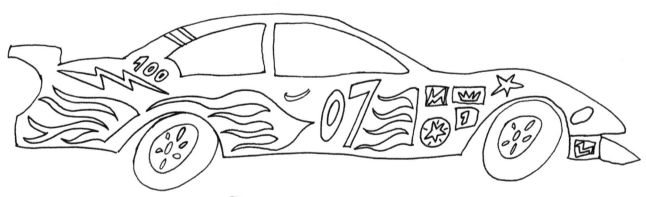

3 ADD THE DETAILS! HAVE FUN WITH THIS—IT'S HOW YOU CAN REALLY PERSONALIZE YOUR DRAWING.

4 DRAW YOUR DRIVER—AND MAYBE EVEN A BEMUSED PASSENGER.

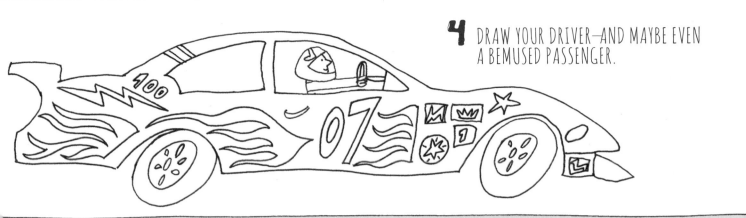

5 NOW ADD SOME HEAVIER LINES WITH INK AND A FINE BRUSH. THIS INDICATES WEIGHT AND SHADOWS. AGAIN, A FEW WOBBLES JUST ADD TO THE ENERGY OF THE LINE.

Don't be afraid to be really heavy with your ink.

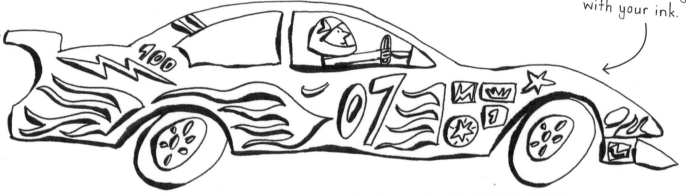

EMBLEM DESIGN IDEAS

Try designing your own emblems for your race car.

6 ADD COLOR! COMPLETE THE PICTURE WITH SPEED LINES AND SHADOWS BEHIND THE WHEELS, SO YOUR CAR ISN'T FLOATING.

Add a finish flag to make your car look like a winner.

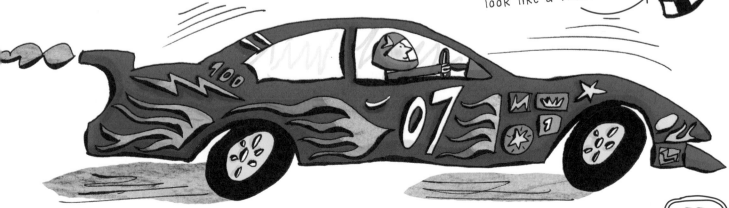

ARCTIC WOLF

1

BEGIN BY DRAWING THREE OVALS—TWO OVERLAPPING FOR THE BODY AND HIND LEGS, AND ONE FOR THE HEAD.

2

USING A SOFT PENCIL, JOIN THE GUIDE SHAPES WITH A SMOOTH OUTLINE, ADDING THE BASIC SHAPES OF THE WOLF'S MUZZLE.

3

USE ROUGH CIRCLES TO SHOW THE SHOULDER AND HIP POSITIONS, THEN ADD THE LEGS FROM THERE. FOLLOW WITH A BUSHY TAIL.

Wolves howl to communicate with each other. Their calls can be heard up to 3 mi away!

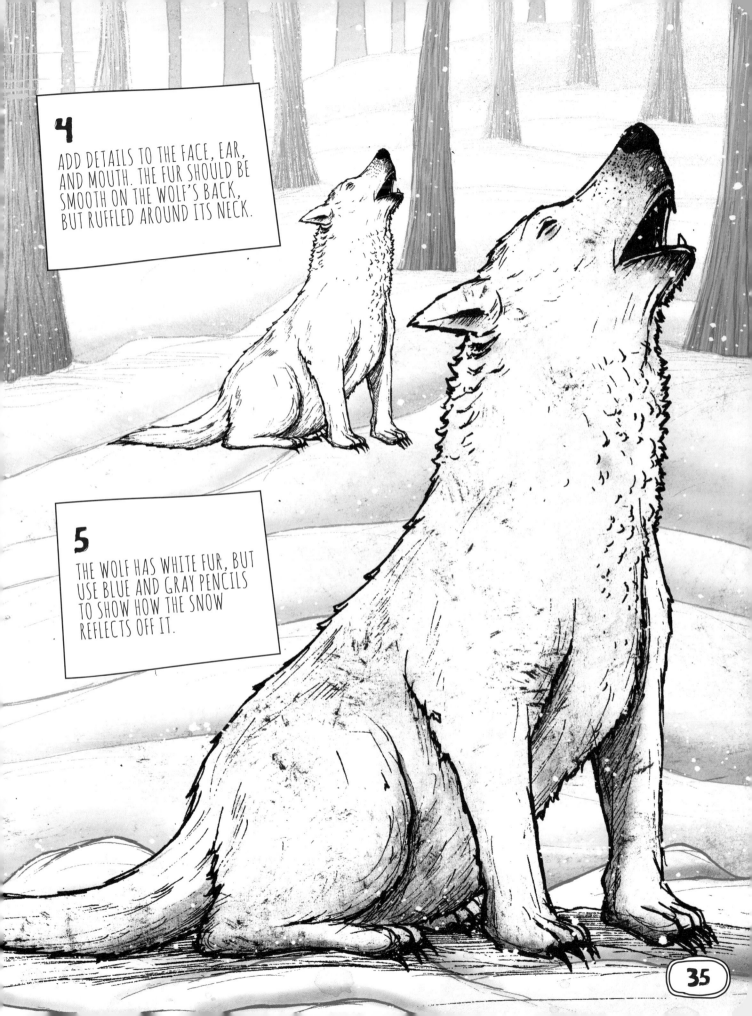

4

ADD DETAILS TO THE FACE, EAR, AND MOUTH. THE FUR SHOULD BE SMOOTH ON THE WOLF'S BACK, BUT RUFFLED AROUND ITS NECK.

5

THE WOLF HAS WHITE FUR, BUT USE BLUE AND GRAY PENCILS TO SHOW HOW THE SNOW REFLECTS OFF IT.

BAGS

LEARN TO DRAW COOL BAGS AND PURSES, SO THAT YOU CAN ADD EXTRA STYLE TO YOUR DRAWINGS OF PEOPLE!

BAGS FOR GUYS

TODAY, THERE ARE MORE BAG STYLES FOR BOYS THAN EVER BEFORE! BE INSPIRED BY FASHION MAGAZINES, OR GO ONLINE FOR THE LATEST LOOKS. TRY DRAWING A BAG AT AN ANGLE TO GIVE IT MORE INTEREST.

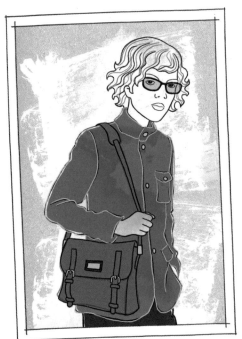

MESSENGER BAG

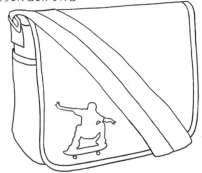

Draw an angled rectangle with a side panel for depth. Add a strap, side pocket, and skateboarder shape.

Use tones of the same color for depth. You could also try a shorter flap with straps and buckles for a vintage look.

KNAPSACK

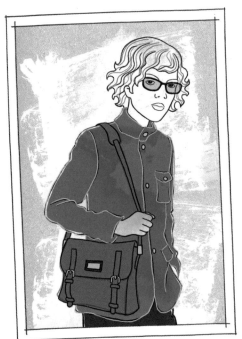

It's all in the extras with this bag! Draw a wobbly rectangle, then sketch pockets, straps, buckles, tassels, and a handle.

ZIPPERED MESSENGER BAG

For the zipper, draw two long horizontal lines joined by lots of tiny vertical lines, then add a small rectangular zipper pull.

BACKPACK

Too cool for school? Use weirdly complementary colors to create an eye-catching effect that grabs attention.

TOTE, HANDBAG, SATCHEL ... WHAT WILL IT BE? LEARN TO DRAW THE VARIOUS STYLES, THEN TRY DIFFERENT PATTERNS FOR EXTRA DETAIL.

TOTE

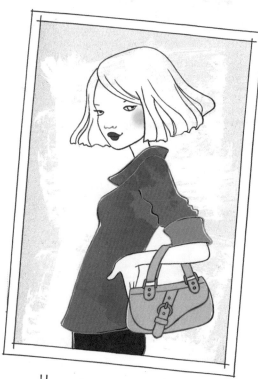

Draw a square, then add two arches for the handle. Draw dashed lines for stitching, a pocket, and some stylin' stars.

Make your star pattern pop by coloring the stars and pocket in lighter or darker shades of the main color.

Have fun creating unique details like this clutch's asymmetrical flap. Stick to a basic color for a sophisticated design.

BUCKLED SHOULDER BAG

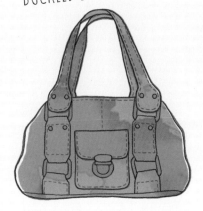

SATCHEL HANDBAG

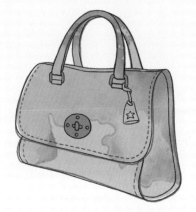

CARPETBAG

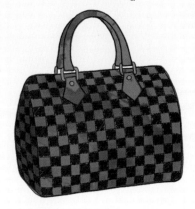

Draw chunky straps and buckles for easy-going elegance. Add a cute pocket and clasp as a finishing touch.

Create clasps and key rings out of circles and rectangles, making an ordinary design feel a little more special.

A carpetbag doesn't need a carpet pattern! Draw lines going down and across to achieve a checkered look.

PIRATE SHIP

1 DRAW THE OUTLINE OF THE SHIP'S HULL. IMAGINE IT AS A LONG BOX, WITH ANOTHER BOX BALANCED ON TOP OF IT AT THE FAR END. DRAW A BEAM AT THE FRONT AND THREE SETS OF PARALLEL LINES FOR THE MASTS.

To help you get the shape right, try looking at a boot or shoe with the toe end tilted slightly toward you. The ship is similar in shape.

2 DRAW SOME BEAMS AT RIGHT ANGLES TO THE MASTS, THEN ADD THE VARIOUS SAILS. THE MAIN SAILS ARE LIKE RECTANGLES WITH CURVED EDGES. ADD A POINTED FLAG, A CROW'S NEST NEAR THE TOP, AND EXTRA DETAIL AT THE FRONT OF THE SHIP.

To get the shape of the sails right, bend a piece of paper and observe it at an angle that matches that of your ship.

3 ADD CANNON PORTS TO THE HULL OF YOUR SHIP BY DRAWING SOME SMALL RECTANGLES. SKETCH AN ANCHOR ON ITS SIDE NEAR THE FRONT. ERASE THE PARTS OF THE SHIP THAT ARE VISIBLE THROUGH THE SAILS, SUCH AS THE MASTS.

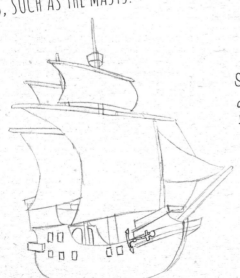

4 USING LONG, WIGGLY LINES, ADD FLAGS TO THE TOP OF THE MIDDLE AND REAR MASTS. DRAW CANNONS PEEPING OUT OF THE HULL, AND ADD HORIZONTAL LINES TO CREATE THE PORT COVERS. SKETCH A LANTERN, ROPES, AND A SKULL AND CROSSBONES.

Start shading darker areas, such as inside the cannon ports.

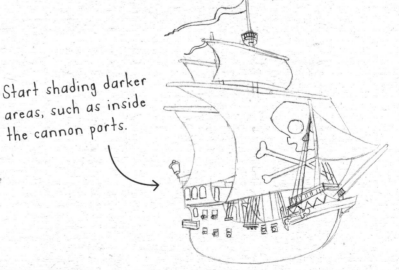

5 WORK ON THE FINE DETAILS. SKETCH A CROSSHATCH DESIGN ON THE REAR WINDOWS, AND ADD HORIZONTAL LINES TO THE RIGGING. DRAW THE SHIP'S WHEEL, AS WELL AS PATCHES AND TEARS ON THE SAILS.

Fine detail will add extra visual interest. Add extra lines to the hull, beams, and balconies.

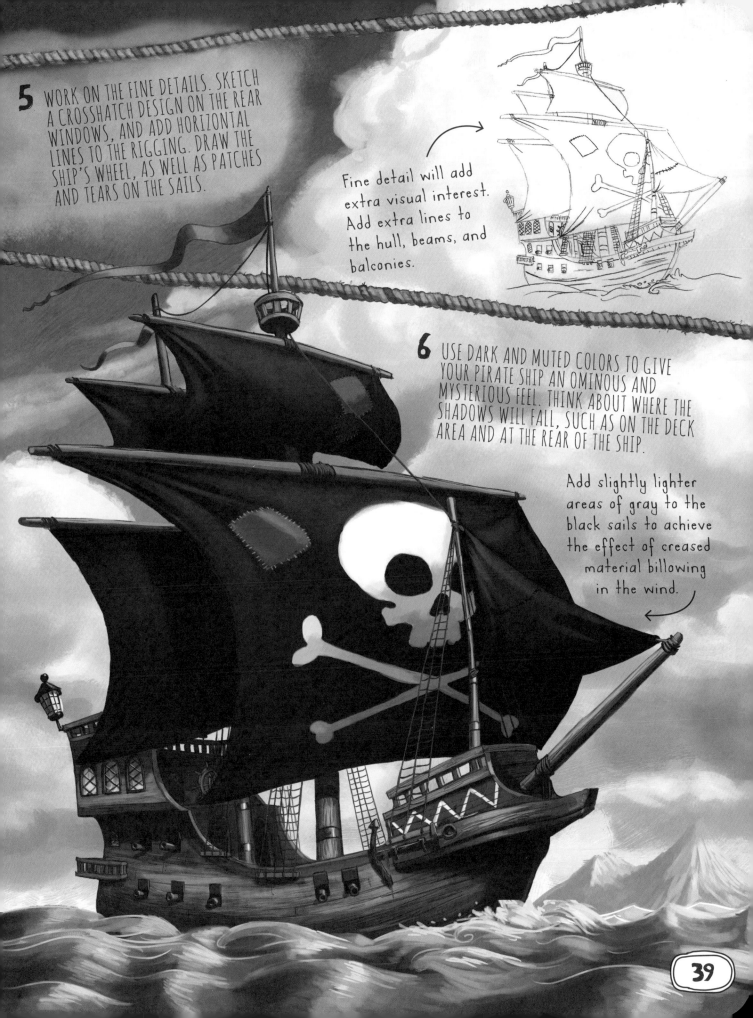

6 USE DARK AND MUTED COLORS TO GIVE YOUR PIRATE SHIP AN OMINOUS AND MYSTERIOUS FEEL. THINK ABOUT WHERE THE SHADOWS WILL FALL, SUCH AS ON THE DECK AREA AND AT THE REAR OF THE SHIP.

Add slightly lighter areas of gray to the black sails to achieve the effect of creased material billowing in the wind.

MANDRILL

MANDRILLS ARE THE LARGEST AND MOST COLORFUL OF THE MONKEYS. FOLLOW THESE STEPS TO DRAW YOUR OWN!

Mandrills have colorful red and blue bottoms that are used to attract a mate. Try using highlighter pens!

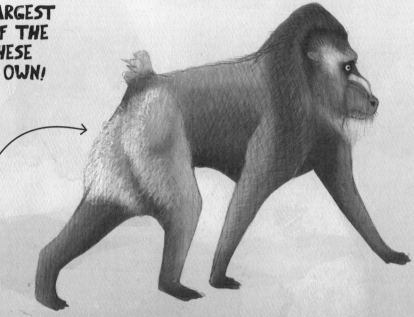

1

START BY SKETCHING A LARGE OVAL FOR THE BODY AND A CIRCLE FOR THE HEAD. ADD FOUR BASIC SAUSAGE SHAPES FOR THE LIMBS.

2

WORK UP THE OUTLINE, ADDING FEET AND A TAIL. SKETCH IN THE FACE—A T-SHAPED BROW AND EGG-SHAPED MUZZLE.

3

FURTHER DEFINE THE FACE WITH A SOFT PENCIL. USE CROSSHATCHING TO ADD DARK SHADING AROUND THE EYES AND CHEEKS.

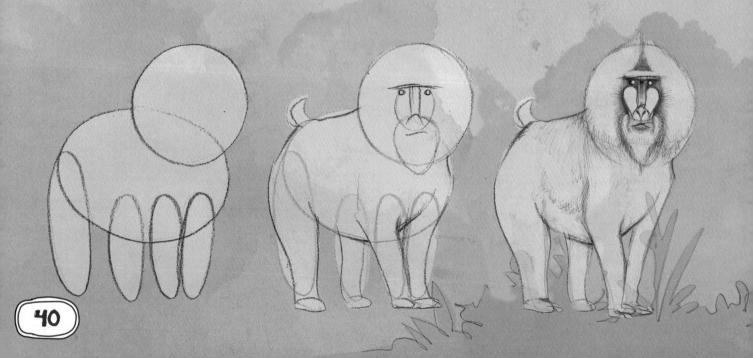

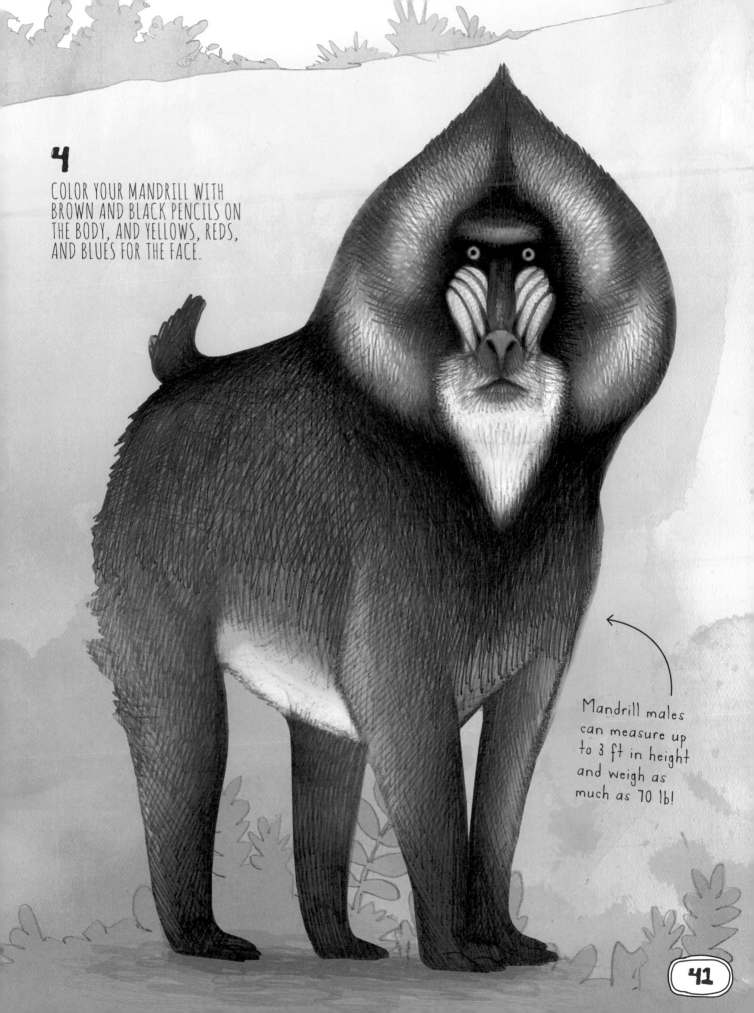

4

COLOR YOUR MANDRILL WITH BROWN AND BLACK PENCILS ON THE BODY, AND YELLOWS, REDS, AND BLUES FOR THE FACE.

Mandrill males can measure up to 3 ft in height and weigh as much as 70 lb!

SYDNEY OPERA HOUSE

Find a reference photo of this famous Australian building before you start.

1

BREAK DOWN THE OPERA HOUSE INTO SIMPLE STAGES. FIRST, SKETCH OVERLAPPING TRIANGULAR SHAPES FOR THE SAILS OF THE BUILDING.

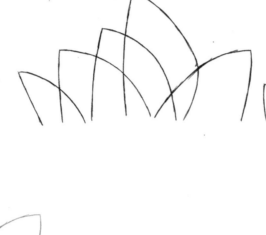

2

ADD A RECTANGULAR SHAPE BENEATH THE SAILS FOR THE BASE OF THE BUILDING AND A HORIZONTAL LINE FOR THE GROUND.

Add some people at the bottom of the building to give a sense of its huge scale.

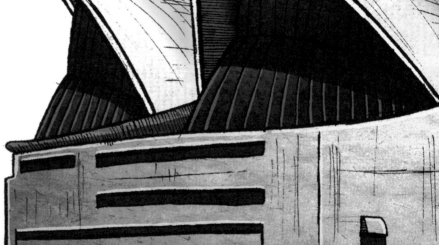

3

DRAW LINES INSIDE THE SAILS, AS SHOWN. DARKEN THESE LINES SO THE SHAPE OF THE BUILDING IS CLEAR.

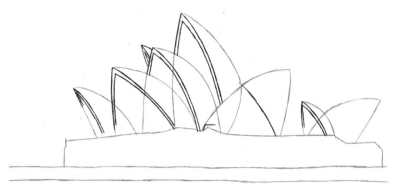

4

START FILLING IN THE DETAIL. DRAW MORE TRIANGULAR SHAPES INSIDE THE SAILS, AND ADD RECTANGULAR WINDOWS AND DOORS AT THE BASE OF THE BUILDING.

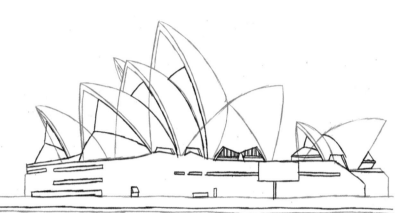

Use light and medium blues on the white sails for shading. Darken the areas inside the sails and on the windows to suggest the direction of light.

5

USE PEN OR INK TO GO AROUND THE OUTLINE OF THE BUILDING. ADD SOME HATCHING TO THE SAILS. THEN ADD COLOR! INCLUDE A HINT OF WATER FOR THE SETTING.

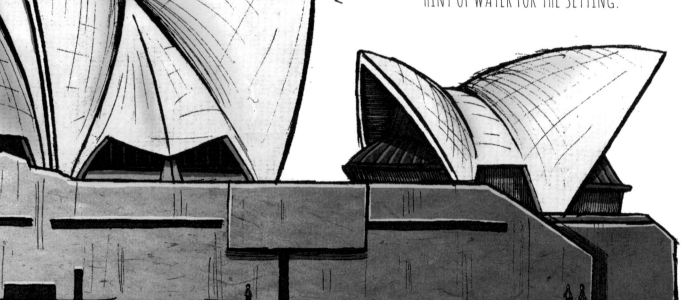

ELECTRIC GUITAR

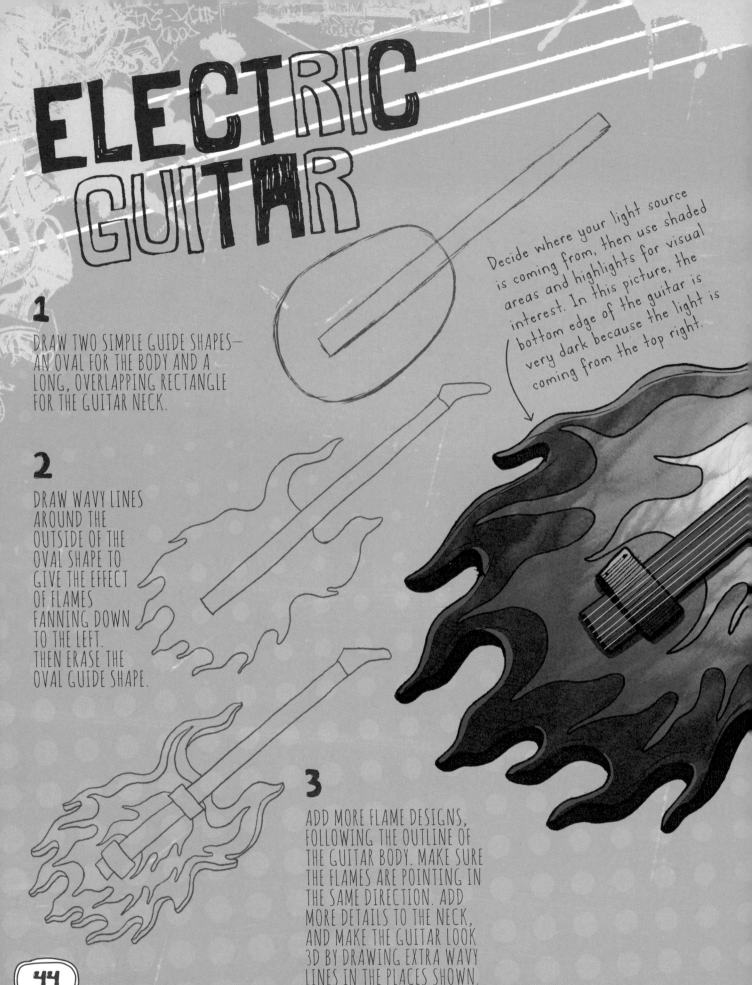

1
DRAW TWO SIMPLE GUIDE SHAPES—AN OVAL FOR THE BODY AND A LONG, OVERLAPPING RECTANGLE FOR THE GUITAR NECK.

2
DRAW WAVY LINES AROUND THE OUTSIDE OF THE OVAL SHAPE TO GIVE THE EFFECT OF FLAMES FANNING DOWN TO THE LEFT. THEN ERASE THE OVAL GUIDE SHAPE.

3
ADD MORE FLAME DESIGNS, FOLLOWING THE OUTLINE OF THE GUITAR BODY. MAKE SURE THE FLAMES ARE POINTING IN THE SAME DIRECTION. ADD MORE DETAILS TO THE NECK, AND MAKE THE GUITAR LOOK 3D BY DRAWING EXTRA WAVY LINES IN THE PLACES SHOWN.

Decide where your light source is coming from, then use shaded areas and highlights for visual interest. In this picture, the bottom edge of the guitar is very dark because the light is coming from the top right.

4

USE BRIGHT COLORS FOR THE BODY OF THE GUITAR AND A DARKER COLOR FOR THE NECK AND HEAD. DRAW FIVE DASHED LINES IN A LIGHT COLOR FOR THE STRINGS, THEN ADD TUNING PEGS AT THE TOP.

It's easier to draw the guitar strings last. Use a ruler to guarantee straight lines!

ELECTRIC DESIGNS

GUITARS CAN COME IN ALL KINDS OF STRANGE SHAPES. EXPERIMENT WITH IMAGINATIVE DESIGNS OF YOUR OWN.

You could use animals as inspiration ... This guitar has a scorpion feel to it.

Streamlined designs look good, such as this triangular-shaped guitar.

A rounded edge makes for a more classic-looking electric guitar.

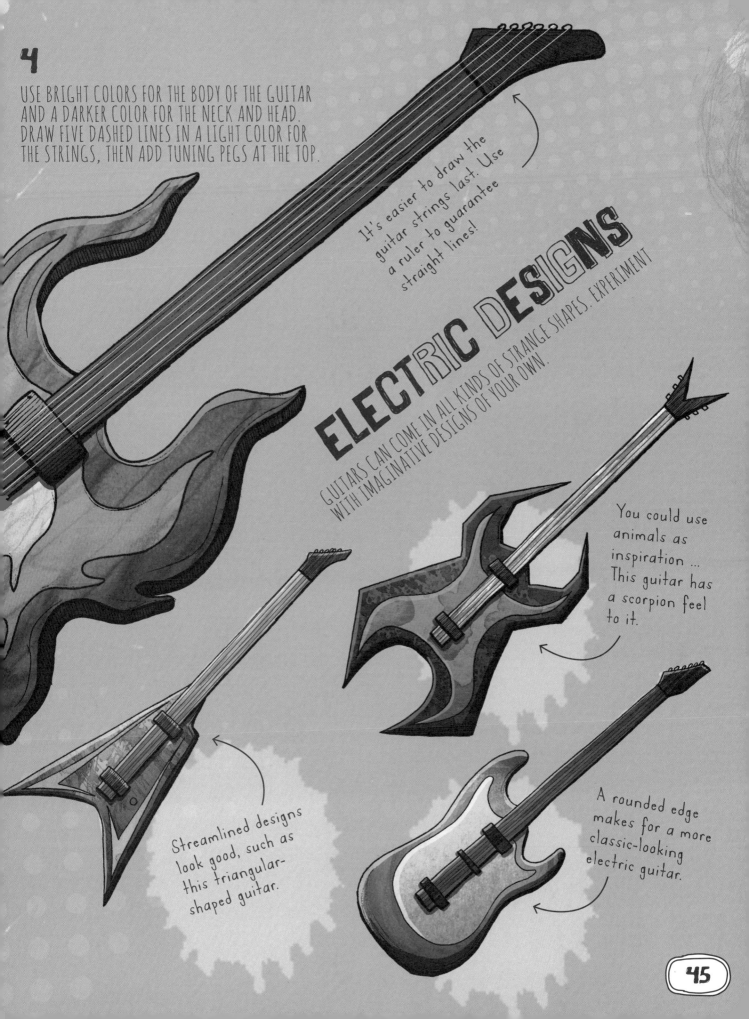

LION

THIS ENDANGERED SPECIES OF WEST AFRICAN LION IS SMALLER THAN LIONS FROM SOUTHERN AFRICA, AND IS ON THE VERGE OF EXTINCTION.

1

DRAW A SQUASHED CIRCLE FOR THE FRONT OF THE BODY AND A CURVED LINE FOR THE BACK. ADD A CIRCLE FOR THE HEAD, AND LINES FOR THE NECK AND LEGS.

2

USING THE BASIC SHAPES AND LINES AS A GUIDE, WORK UP THE BUSHY MANE, ROUGH FACIAL FEATURES, BODY, RECTANGULAR LEGS, ROUGH FEET, AND TAIL.

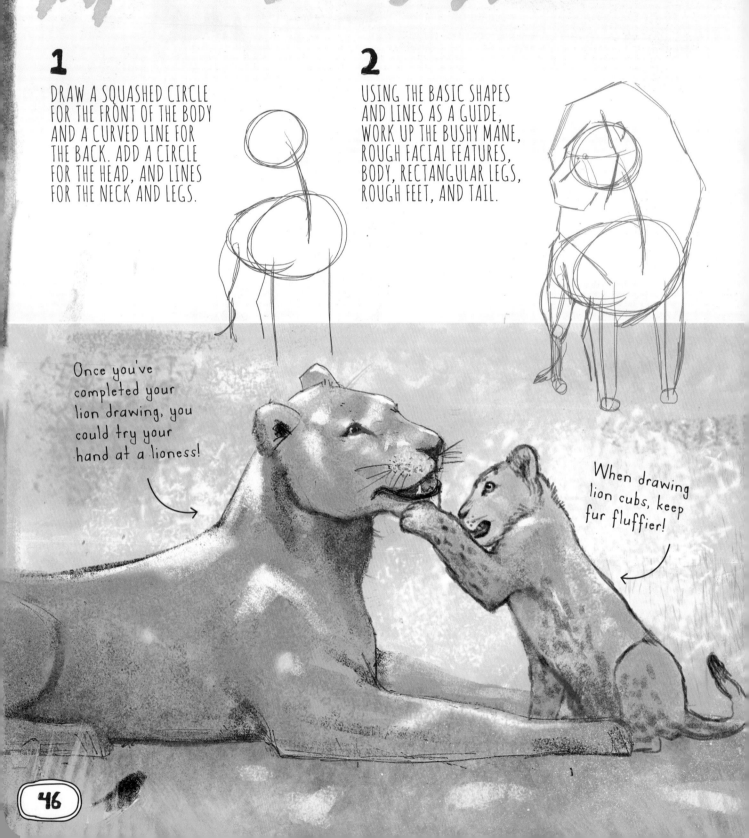

Once you've completed your lion drawing, you could try your hand at a lioness!

When drawing lion cubs, keep fur fluffier!

3

NOW ADD THE DETAIL TO THE LION. SKETCH IN ITS EYES, NOSE, MOUTH, EAR, AND LINES ON ITS PAWS. USE A SOFT PENCIL TO ADD HAIR, THEN SMUDGE IT FOR A FUR EFFECT.

4

FOR THE COLORING STAGE, USE SHADES OF BROWN WITH A LITTLE YELLOW AND ORANGE FOR THE LION'S FUR. USE A SHARP BLACK PENCIL TO DEFINE THE FACIAL FEATURES.

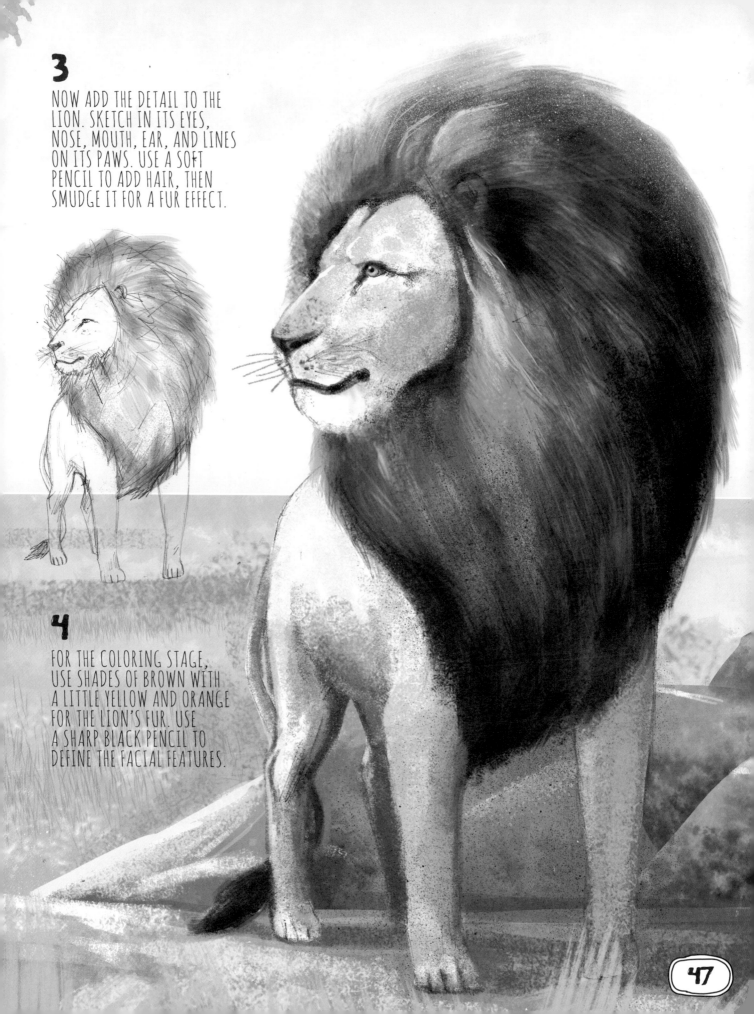

BIPLANE

1 DRAW A LONG, BREADLIKE SHAPE, WITH A CURVE AT THE BOTTOM. TAPER OFF THE ENDS, THEN ADD TWO ROUNDED LINES IN THE CENTER AND ANOTHER AT THE FRONT, LIKE THIS.

2 SKETCH AN OVAL SHAPE FOR THE VERTICAL TAIL AT THE BACK OF THE PLANE. ADD ROUNDED RECTANGLES FOR THE WINGS AND HORIZONTAL TAIL. DRAW A CIRCLE FOR THE PROPELLER AT THE FRONT AND MORE LINES ON THE BODY.

3 FOR THE WING SUPPORTS AND PROPELLER BLADES, DRAW LONG RECTANGLE SHAPES. SKETCH OVAL-SHAPED WHEELS, THEN ADD THE ENGINE COMPONENTS, USING OVALS AND RECTANGLES, ONTO THE BIPLANE'S BODY.

4 FILL IN MORE DETAIL USING STRAIGHT LINES, CIRCLES, AND RECTANGLES, AS SHOWN. CREATE A PILOT USING AN OVAL FOR THE HEAD AND CURVED LINES FOR THE SHOULDERS.

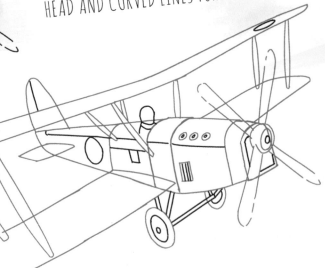

48

5

ADD STRAIGHT LINES ON THE WINGS AND TAIL. SKETCH CURVED LINES BEHIND THE PILOT FOR THE COCKPIT AND AROUND THE PROPELLER TO SUGGEST MOTION. GIVE YOUR PILOT SOME GOGGLES, A HELMET, AND A FLOWING SCARF.

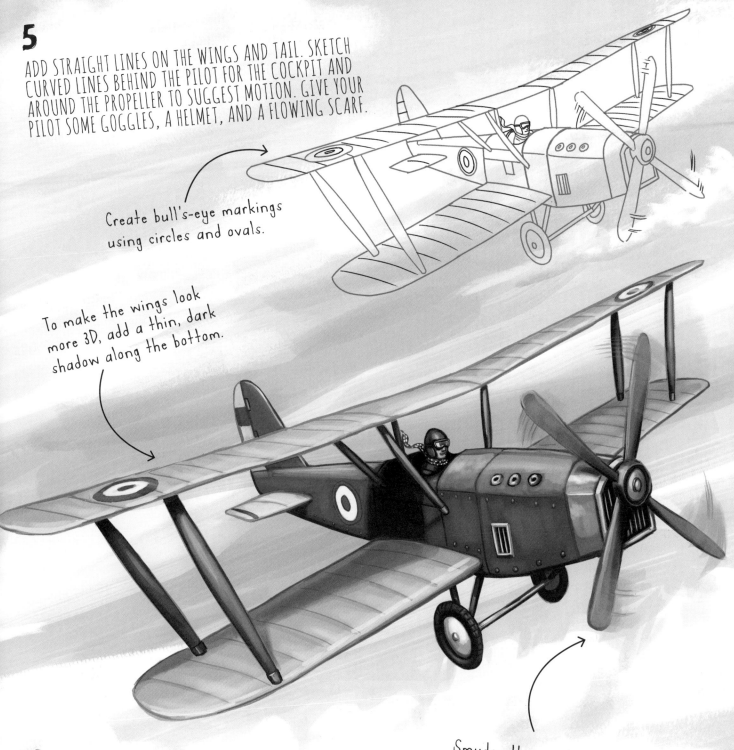

Create bull's-eye markings using circles and ovals.

To make the wings look more 3D, add a thin, dark shadow along the bottom.

6

USE OPAQUE (THICK) OR ACRYLIC PAINT TO COLOR YOUR DRAWING. ADD LIGHT AND DARK SHADING ON THE AIRCRAFT AND PILOT. FINISH WITH A SPOTTED SCARF FOR THE PILOT AND A STRIPY PATTERN ON THE HORIZONTAL AND VERTICAL TAILS FOR CHARACTER.

Smudge the paint with a fat brush to make the propeller look like it's spinning fast.

MAIN STREET

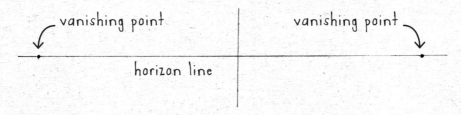

vanishing point vanishing point

horizon line

1

USE A RULER TO DRAW A HORIZONTAL LINE. DRAW A DOT AT EACH END OF THE LINE. THESE ARE THE VANISHING POINTS, WHERE ALL LINES WILL COME TOGETHER. NEXT, DRAW A VERTICAL LINE—THIS WILL BE THE HEIGHT OF THE BUILDINGS AT THE FRONT OF THE PICTURE.

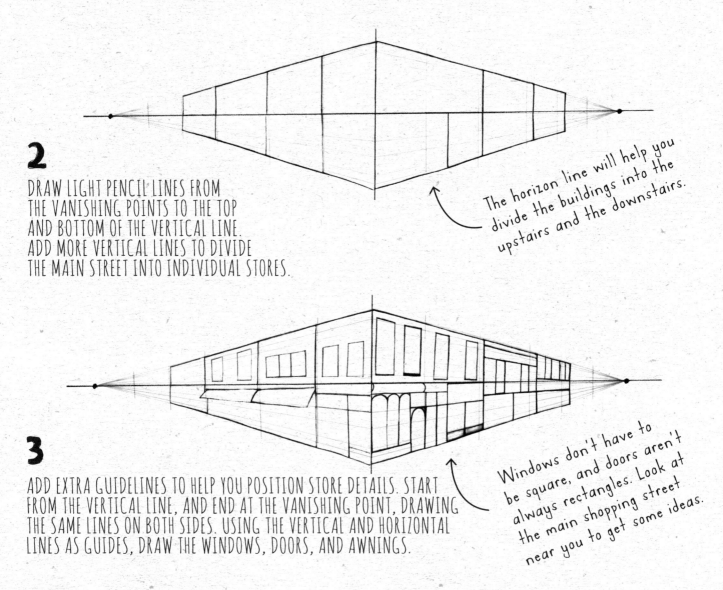

2

DRAW LIGHT PENCIL LINES FROM THE VANISHING POINTS TO THE TOP AND BOTTOM OF THE VERTICAL LINE. ADD MORE VERTICAL LINES TO DIVIDE THE MAIN STREET INTO INDIVIDUAL STORES.

The horizon line will help you divide the buildings into the upstairs and the downstairs.

3

ADD EXTRA GUIDELINES TO HELP YOU POSITION STORE DETAILS. START FROM THE VERTICAL LINE, AND END AT THE VANISHING POINT, DRAWING THE SAME LINES ON BOTH SIDES. USING THE VERTICAL AND HORIZONTAL LINES AS GUIDES, DRAW THE WINDOWS, DOORS, AND AWNINGS.

Windows don't have to be square, and doors aren't always rectangles. Look at the main shopping street near you to get some ideas.

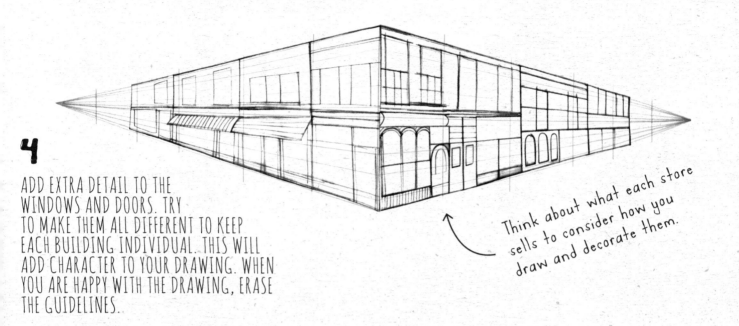

4

ADD EXTRA DETAIL TO THE
WINDOWS AND DOORS. TRY
TO MAKE THEM ALL DIFFERENT TO KEEP
EACH BUILDING INDIVIDUAL. THIS WILL
ADD CHARACTER TO YOUR DRAWING. WHEN
YOU ARE HAPPY WITH THE DRAWING, ERASE
THE GUIDELINES.

Think about what each store sells to consider how you draw and decorate them.

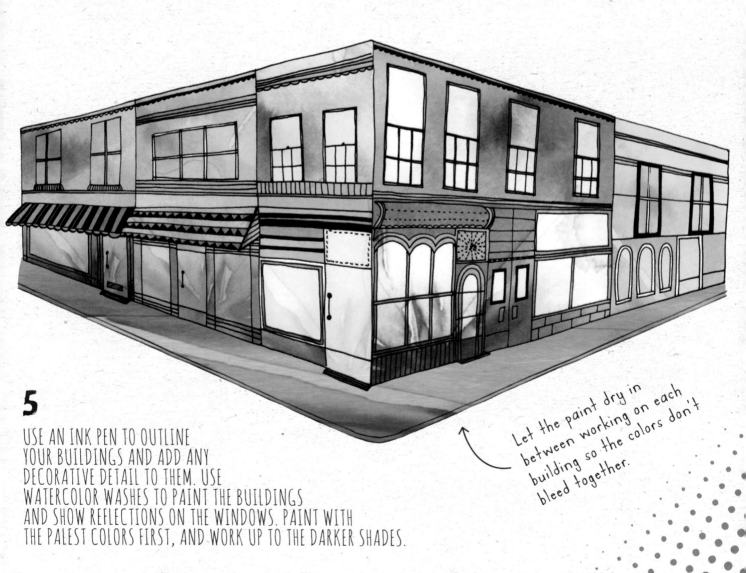

5

USE AN INK PEN TO OUTLINE
YOUR BUILDINGS AND ADD ANY
DECORATIVE DETAIL TO THEM. USE
WATERCOLOR WASHES TO PAINT THE BUILDINGS
AND SHOW REFLECTIONS ON THE WINDOWS. PAINT WITH
THE PALEST COLORS FIRST, AND WORK UP TO THE DARKER SHADES.

Let the paint dry in between working on each building so the colors don't bleed together.

ANIMALS IN CLOTHES

1
TO DRAW A DOG, SKETCH OVALS FOR THE HEAD AND FEET, CIRCLES FOR THE CHEST, REAR, AND JOINTS, AND LINES FOR THE BACK AND LEGS, AS SHOWN.

2
START OUTLINING THE DOG'S BODY SHAPE, GOING AROUND THE GUIDELINES, AS SHOWN. THEN SKETCH THE EARS AND TAIL.

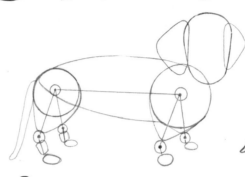

3
CONNECT THE SHAPES USING A STRONGER OUTLINE TO BRING OUT THE REAL CONTOUR OF THE DOG'S BODY.

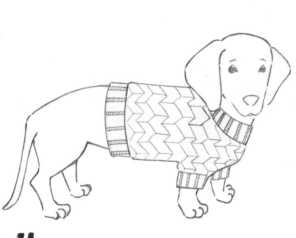

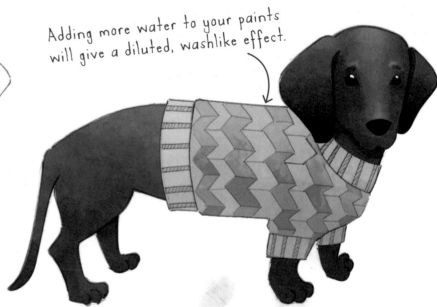

Adding more water to your paints will give a diluted, washlike effect.

4
ERASE THE GUIDELINES, THEN DRAW THE DOG'S FACIAL FEATURES, TOES, AND CLAWS. ADD A ZIGZAG PATTERNED SWEATER.

5
USE WATERCOLOR PAINTS TO COLOR THE DOG AND SWEATER. CHOOSE BRIGHT COLORS FOR THE SWEATER TO MAKE IT STAND OUT FROM THE DOG'S DARK FUR. ADD SOME LIGHT AND DARK SHADING FOR DEPTH AND TEXTURE.

GO CRAZY DRAWING OTHER ANIMALS IN FUNNY CLOTHES AND ACCESSORIES!

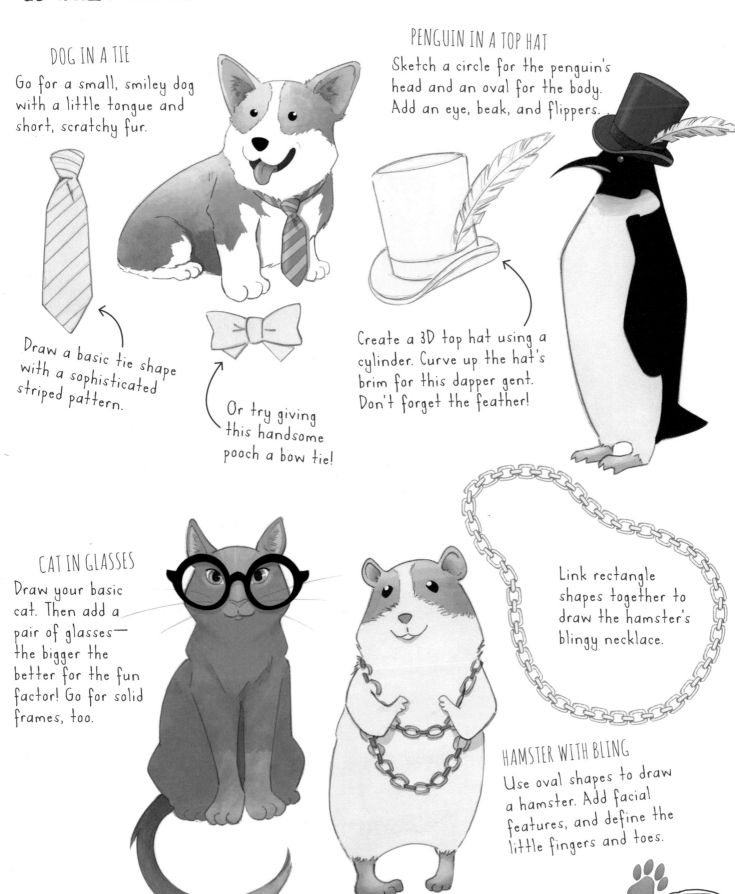

DOG IN A TIE

Go for a small, smiley dog with a little tongue and short, scratchy fur.

Draw a basic tie shape with a sophisticated striped pattern.

Or try giving this handsome pooch a bow tie!

PENGUIN IN A TOP HAT

Sketch a circle for the penguin's head and an oval for the body. Add an eye, beak, and flippers.

Create a 3D top hat using a cylinder. Curve up the hat's brim for this dapper gent. Don't forget the feather!

CAT IN GLASSES

Draw your basic cat. Then add a pair of glasses—the bigger the better for the fun factor! Go for solid frames, too.

Link rectangle shapes together to draw the hamster's blingy necklace.

HAMSTER WITH BLING

Use oval shapes to draw a hamster. Add facial features, and define the little fingers and toes.

MOUNTAIN RANGE

START BY SKETCHING BASIC TRIANGLE AND RECTANGLE SHAPES AS A GUIDE FOR THE OVERALL LOOK OF YOUR MOUNTAIN RANGE SCENE.

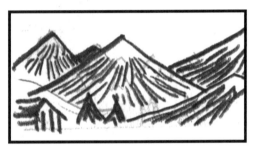

ADD HATCHING LINES, FOLLOWING THE DIRECTION OF THE MOUNTAINS WITH YOUR STROKES. LEAVE THE MOUNTAIN PEAKS WHITE FOR SNOWY TOPS.

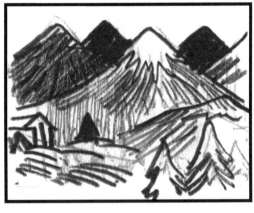

USE LIGHT AND HEAVY SHADING TO CREATE DEPTH. SKETCH SPIKY LINES AROUND THE WHITE MOUNTAIN PEAK FOR THE SNOW.

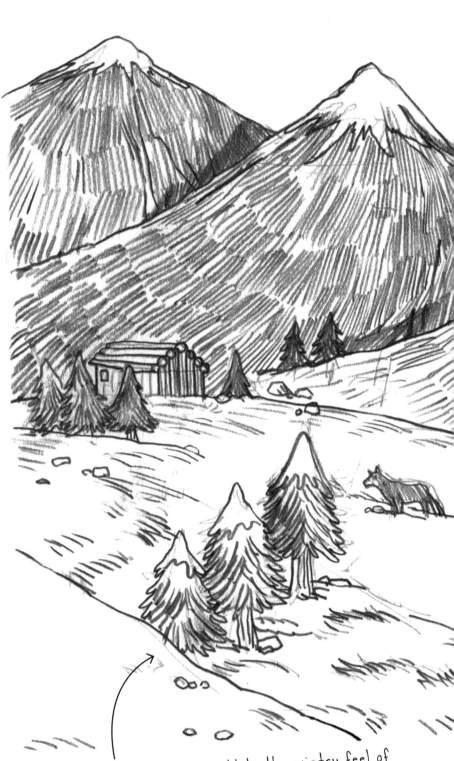

Snow-capped pine trees add to the wintry feel of your drawing. Give the drawing personality with other small details, such as a wolf and log cabin.

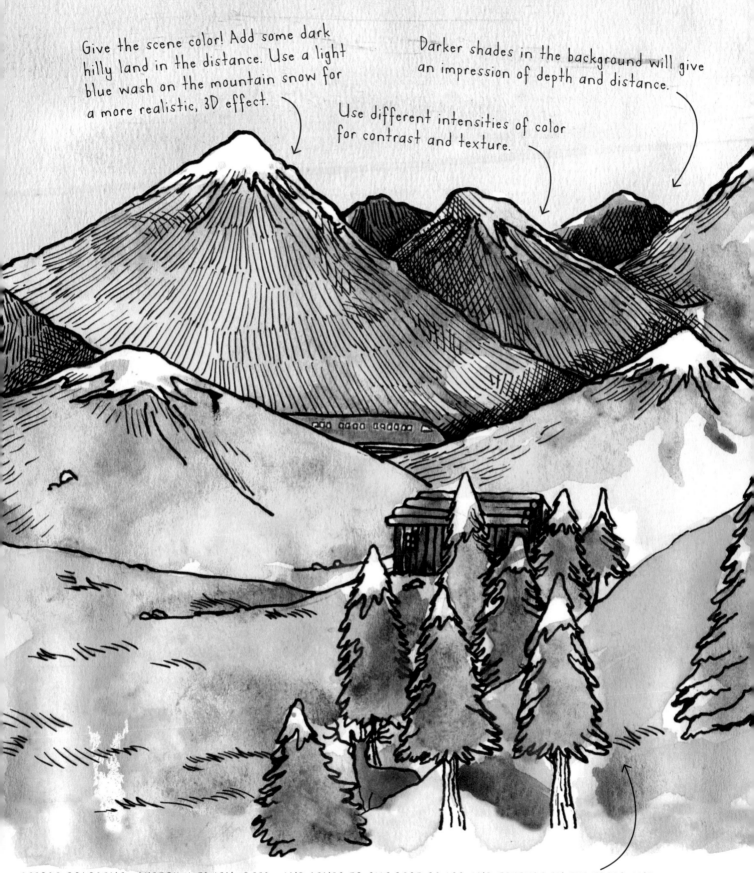

Give the scene color! Add some dark hilly land in the distance. Use a light blue wash on the mountain snow for a more realistic, 3D effect.

Use different intensities of color for contrast and texture.

Darker shades in the background will give an impression of depth and distance.

BEFORE COLORING, SKETCH A TRAIN, DEER, AND LINES TO SUGGEST GRASS AND TEXTURE IN THE TREES AND MOUNTAINS. USE AN INK PEN TO GO OVER ALL YOUR LINES, THEN ADD COLOR. BUILD UP THE SCENE WITH MORE TREES.

Fashion Boys

1

SKETCH AN OVAL SHAPE FOR THE HEAD AND GUIDELINES FOR THE SHOULDERS, BODY, HIPS, ARMS, AND LEGS.

2

DRAW ARM AND LEG SHAPES AROUND YOUR GUIDELINES. ADD HANDS AND FEET.

3

ADD A HOODIE AND JEANS TO THE SHAPE. USE WAVY LINES TO SHOW CREASES AT THE ELBOWS AND KNEES.

Use light and dark shades of the same color to vary the texture. Try rubbing chalk or wash a damp paintbrush over a color.

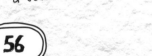

You can add some texture to the clothes to make them more realistic.

Try drawing a figure holding a skateboard. Look at the way this boy's shoulders and hips are tilted and one foot is turned up.

4

ADD HAIR AND A FACE, AND FINISH THE DETAILS SUCH AS LACES, POCKETS, AND ZIPPERS. ERASE ANY GUIDELINES THAT ARE STILL SHOWING BEFORE COLORING THE FINISHED FIGURE.

Add skater graphics to make your drawing more realistic. Make up your own, or take inspiration from your favorite brands and logos.

Make up swatches of colors you think will look good together.

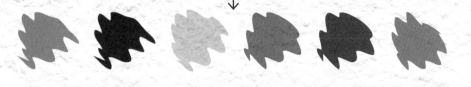

KANGAROO

1

DRAW A LARGE CIRCLE, WITH AN OVAL INSIDE IT FOR THE BODY. ADD A SMALL OVAL HEAD AND GUIDELINES FOR THE NECK, TAIL, AND LEGS.

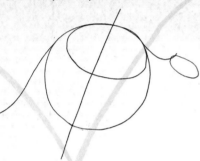

2

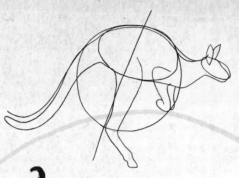

REFINE THE SHAPE OF THE HEAD AND DRAW SOME EARS. PENCIL IN THE KANGAROO'S LARGE HIND LEGS, TWO SMALLER FOLDED FRONT LEGS, AND TAIL.

3

NOW ADD SOME DETAILS TO THE FACE, INCLUDING THE EYE, NOSE, AND MOUTH. SKETCH IN A BIT OF MUSCLE DEFINITION TO THE LEGS AND SHOULDER AREAS.

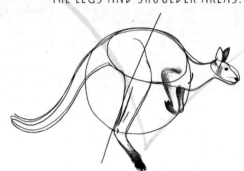

1

DRAW AN OVAL FOR THE LOWER BODY AND AN EGG SHAPE FOR THE UPPER BODY. DRAW TWO CIRCLE HEADS— ONE FOR THE MOTHER, ONE FOR THE JOEY. ADD AN OVAL FOR THE HIP OF THE HIND LEG.

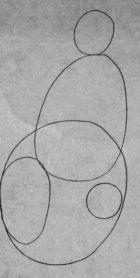

2

WITH A SOFT PENCIL USE THE GUIDE SHAPES TO FIRM UP THE OVERALL OUTLINE. ADD ARMS, LEGS, AND A TAIL. SKETCH DETAILS TO EACH FACE, INCLUDING EARS, AND ADD THE JOEY'S ARMS.

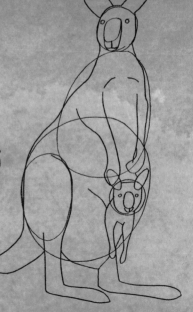

4

COLOR WITH A BROWN WATERCOLOR WASH. ADD DARKER TONES OF BROWNS AND A LITTLE GRAY. USE BLACK TO ADD IN THE EYES AND NOSE.

Kangaroos move at speeds of up to 35 mph by jumping using their powerful hind legs!

3

REFINE THE SHAPE OF THE KANGAROO, NARROWING THE UPPER BODY AND HEAD. COMPLETE THE FACE BY ADDING LINES AND SHADING. ADD LINES TO SHOW MUSCLES AND FUR TEXTURE.

4

COLOR WITH LIGHT AND DARK SHADES OF BROWN. ADD FACE DETAILS IN GRAY AND BLACK AND A FEW FUR HIGHLIGHTS USING A WHITE PEN OR PAINT.

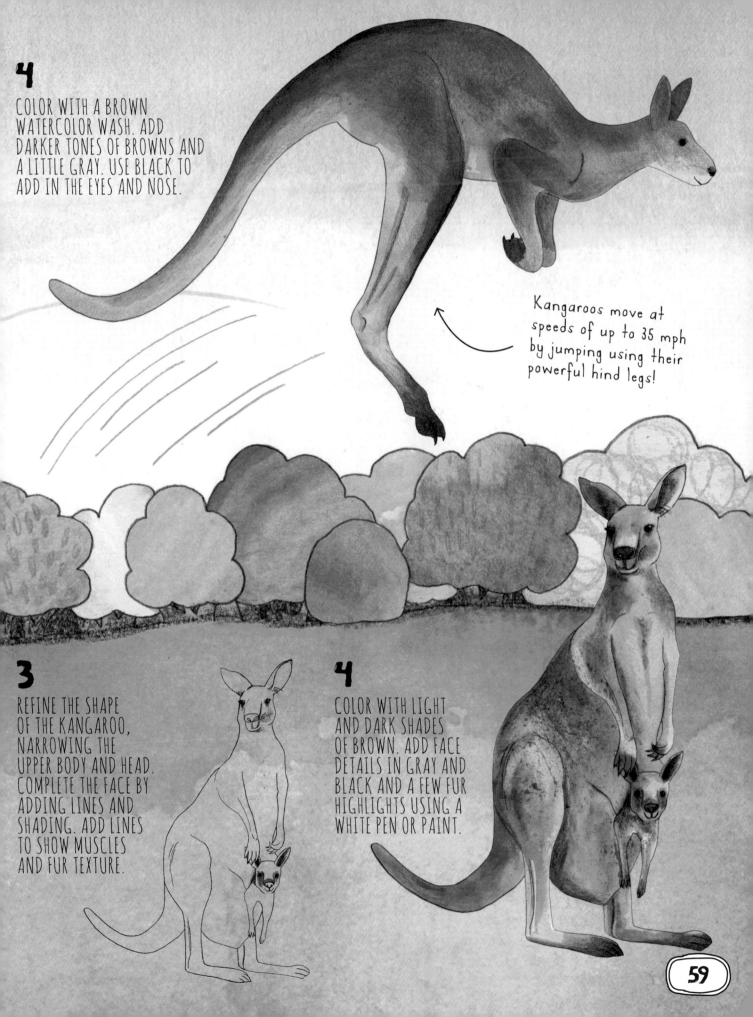

TENNIS PLAYER

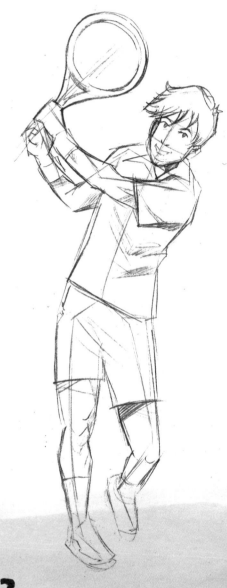

1

LIGHTLY SKETCH A STICK FIGURE IN AN ACTION POSE WITH THE LEFT ARM ACROSS THE CHEST, HOLDING ONTO A STICK. THE RIGHT LEG SHOULD BE STRAIGHT AND THE LEFT ONE BENT.

2

SKETCH THE LOOSE OUTLINE OF THE PLAYER AROUND THE GUIDES. THE RIGHT SHOULDER IS SLIGHTLY HIGHER, SO THE CLOTHES SHOULD APPEAR SLIGHTLY TWISTED.

3

START WORKING ON THE DETAIL. ADD THE FACIAL FEATURES, AND GIVE THE RACKET SOME SHAPE. USE LIGHT SHADING TO SHOW THE FOLDS IN THE CLOTHES.

Think about which direction the light is coming from to help you figure out where the shadowed areas should be.

Add small, colorful details for interest, such as a simple three-tone design on the racket frame.

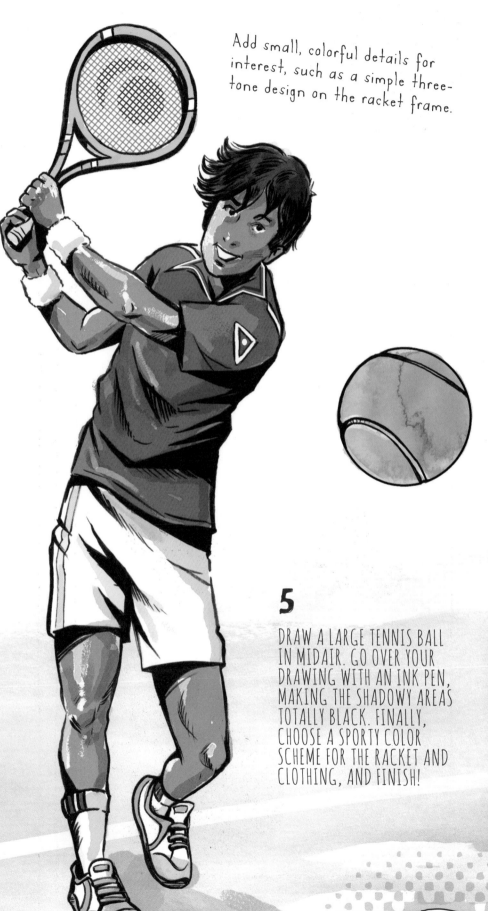

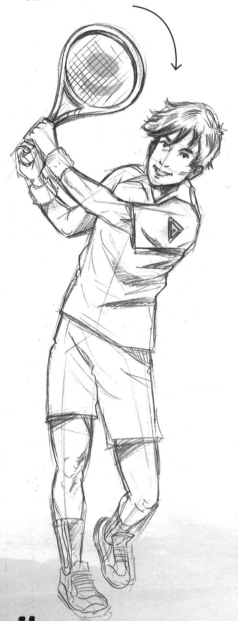

4

USING A 4B PENCIL, ADD DEFINED AREAS OF SHADOW AND MUSCLE TONE. USE CRISSCROSSING LINES FOR THE RACKET STRINGS, AND ADD DETAIL TO THE HANDS, HAIR, AND SHOES.

5

DRAW A LARGE TENNIS BALL IN MIDAIR. GO OVER YOUR DRAWING WITH AN INK PEN, MAKING THE SHADOWY AREAS TOTALLY BLACK. FINALLY, CHOOSE A SPORTY COLOR SCHEME FOR THE RACKET AND CLOTHING, AND FINISH!

OPTICAL ILLUSIONS

OPTICAL ILLUSIONS CAN MAKE PEOPLE SEE THINGS THAT AREN'T THERE. LEARN TO DRAW THEM TO TRICK YOUR FRIENDS AND FAMILY!

CUBES

 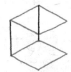 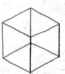

Draw a flattened diamond for the top of the cube, then exactly the same for the base. Draw vertical lines to link the corners together.

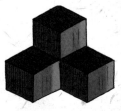 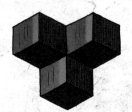

Add shading to some sides of the cube, like this. This helps gives them a 3D look.

Draw a lot of cubes together to get the optical illusion. Are the cubes the right way up or upside down? Or maybe you see them flip back and forth!

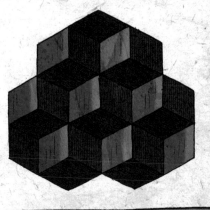

FACE OR VASE?

Draw a simple outline of a face looking to the right, using only one smooth line.

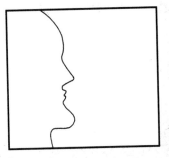

Then draw or trace the same face again, facing the first.

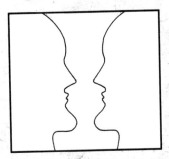

Darken the gap between the two faces. Some people will see the dark vase, and some people will see the faces!

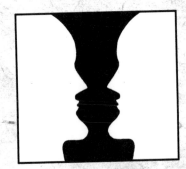

62

IMPOSSIBLE TRIANGLE

IF YOU LOOK CLOSELY, THIS TRIANGLE COULDN'T ACTUALLY EXIST. FOLLOW THE STEPS CAREFULLY TO CREATE ANOTHER TRICK OF THE EYES!

Start with a simple triangle.

At the three points, extend the lines slightly, like this.

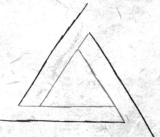

From the end of these new lines, draw parallel lines following the original triangle's sides.

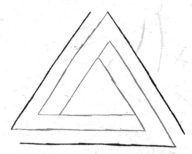

From the end of the last lines, draw three more parallel lines. Your impossible triangle should now be taking shape.

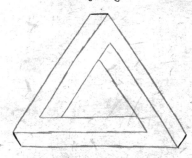

To create the illusion, link the last three lines to the rest of the triangle.

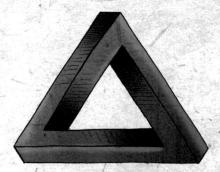

Color your image. Be careful with the shading, and you'll get the amazing effect!

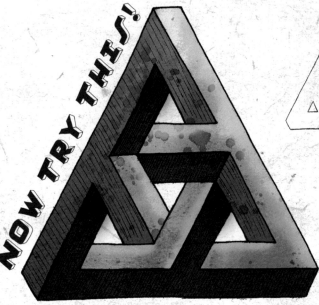

NOW TRY THIS!

 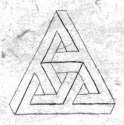

Draw a simple triangle with the three tips cut off. Then draw four small triangles inside. Extend lines from each point of each triangle. Now draw in the last lines, filling in all the gaps. Then add some shading and your impossible triangle is complete and an awesome illusion!

ELEPHANT

AFRICAN ELEPHANTS HAVE LARGE, TRIANGULAR EARS, WHILE ASIAN
ELEPHANTS HAVE SMALLER, ROUNDED EARS. THIS ONE IS AFRICAN!

1

DRAW FIVE ROUGH CIRCLES FOR THE HEAD,
EARS, BODY, AND BASE OF THE TRUNK. THEN
ADD TWO SMALL CIRCLES FOR EYES.

2

NEXT, ADD GUIDELINES FOR THE TRUNK AND
LEGS. THEN SKETCH DASHED LINES FOR THE
BASIC POSITIONS OF THE THREE VISIBLE FEET.

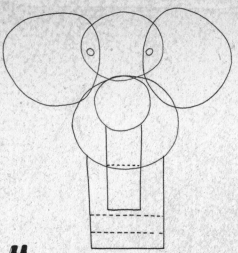

3

USE A SOFT PENCIL TO SKETCH IN THE BASIC
OUTLINE. ADD WAVY LINES FOR THE OUTSIDE
OF THE EARS AND TRUNK, AND TWO TUSKS.

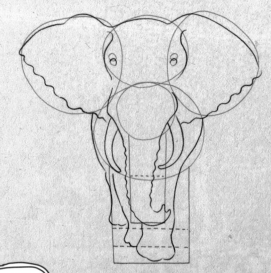

4

WORK UP THE EYES, THEN DRAW CURVED
LINES DOWN THE TRUNK. DO THE SAME FOR
THE KNEES, WHICH ARE LOW ON AN ELEPHANT.

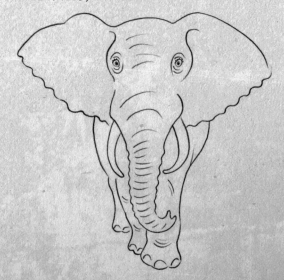

5

USE A BLUE-GRAY WATERCOLOR WASH. ADD PINK TO THE TIPS OF THE EARS. PAINT THE TUSKS WHITE. DRAW THE FINAL LINE WITH A DEEP BLUE PENCIL.

The large surface area of an elephant's ears helps to keep it cool under the harsh African sun.

Elephants use their trunks to keep cool— they squirt water and dust over their bodies to create a protective layer of dirt on their skin.

SUNRISE

Use lighter shades for the middle area of your picture. This will help draw your eye to the most interesting parts—the sun, house, and rowboat.

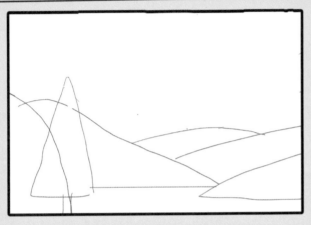

1 SKETCH A ROUGH LANDSCAPE USING SIMPLE CURVES. DRAW TRIANGULAR SHAPES FOR TREES.

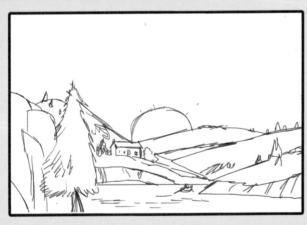

2 KEEPING YOUR LINE WORK LOOSE, SKETCH A RISING SUN IN THE DISTANCE. ADD OTHER DETAILS, SUCH AS A HOUSE AND ROWBOAT. SKETCH IN MORE LANDSCAPE FEATURES AS WELL.

Think about how the sunlight affects the objects in your picture. Draw some birds silhouetted against the dazzling sky, and add highlights to the rippling water. The hills just below are lit by the sun, too.

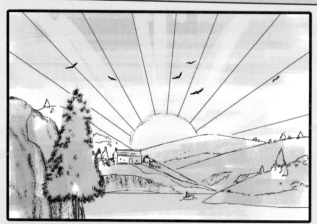

3 REFINE THE OUTLINES OF THE DIFFERENT SHAPES, AND USE A RULER TO DRAW LONG SUNBEAMS RADIATING OUT FROM THE SUN. NOW START TO BLOCK IN ROUGH AREAS OF COLOR.

4 USE DIFFERENT SHADES OF YOUR CHOSEN COLORS TO ADD DEPTH AND DETAIL. FADE BETWEEN THE YELLOWS AND ORANGES OF THE SUNRISE AND THE PURPLY TONES OF THE SKY. A SUNRISE IS ALL ABOUT THE COLOR AND FEEL!

Skateboards

THE BASIC SHAPE OF A SKATEBOARD IS VERY EASY TO DRAW. THE FUN PART IS COMING UP WITH AN EXCITING AND ORIGINAL PATTERN!

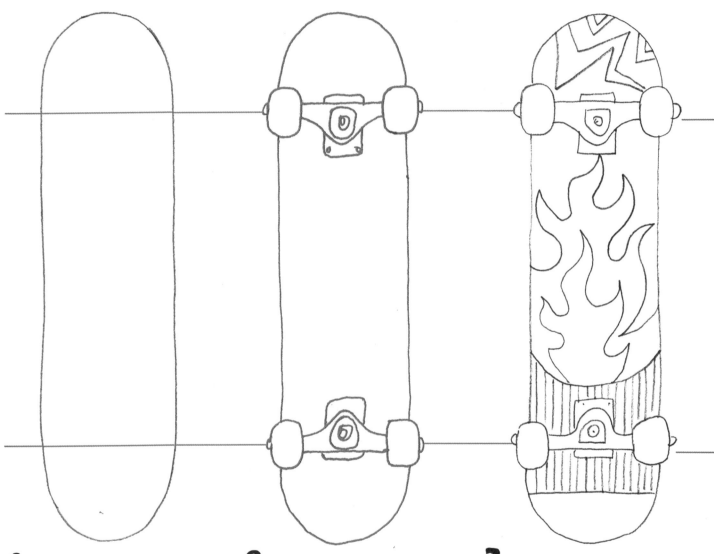

1
DRAW A LARGE RECTANGULAR SHAPE WITH TWO ROUNDED ENDS. SKETCH IN TWO GUIDELINES. THIS WILL HELP YOU ADD THE WHEELS TO THE BOTTOM OF THE SKATEBOARD.

2
SKETCH IN THE SIMPLE SHAPES OF THE SKATEBOARD'S WHEELS AND AXLES, USING THE LINES TO HELP. MAKE SURE THEY ARE THE SAME DISTANCE APART AT EACH END.

3
DRAW THE PATTERN FOR YOUR SKATEBOARD. DIVIDING THE DESIGN INTO THREE PARTS WILL HELP. WHEN YOU ARE HAPPY WITH IT, GO OVER THE PENCIL LINES IN INK.

BOARD DESIGNS

Use your imagination to come up with original designs for the bottom of your board. Color in the skateboards brightly to make the patterns look striking!

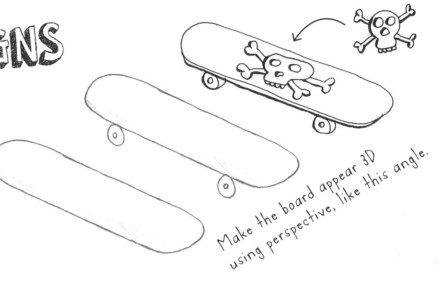

Make the board appear 3D using perspective, like this angle.

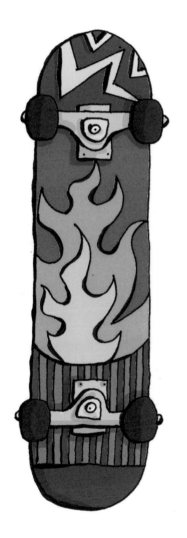

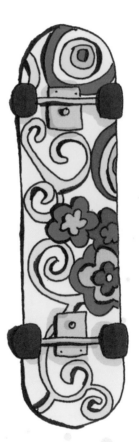

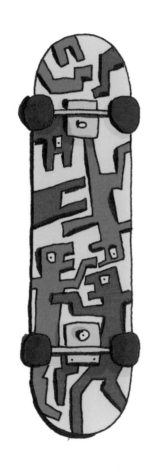

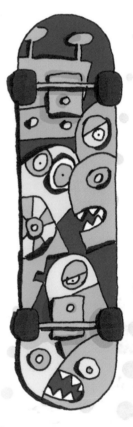

4

USE PAINTS TO COLOR IN YOUR SKATEBOARD. GIVE DEPTH TO THE DESIGN WITH A SLIGHTLY HEAVIER LINE USING A FINE BRUSH AND INK AROUND PARTS OF THE PATTERN.

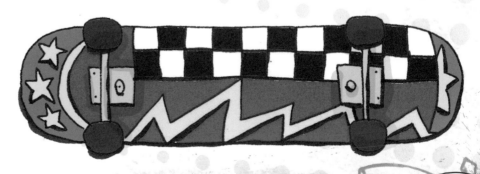

REPTILE SCALES

REPTILE SKIN IS MADE UP OF THOUSANDS OF SCALES. HERE ARE A FEW DIFFERENT CLOSE-UPS TO SHOW YOU THE KIND OF DETAILS YOU CAN ADD TO YOUR DRAWINGS!

CROCODILE

Start with lines of rough diamond shapes, then add ovals in the middle of each scale.

SEA TURTLE

Draw large irregular pentagon shapes that slot into one another.

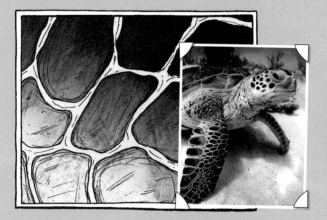

GILA MONSTER

Start with irregular splodges, then add regular circular bumps.

GREEN IGUANA

Draw vertical lines of rough rectangles, one below the other.

CHAMELEON

Draw wavy horizontal lines, then add different-sized circles within the lines.

EMERALD TREE BOA

Add diamond-shaped scales one line at a time.

 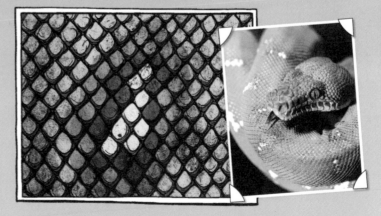

BUTTERFLIES

BUTTERFLY WING PATTERNS CAN LOOK COMPLEX, BUT THEY ARE EASY TO DRAW IF YOU USE SYMMETRY. TRY THESE, THEN CREATE YOUR OWN!

1
START BY DRAWING A CIRCLE ON TOP OF TWO OVALS TO CREATE THE HEAD AND BASIC BODY SHAPE OF A BUTTERFLY.

2
SKETCH A TOP WING ON EITHER SIDE OF THE BODY. THEN ADD A TEARDROP ON EACH SIDE FOR THE SMALLER WINGS, AS SHOWN.

3
DRAW A SYMMETRICAL PATTERN ON THE WINGS, MIRRORING OVAL AND RECTANGLE SHAPES ON EACH SIDE. ADD TWO LINES FOR THE ANTENNAE.

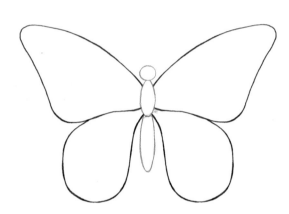

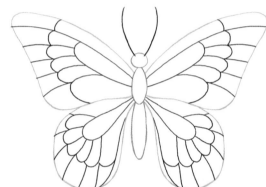

4
USE MORE SYMMETRY WHEN YOU COLOR THE BUTTERFLY, MAKING SURE BOTH WINGS ARE A MIRROR IMAGE OF EACH OTHER.

Try drawing different-shaped wings. Start with one side, then just repeat on the other!

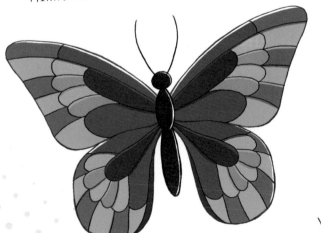

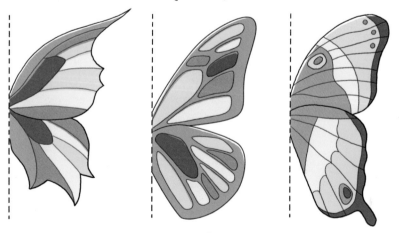

Vary the patterns, trying circles, ovals, and rectangles. Try mixing shapes together for new patterns.

EXPERIMENT WITH MORE ELABORATE PATTERNS ...

SPOTTED

Decorate the wings with different-sized spots, circles, and stripes.

Use only three colors, but use different shades of each for depth.

Add outlines around some shapes to make them stand out.

SWIRLY

Draw darker, swirly lines inside light pencil wing shapes.

Trace around the swirls in colored pens. Erase any pencil marks.

Color big swirls in one color and small swirls in another.

STRIPY

 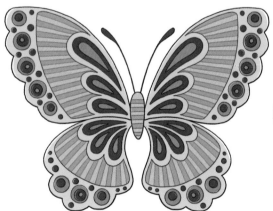

Try spots, stripes, and teardrops on wavy-edged wings.

Color the pattern in a mixture of complementary shades and colors.

Draw a thin border around some of the pattern for emphasis.

ALIEN UFO

1 DRAW THREE PAIRS OF ELLIPSES, MAKING EACH NEW PAIR NOTICEABLY BIGGER AS YOU MOVE DOWNWARD. DRAW THE SHAPES AT A SLIGHT ANGLE.

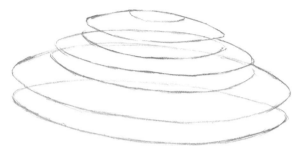

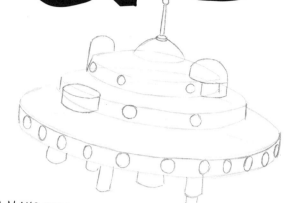

2 TO MAKE THREE SHALLOW CYLINDRICAL SHAPES, USE VERTICAL LINES TO JOIN EACH PAIR OF ELLIPSES AT THE FAR EDGES. FOR WINDOWS, ADD A ROW OF SMALL CIRCLES TO THE SIDE OF EACH CYLINDER. DRAW MORE CYLINDERS UNDERNEATH THE UFO'S BODY TO FORM THE BOOSTERS. ADD MORE DOMES AND CYLINDERS AS SHOWN.

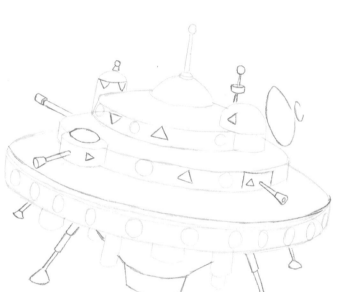

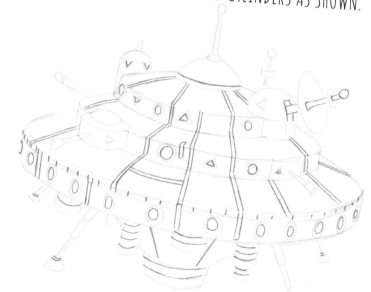

3 ADD MORE WINDOWS BY SKETCHING SOME TRIANGULAR SHAPES. ADD LEGS AND ARMS USING LONG RECTANGLES WITH TRIANGULAR OR 3D CONE SHAPES AT THE ENDS. ADD AN ELLIPSE TO FORM THE BASIC SHAPE OF A SATELLITE DISH. DRAW A LARGE CYLINDER UNDERNEATH THE UFO.

4 ADD EXTRA BODY DETAIL. DRAW MORE CIRCLES AND TRIANGLES AROUND THE WINDOWS. EMPHASIZE THE SENSE OF PERSPECTIVE BY DRAWING PAIRS OF PARALLEL LINES THAT FOLLOW THE STEPPED SHAPE OF THE UFO, SEPARATING SLIGHTLY AS THEY APPROACH THE VIEWER. ADD EXTRA CURVES TO THE BOOSTERS, LEGS, AND POLES.

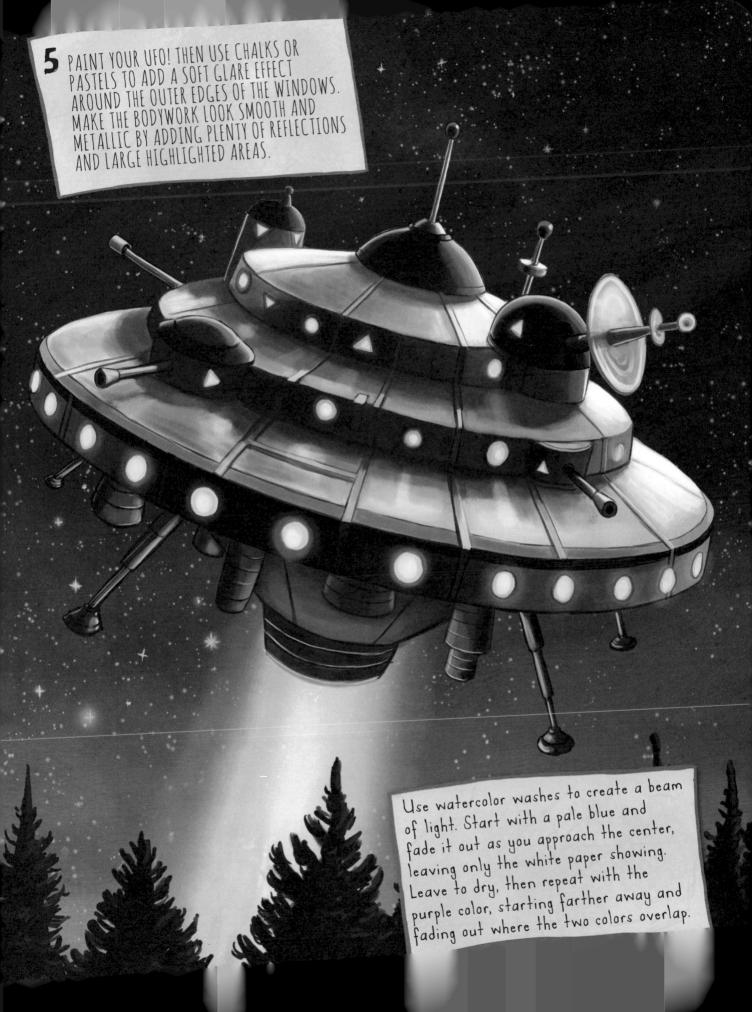

5 PAINT YOUR UFO! THEN USE CHALKS OR PASTELS TO ADD A SOFT GLARE EFFECT AROUND THE OUTER EDGES OF THE WINDOWS. MAKE THE BODYWORK LOOK SMOOTH AND METALLIC BY ADDING PLENTY OF REFLECTIONS AND LARGE HIGHLIGHTED AREAS.

Use watercolor washes to create a beam of light. Start with a pale blue and fade it out as you approach the center, leaving only the white paper showing. Leave to dry, then repeat with the purple color, starting farther away and fading out where the two colors overlap.

TOUCAN

The toco toucan's bright orange beak is 8 in long—a third of the bird's total length!

1

USE SQUASHED OVAL SHAPES FOR THE BODY, HEAD AND TAIL. CONNECT THE HEAD AND BODY WITH TWO LINES FOR THE NECK. ADD SMALL CIRCLES FOR THE FEET.

2

DRAW A CIRCLE FOR THE EYE AND SKETCH TWO DIVIDING LINES ON THE BEAK. ADD A TEARDROP SHAPE FOR THE WING AND SMALL CURVED TOES TO THE FEET.

3

CONNECT THE SHAPES WITH A FLUID OUTLINE. ADD INDIVIDUAL FEATHERS TO THE TAIL AND A LINE AROUND THE NECK TO SHOW THE WHITE AREA.

4

LIGHTLY SHADE THE HEAD AND BODY, LEAVING A WHITE PATCH AROUND THE FACE AND NECK. ADD FEATHERS TO THE WING.

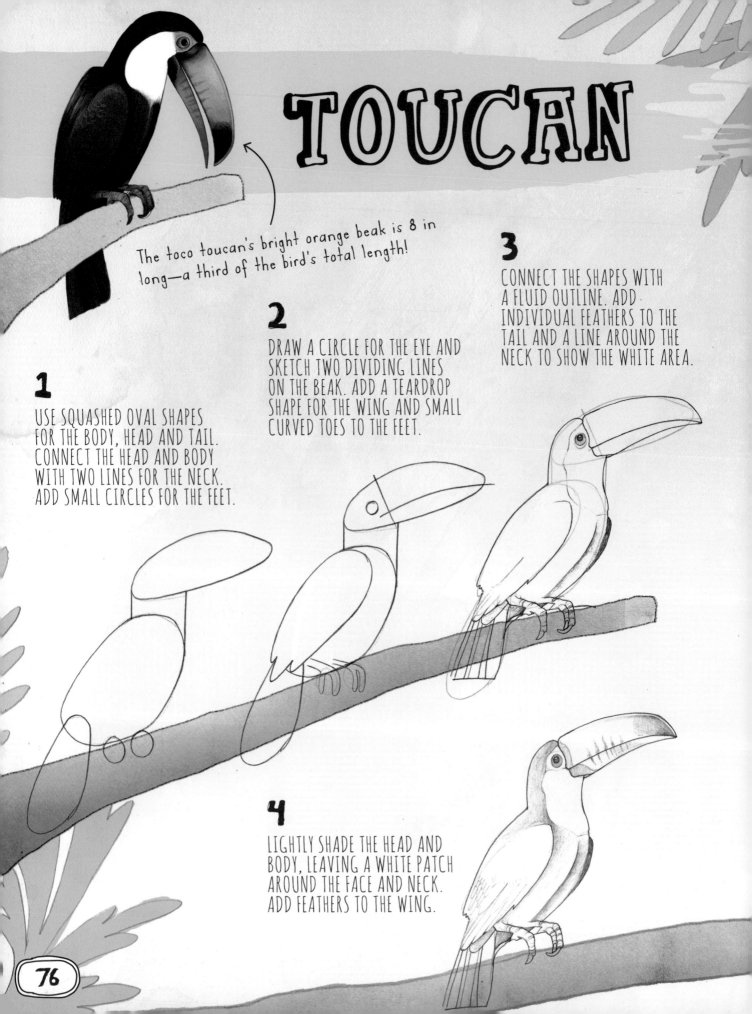

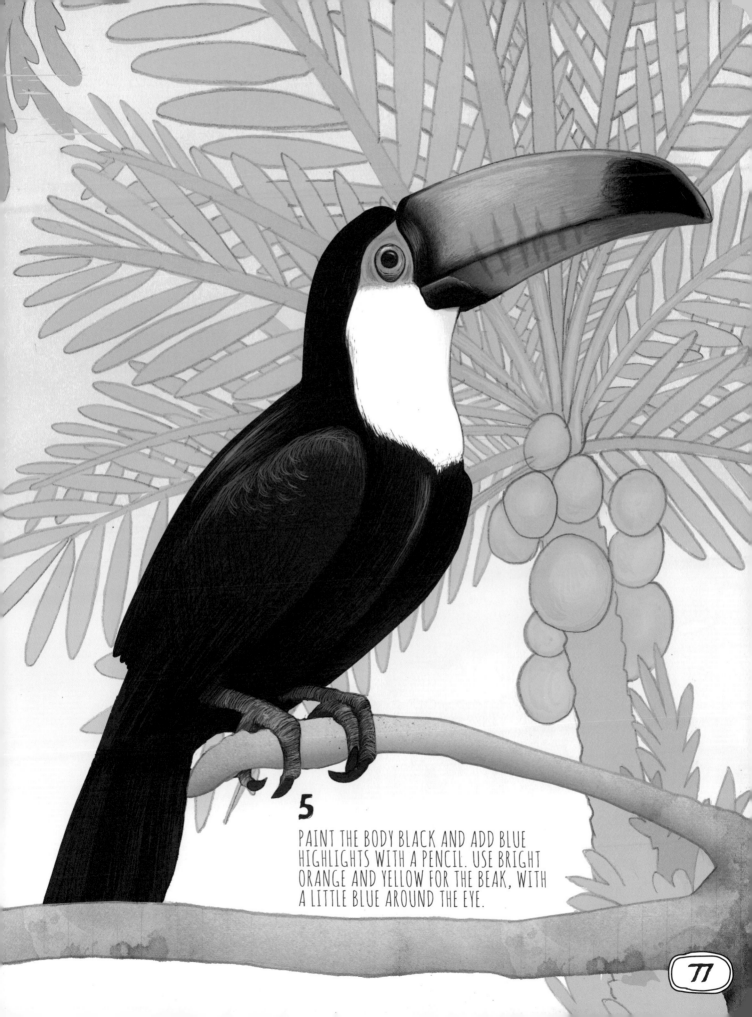

5

PAINT THE BODY BLACK AND ADD BLUE
HIGHLIGHTS WITH A PENCIL. USE BRIGHT
ORANGE AND YELLOW FOR THE BEAK, WITH
A LITTLE BLUE AROUND THE EYE.

SKELETON

1
SKETCH AN OVAL FOR THE HEAD, CIRCLES FOR THE SHOULDERS, ELBOWS, AND KNEES, AND LINES FOR THE BASIC BODY FRAME.

2
ADD GUIDELINES, TRIANGLES, AND CIRCLES, READY TO POSITION THE EYES, NOSE, MOUTH, RIB CAGE, AND PELVIS, AS SHOWN.

3
USING THE SHAPES AND GUIDELINES, DRAW THE OUTLINE OF THE SKELETON. ADD CYLINDER SHAPES FOR THE HANDS AND FEET.

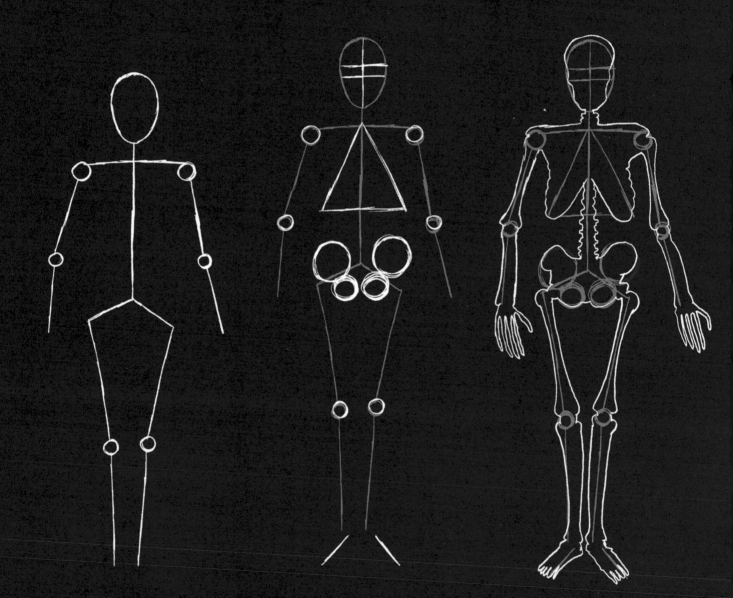

4

NOW SKETCH IN ALL THE BONE SHAPES,
USING OVALS, RECTANGLES, TRIANGLES,
AND CURVED LINES, LIKE THIS.

For the rib cage, draw the
central bone first, then add
the ribs one side at a time.

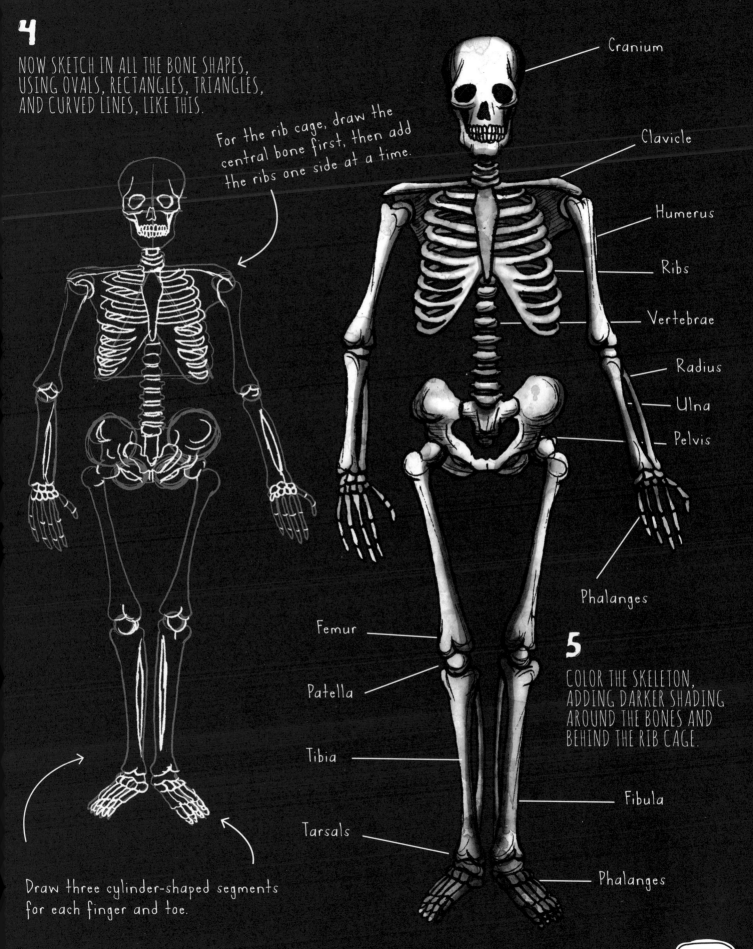

Cranium

Clavicle

Humerus

Ribs

Vertebrae

Radius

Ulna

Pelvis

Phalanges

Femur

Patella

Tibia

Tarsals

Phalanges

Fibula

5

COLOR THE SKELETON,
ADDING DARKER SHADING
AROUND THE BONES AND
BEHIND THE RIB CAGE.

Draw three cylinder-shaped segments
for each finger and toe.

tORNADO

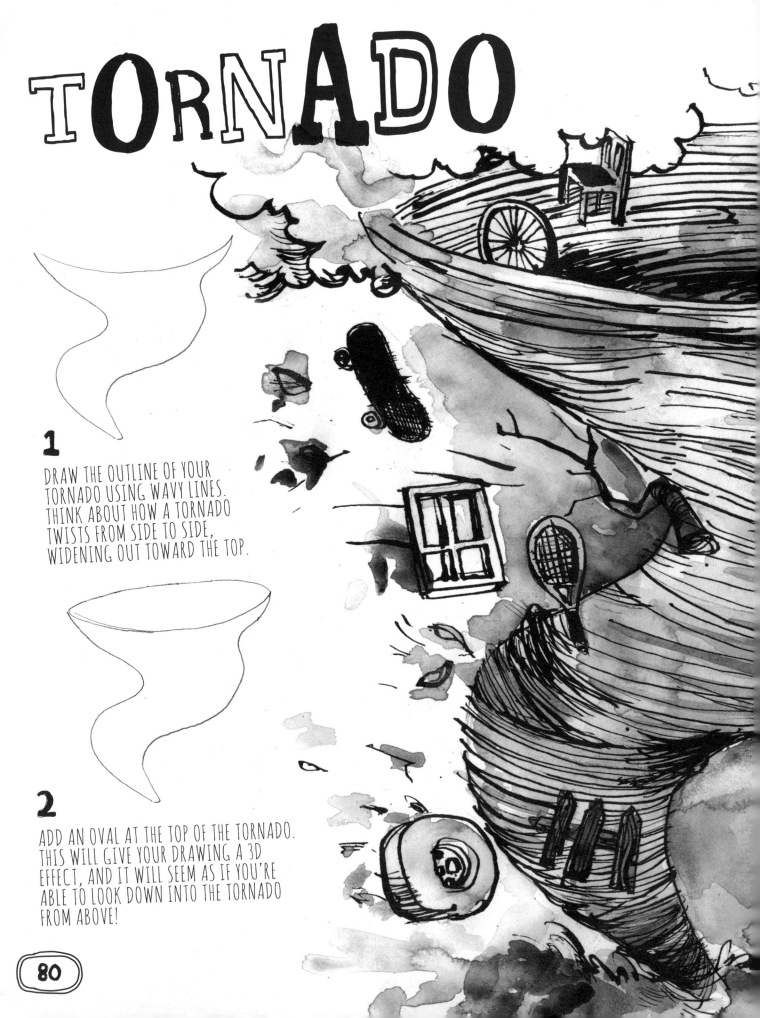

1

DRAW THE OUTLINE OF YOUR TORNADO USING WAVY LINES. THINK ABOUT HOW A TORNADO TWISTS FROM SIDE TO SIDE, WIDENING OUT TOWARD THE TOP.

2

ADD AN OVAL AT THE TOP OF THE TORNADO. THIS WILL GIVE YOUR DRAWING A 3D EFFECT, AND IT WILL SEEM AS IF YOU'RE ABLE TO LOOK DOWN INTO THE TORNADO FROM ABOVE!

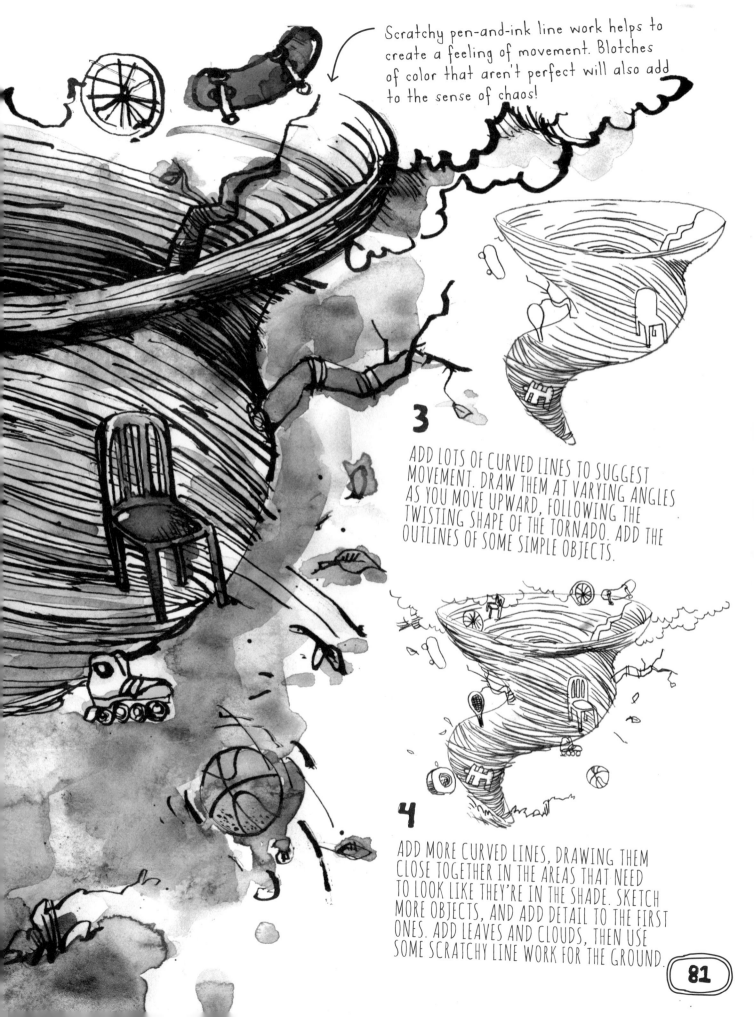

Scratchy pen-and-ink line work helps to create a feeling of movement. Blotches of color that aren't perfect will also add to the sense of chaos!

3

ADD LOTS OF CURVED LINES TO SUGGEST MOVEMENT. DRAW THEM AT VARYING ANGLES AS YOU MOVE UPWARD, FOLLOWING THE TWISTING SHAPE OF THE TORNADO. ADD THE OUTLINES OF SOME SIMPLE OBJECTS.

4

ADD MORE CURVED LINES, DRAWING THEM CLOSE TOGETHER IN THE AREAS THAT NEED TO LOOK LIKE THEY'RE IN THE SHADE. SKETCH MORE OBJECTS, AND ADD DETAIL TO THE FIRST ONES. ADD LEAVES AND CLOUDS, THEN USE SOME SCRATCHY LINE WORK FOR THE GROUND.

TrOPICAL FISH

ORANGE CLOWNFISH

A clownfish has three white lines across its bright orange body. Each fin has a black edging.

1

START WITH AN OVAL FOR THE BASIC BODY OF THE FISH. ADD A HORIZONTAL GUIDELINE AND ROUGH TAIL FIN.

2

BELOW THE GUIDELINE, ADD A C-SHAPED PECTORAL FIN. THEN ADD TWO FLAT DORSAL FINS AND AN ANAL FIN.

COPPER BUTTERFLYFISH

This fish is also known as "beaked coralfish," because of its snout. It has a distinctive eye-spot on its dorsal fin.

1

DRAW A CIRCLE WITH A POINTED END FOR THE BODY. ADD A HORIZONTAL GUIDELINE AND ROUGH TAIL FIN.

2

ADD A V-SHAPED DORSAL FIN, AND SMALLER V-SHAPED ANAL FIN. DRAW TRIANGULAR PECTORAL FINS AND A DOT FOR THE EYE.

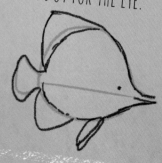

PENNANT CORALFISH

These fish are mostly black and white, with elongated dorsal fins. Their fins can be bright yellow.

1

SKETCH A CIRCLE WITH A POINTED END FOR THE BODY, A LINE FOR THE DORSAL FIN, AND TRIANGLES FOR THE OTHER FINS.

2

USING THE GUIDE SHAPES, FIRM UP THE OUTLINE OF THE FISH. ADD AN EYE AND ROUGH STRIPE PATTERN.

3

COLOR WITH YELLOW AND ORANGE FIRST, THEN ADD THE WHITE STRIPES. COLOR THE EDGE OF THE FINS WITH BLACK.

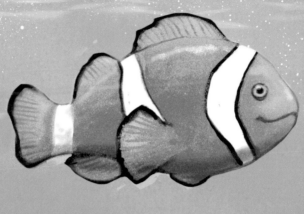

CORAL

Draw the rough shape of the coral, adding plenty of varied twisting branch shapes.

3

COLOR THE STRIPES WITH YELLOW AND ORANGE. ADD GRAY TO THE WHITE SECTIONS AND A BLACK EYE.

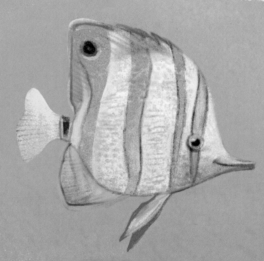

Paint a flat color and then sprinkle sea salt onto the wet picture for a coral effect!

3

COLOR THE FISH WITH BLACK AND YELLOW STRIPES, ADDING GRAY HIGHLIGHTS TO THE WHITE STRIPES.

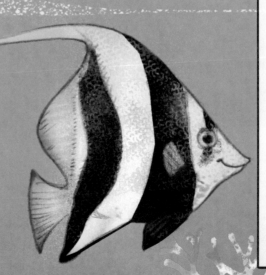

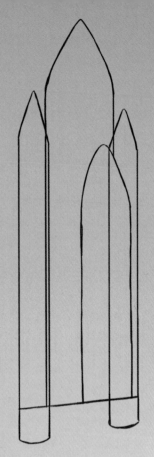

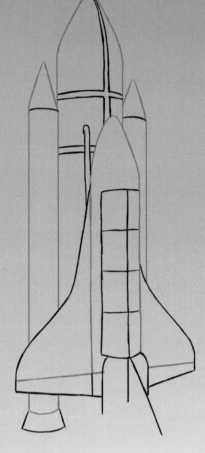

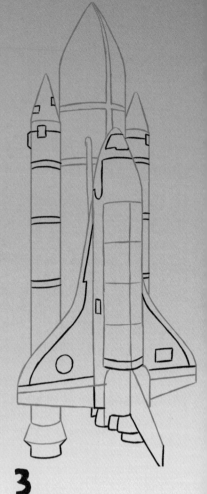

1

DRAW A TALL CYLINDER SHAPE WITH A POINTED TIP. ADD TWO SIMILAR, BUT THINNER, SHAPES ON EITHER SIDE, THEN A THIRD, SHORTER SIMILAR SHAPE IN FRONT.

2

DRAW THE OUTLINE OF THE SPACE SHUTTLE, AND ADD ITS CURVED DOORS. DRAW CURVES ON THE TWO BOOSTERS AND FUEL TANK TO MAKE THEM LOOK MORE 3D.

3

DRAW EXTRA CURVED BANDS ON THE ROCKET BOOSTERS, PLUS OTHER DETAILS AT THE TOP. ADD MORE LINES ON THE WINGS, FOLLOWING THE CURVED SHAPE OF EACH ONE.

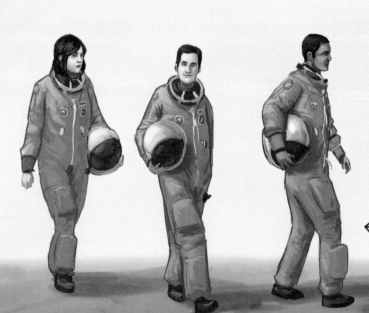

Don't forget to add astronauts in spacesuits, walking toward their shuttle and mission!

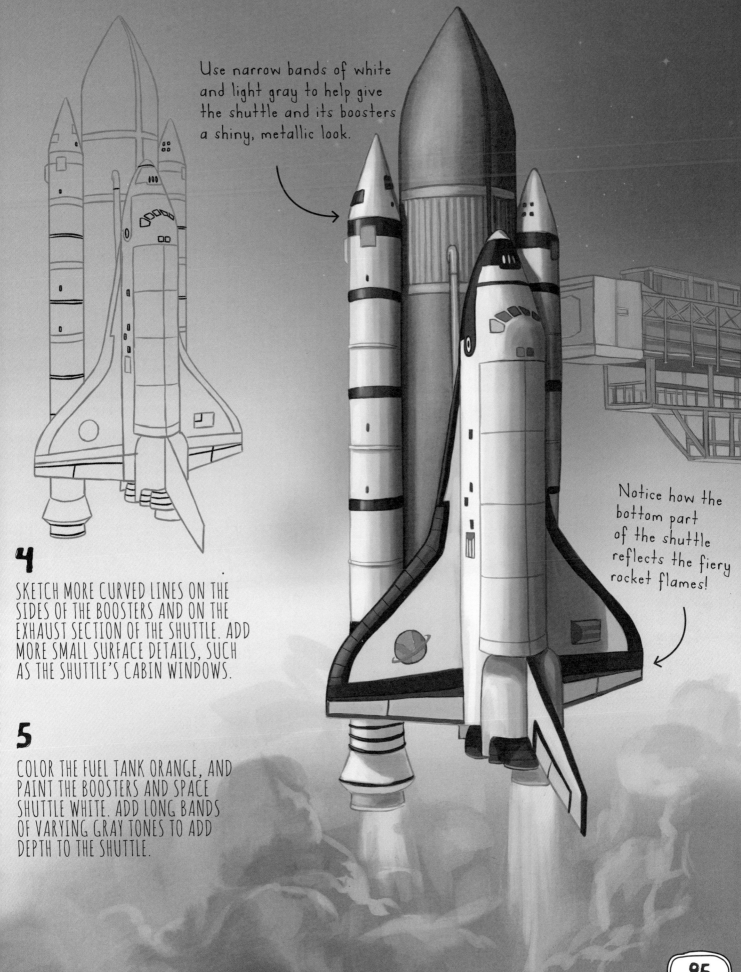

Use narrow bands of white and light gray to help give the shuttle and its boosters a shiny, metallic look.

Notice how the bottom part of the shuttle reflects the fiery rocket flames!

4

SKETCH MORE CURVED LINES ON THE SIDES OF THE BOOSTERS AND ON THE EXHAUST SECTION OF THE SHUTTLE. ADD MORE SMALL SURFACE DETAILS, SUCH AS THE SHUTTLE'S CABIN WINDOWS.

5

COLOR THE FUEL TANK ORANGE, AND PAINT THE BOOSTERS AND SPACE SHUTTLE WHITE. ADD LONG BANDS OF VARYING GRAY TONES TO ADD DEPTH TO THE SHUTTLE.

The Eiffel Tower was completed in 1889 and is the tallest building in Paris, France. It is also pretty easy to draw!

3

ADD MORE DETAIL TO YOUR TOWER BY DIVIDING THE DRAWING INTO SHAPES AND SECTIONS WITH A PENCIL. WHEN THE SHAPE IS COMPLETE, YOU CAN ERASE THE GUIDELINES.

1

USE A PENCIL AND RULER TO DRAW A TALL, TRIANGULAR GUIDELINE SHAPE. BREAK THE SHAPE UP WITH FOUR HORIZONTAL LINES, POSITIONED AS SHOWN.

2

USE YOUR GUIDELINES TO SKETCH OUT THE SHAPE OF THE TOWER. THE STRUCTURE IS WIDE AT THE BASE AND RISES TO A SINGLE POINT.

The design of the Eiffel Tower can look complicated close up! Break it down into small sections to create the intricate detail. The design is full of triangle and square shapes, as well as decorative swirls. Have fun practicing your line work drawing!

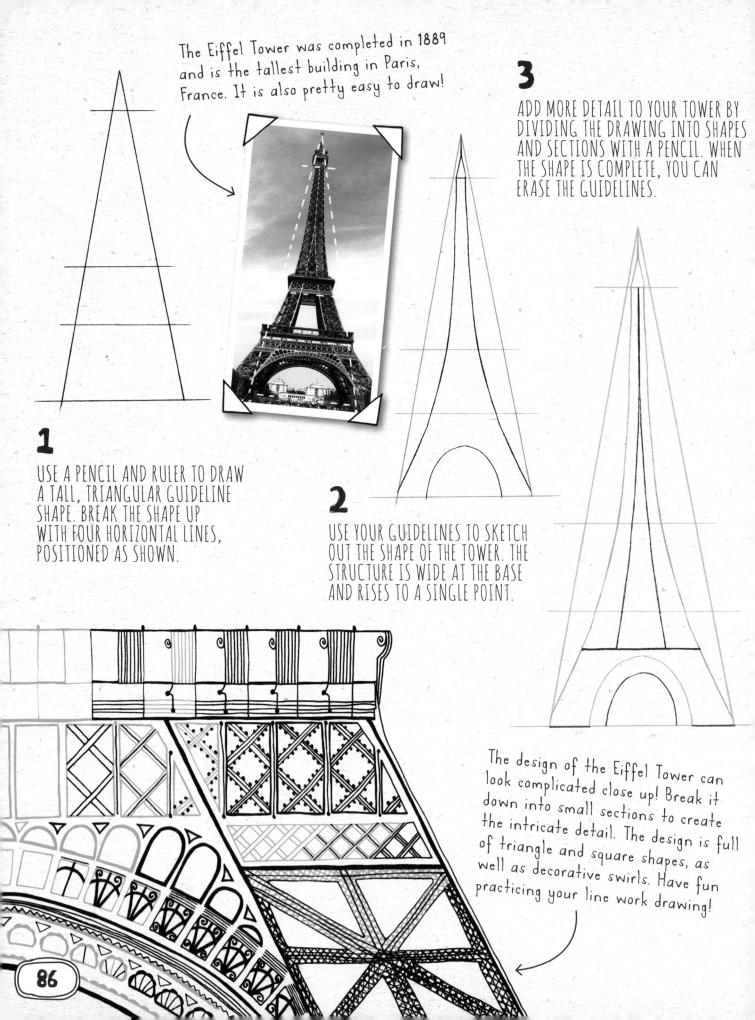

4

USE A FINE-POINT INK PEN AND A RULER TO BREAK THE DRAWING INTO EVEN SMALLER SHAPES, LIKE THIS. A RULER WILL HELP MAKE SURE THE LINES ARE NEAT AND AT THE SAME LEVEL.

When your Eiffel Tower is finished, give your picture a wow-factor background. Watercolor paints or inks are good for this. Using a large brush loaded with water, wet the paper. Add on the inks or paint, and watch the colors bleed together.

5

USING A FINE-POINT WATERPROOF PEN, ADD LOTS OF DECORATIVE DETAIL TO FINISH THE DESIGN OF THE TOWER. DRAW IN SOME SILHOUETTED PEOPLE AT THE BOTTOM TO GIVE AN IDEA OF HOW IMPRESSIVELY TALL THE TOWER IS.

EIFFEL TOWER

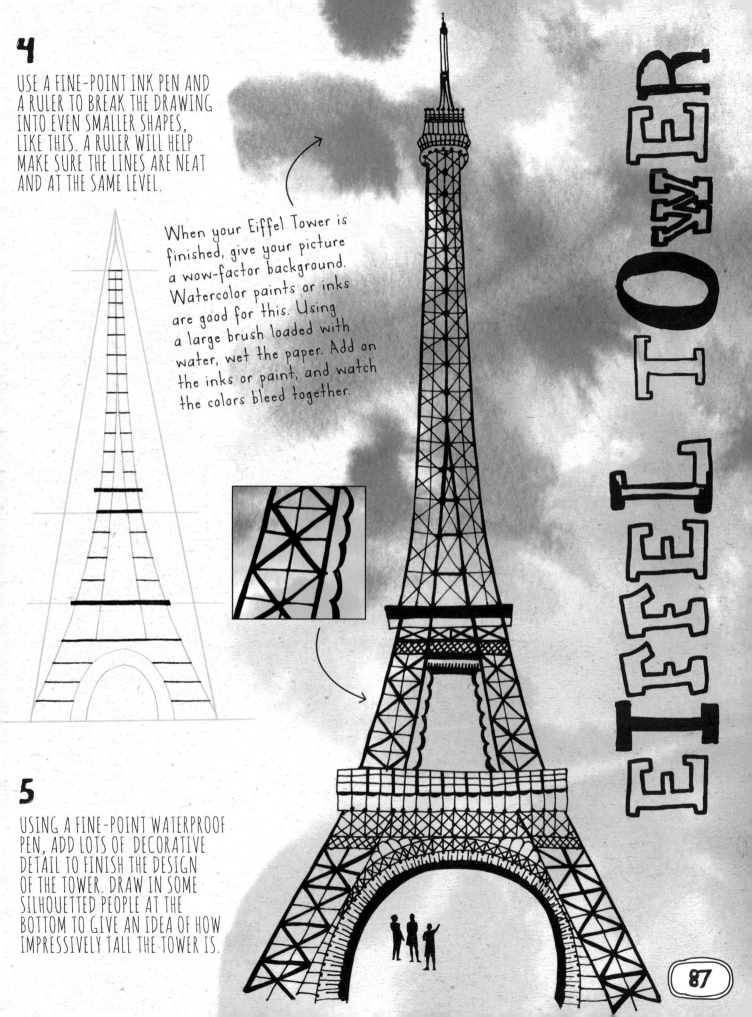

PIZZA

FEELING HUNGRY? DISCOVER HOW EASY IT IS TO
DRAW YOUR OWN PIZZA WITH SIMPLE SHAPES!

Draw a large circle. It helps if you
use a compass to give you a center
point. Draw four lines through the
center of the pizza, like this, to
divide it into eight slices.

TOPPINGS

ADDING SLIGHTLY BROADER INK LINES GIVES
YOUR PIZZA ILLUSTRATION MORE DEPTH.

TOMATO

SALAMI

OLIVES

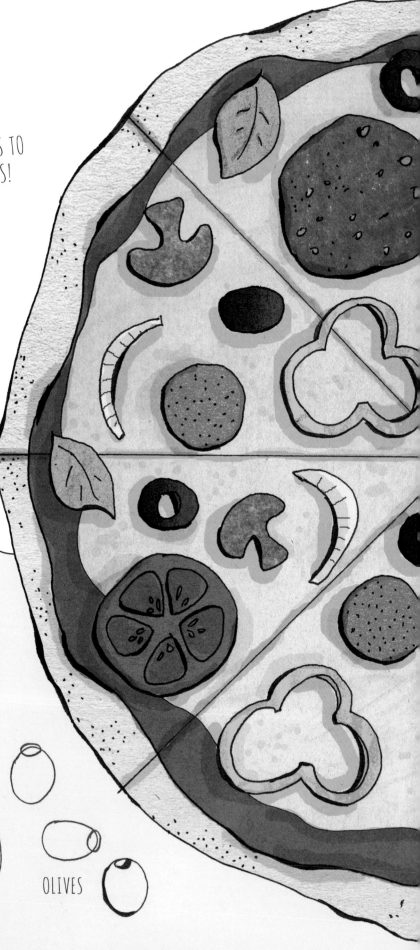

1

TO DRAW A 3D SLICE, SKETCH AN ANGLED TRIANGLE SHAPE FOR SIMPLE PERSPECTIVE, LIKE THIS.

2

ADD DEPTH WITH ANOTHER LINE UNDERNEATH TO GIVE THE SLICE SOME THICKNESS.

3

GIVE THE CRUST A WAVY EDGE, AND ADD SOME TOPPINGS AND MELTING CHEESE DRIPPING DOWN.

Have fun with the color! Spread the toppings out, and don't put all the same colors next to each other, to balance the drawing.

PEPPER

BASIL

ONIONS

Add irregular lines around the edge to create the wobbly and authentic shape of a pizza crust.

MUSHROOM

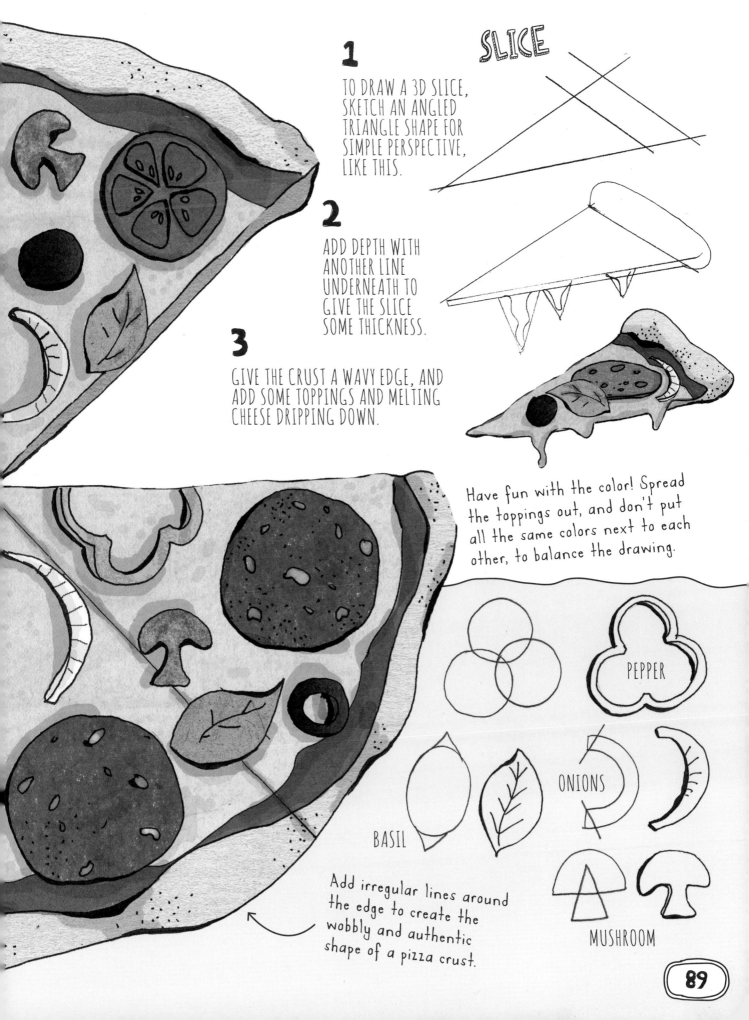

GRIFFIN

1

START WITH SIMPLE OVALS TO SKETCH THE BASIC SHAPE OF YOUR GRIFFIN, AS SHOWN.

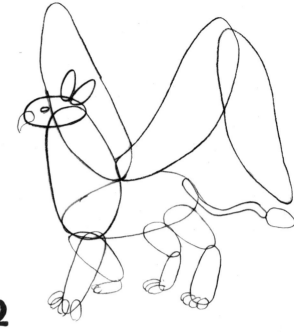

2

DRAW MORE ROUGH OVALS FOR THE WINGS, EARS, TOES, EYE, AND TAIL END. CREATE A HOOKED, EAGLE-SHAPED BEAK AND A THIN, LIONLIKE TAIL.

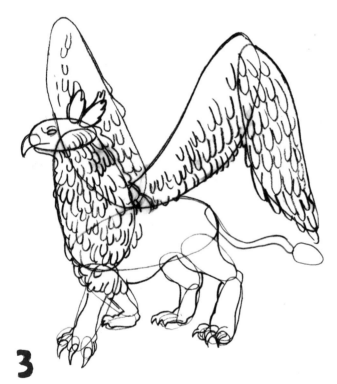

3

REPEAT SIMPLE U SHAPES ON THE GRIFFIN'S WINGS AND TORSO FOR A FEATHERY EFFECT. USE A HEAVIER, MORE FLUID LINE TO DRAW AROUND THE EARS, FACE, BODY, LEGS, AND CLAWS, TO CONNECT THEM.

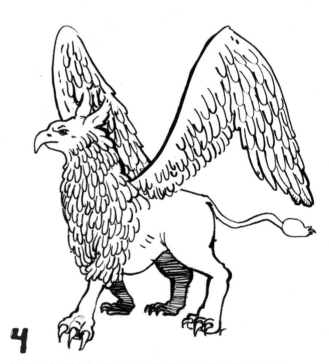

4

OUTLINE YOUR SKETCH WITH BLACK PEN OR INK. ADD SOME SHADING ON THE TWO LEGS IN THE BACKGROUND. FILL IN MORE DETAIL ON THE BEAK, FACE, EARS, AND TAIL. ERASE ANY PENCIL MARKS.

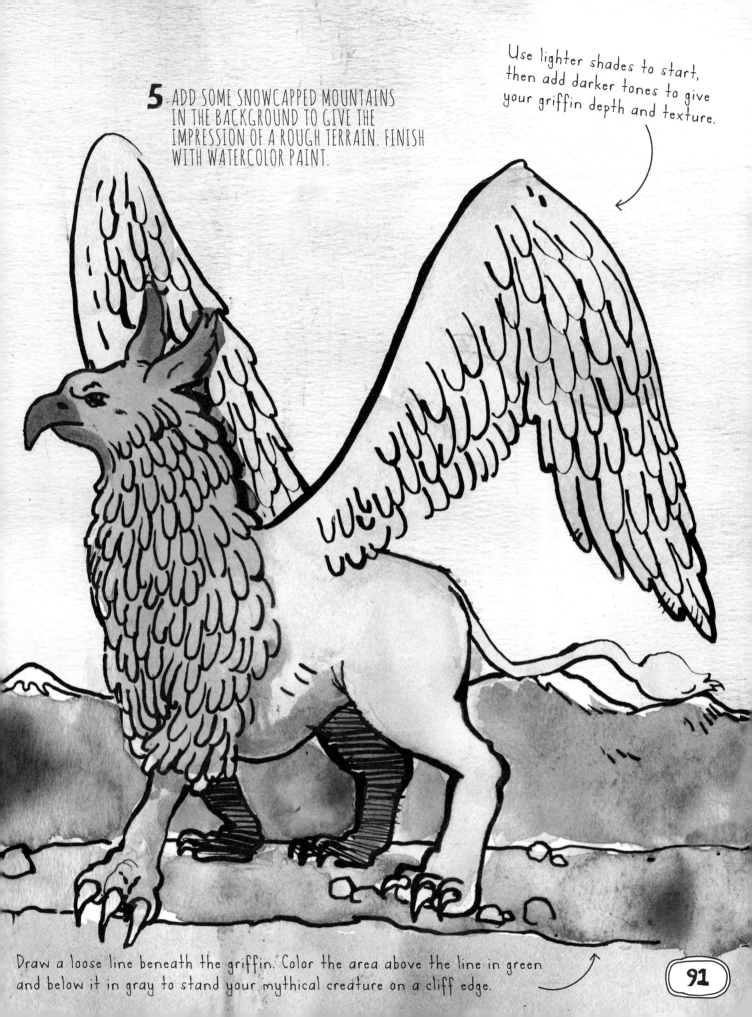

5 ADD SOME SNOWCAPPED MOUNTAINS IN THE BACKGROUND TO GIVE THE IMPRESSION OF A ROUGH TERRAIN. FINISH WITH WATERCOLOR PAINT.

Use lighter shades to start, then add darker tones to give your griffin depth and texture.

Draw a loose line beneath the griffin. Color the area above the line in green and below it in gray to stand your mythical creature on a cliff edge.

SKATEBOARDER

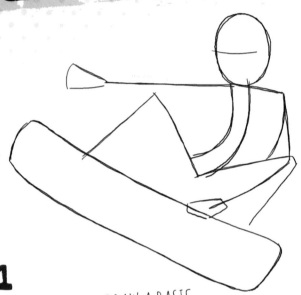

1

USING A PENCIL, DRAW A BASIC RECTANGULAR SHAPE FOR THE SKATEBOARD. SKETCH A ROUGH CIRCLE FOR THE BOY'S HEAD AND GUIDELINES FOR HIS BODY, ARMS, HANDS, AND LEGS.

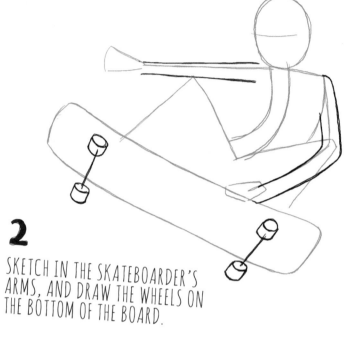

2

SKETCH IN THE SKATEBOARDER'S ARMS, AND DRAW THE WHEELS ON THE BOTTOM OF THE BOARD.

The helmet should sit slightly above the top of the skateboarder's head.

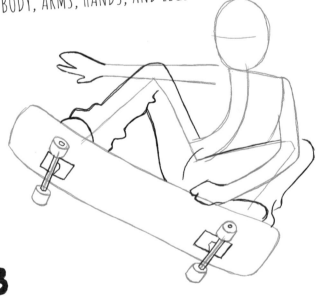

3

ADD MORE DETAIL TO THE BOARD'S WHEELS, AND GIVE YOUR FIGURE SOME ROUGH HANDS AND JEANS. DRAW TWO CURVED LINES FOR HIS SHOES.

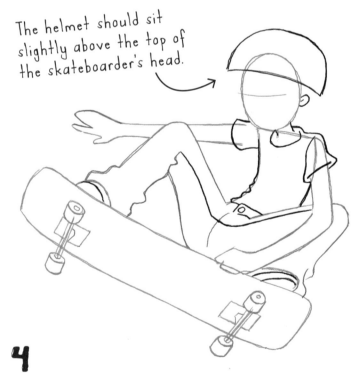

4

DRAW A HALF CIRCLE ABOVE THE HEAD FOR THE SKATEBOARDER'S HELMET. SKETCH IN GUIDELINES FOR HIS T-SHIRT, BELT, AND SHOES.

Make sure the boy is holding onto the board tightly!

Change the pose of the character by drawing both arms in the air!

5

FINISH THE SKETCH BY ADDING GLOVES AND FINGERS TO THE HANDS. SKETCH IN THE BOY'S EYES, NOSE, AND MOUTH. GIVE HIM HAIR, TOO. FINALIZE THE DETAILS ON THE HELMET AND BOARD.

Use shading and lines within your color for depth and movement.

6

ADD FINAL DETAILS TO YOUR DRAWING THEN ERASE ANY STRAY LINES FROM THE ORIGINAL SKETCH. ADD COLOR! USE DIFFERENT SHADES OF THE SAME COLOR ON THE CLOTHES TO GIVE THE PICTURE SOME DEPTH.

Give your board an exciting design underneath, like these bright flames. See pages 68 and 69 for some more ideas.

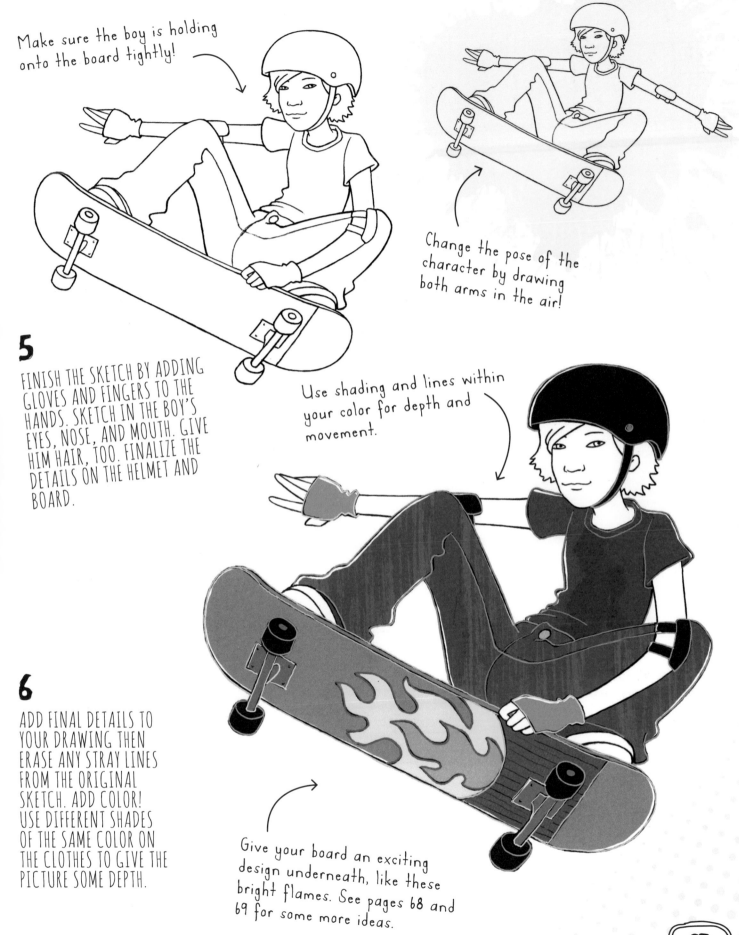

SCARLET MACAW

A MACAW IS A LARGE, LONG-TAILED PARROT. DRAW YOUR SCARLET MACAW IN THE TROPICAL RAINFORESTS OF SOUTH AMERICA!

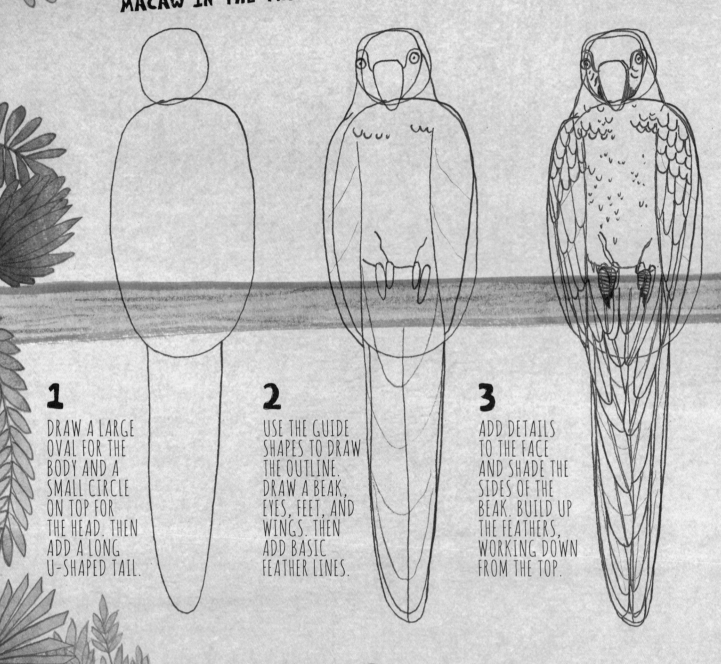

1
DRAW A LARGE OVAL FOR THE BODY AND A SMALL CIRCLE ON TOP FOR THE HEAD. THEN ADD A LONG U-SHAPED TAIL.

2
USE THE GUIDE SHAPES TO DRAW THE OUTLINE. DRAW A BEAK, EYES, FEET, AND WINGS. THEN ADD BASIC FEATHER LINES.

3
ADD DETAILS TO THE FACE AND SHADE THE SIDES OF THE BEAK. BUILD UP THE FEATHERS, WORKING DOWN FROM THE TOP.

4

PAINT THE HEAD, BODY, WING TOPS, AND TAIL RED. ADD BANDS OF YELLOW AND BLUE IN THE MIDDLE OF THE WINGS AND BLACK ON THE FACE.

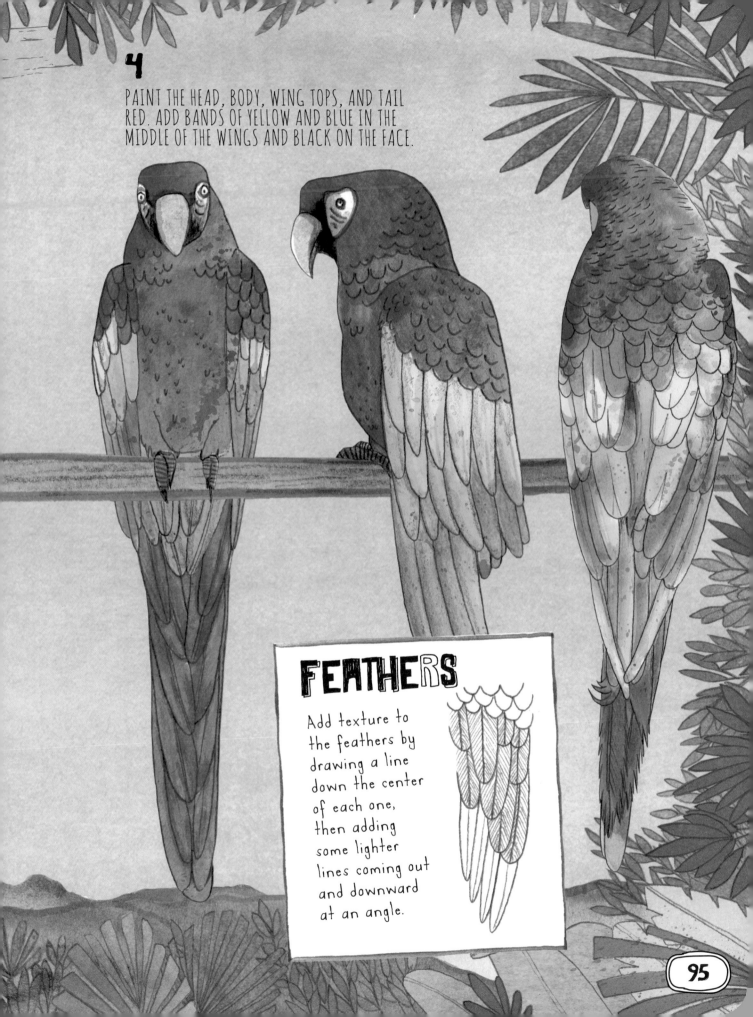

FEATHERS

Add texture to the feathers by drawing a line down the center of each one, then adding some lighter lines coming out and downward at an angle.

BASEBALL PLAYER

1
USE A LIGHT 2H PENCIL TO DRAW A SIMPLE STICK FIGURE. CONCENTRATE ON THE BASIC POSE, MAKING SURE THE FEET ARE PLANTED CORRECTLY.

2
SKETCH THE VARIOUS BODY PARTS, USING YOUR STICKS AS A GUIDE. FOCUS ON GETTING THE OVERALL SHAPE AND PROPORTIONS RIGHT.

3
NOW ADD A LITTLE DETAIL. LIGHTLY SKETCH THE HELMET AND THE SHAPES OF THE CLOTHES. DRAW THE FINGERS, AND ADD ROUGH FACIAL FEATURES.

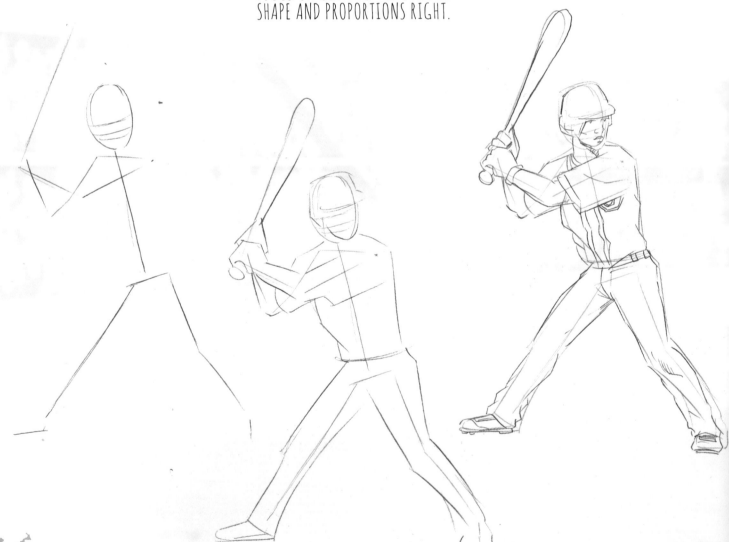

4

USE A 4B PENCIL TO WORK ON THE FINE DETAILS. SHADE IN AREAS NOT HIT BY YOUR LIGHT SOURCE AND THE FOLDS IN THE CLOTHING.

5

GO OVER YOUR PENCIL LINES WITH A BLACK INK PEN. PAINT THE BASEBALL BAT A LIGHT BROWN, AND PICK OUT DETAILS ON THE PLAYER'S CLOTHES IN A BRIGHT, PUNCHY COLOR.

Draw a baseball and add light horizontal lines to show it's moving super fast!

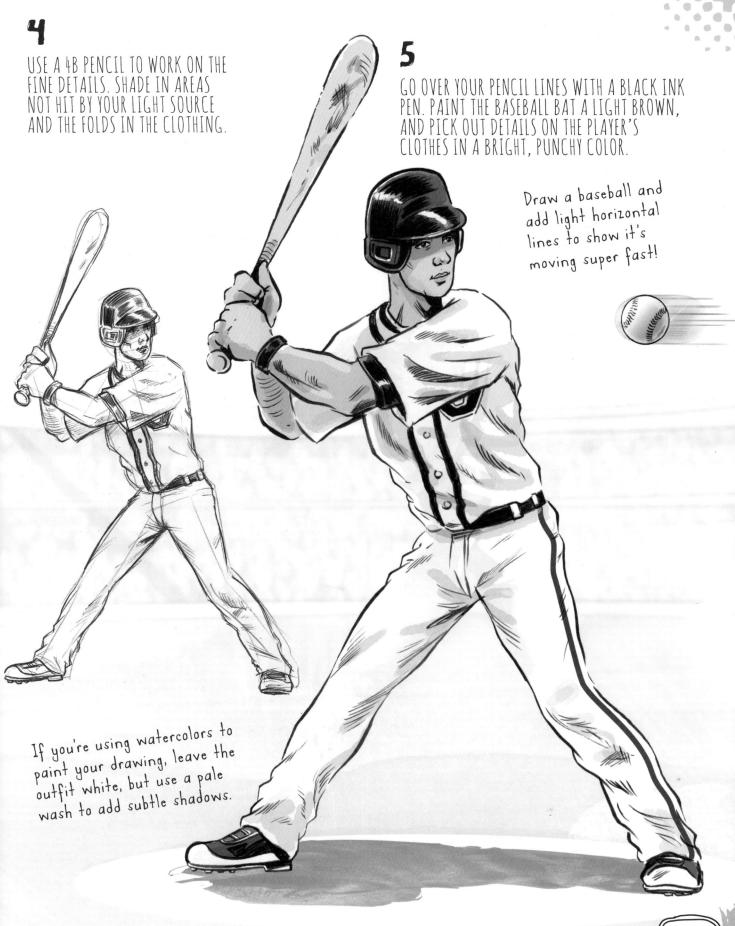

If you're using watercolors to paint your drawing, leave the outfit white, but use a pale wash to add subtle shadows.

SPY CAR

1 CARS ARE SYMMETRICAL, SO DRAW A VERTICAL GUILDELINE, AND SKETCH THE BASIC SHAPE OF A CAR ON ONE HALF. KEEP IT SIMPLE SO THAT YOU CAN COPY IT AS A MIRROR IMAGE ONTO THE OTHER HALF.

2 ADD SOME DETAILS SUCH AS SEATS AND A HOOD, FOLLOWING THE SHAPE OF THE CAR. ADD CIRCLES FOR HEADLIGHTS AND SIDE MIRRORS.

3 TO ADD A SECRET CAMERA, DRAW A GRID, LIKE THE ONE BELOW, WHERE ALL THE LINES LEAD TOWARD A VANISHING POINT. USE THE GRID TO SKETCH IN THE CAMERA. THE PERSPECTIVE WILL HELP THE CAMERA LOOK AS IF IT'S CLOSE UP FRONT.

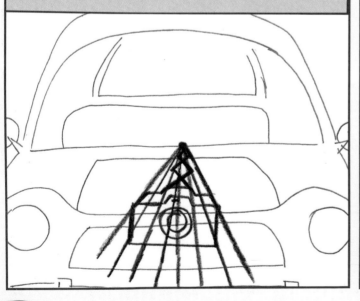

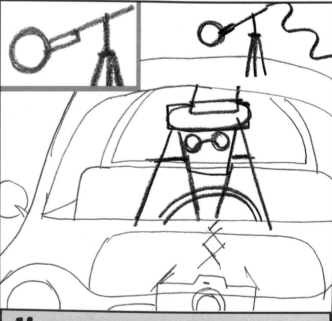

4 ADD A USEFUL MICROPHONE ON A TRIPOD TO THE ROOF OF THE CAR. THEN START DRAWING THE SHAPE OF THE SECRET AGENT AND STEERING WHEEL USING BASIC SHAPES.

5 TO CREATE A CITY SCENE BEHIND THE CAR, DRAW SIMPLE RECTANGLES IN THE BACKGROUND. VARY THE HEIGHT AND WIDTH OF THE BUILDINGS, AND USE GRIDS TO CREATE SLEEK CITY WINDOWS. DRAW VERTICAL LINES TO BUILD UP THE GRILLE ON THE FRONT OF THE CAR.

6 FINALLY, ADD COLOR AND EXTRA DETAIL, SUCH AS CROSSHATCH SHADING, ON THE SEATS. USE WATERCOLOR PENCILS IN COOL COLORS, THEN FINISH THE DRAWING WITH BLACK INK, ESPECIALLY FOR THE BUILDINGS IN THE BACKGROUND. TRY INVENTING MORE GADGETS FOR THE SPY CAR!

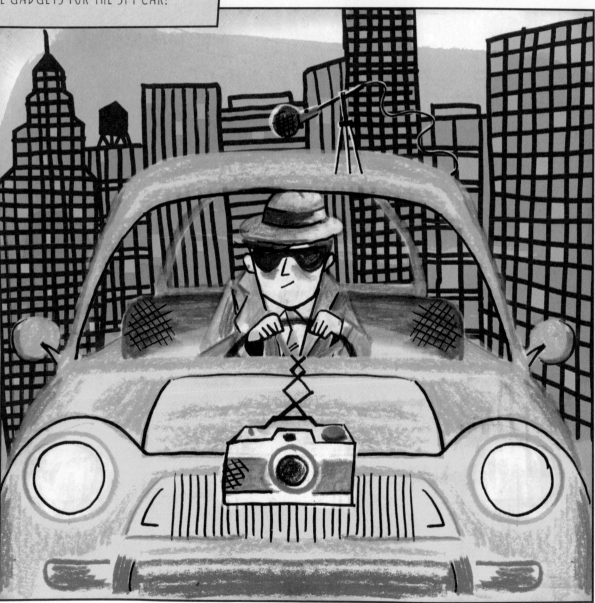

Block in some of the windows with yellow to look as though the lights are turned on.

Make your spy look mysterious with a hat, shades, and turned-up collar.

OSTRICH

An ostrich has the largest eye of any land animal, at 2 in across!

1

DRAW A CIRCULAR HEAD WITH AN OVAL MOUTH. DRAW TWO CIRCLES FOR EYES AND THE ROUGH INSIDE OF THE MOUTH.

2

ADD EYELASHES AND MOUTH DETAILS. SKETCH AROUND THE HEAD SHAPE, WITH QUICK FLICK LINES FOR THE FEATHERS.

3

USE A MIX OF GRAY, BLACK, AND WHITE PENCILS TO COLOR THE FEATHERS, WITH RED AND ORANGE FOR THE MOUTH.

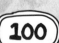

1

DRAW SQUASHED CIRCLES FOR THE HEAD, BODY, AND TAIL. ADD A LONG NECK AND SAUSAGE SHAPES FOR LEGS.

2

NEXT, DEFINE THE OVERALL OUTLINE OF THE OSTRICH, BREAKING THE LINE AT THE TAIL AND TOP OF THE HEAD.

3

PAINT THE FEATHERS GRAY AND BLACK AND THE LEGS WHITE. THEN ADD GRAY HIGHLIGHTS ON BOTH.

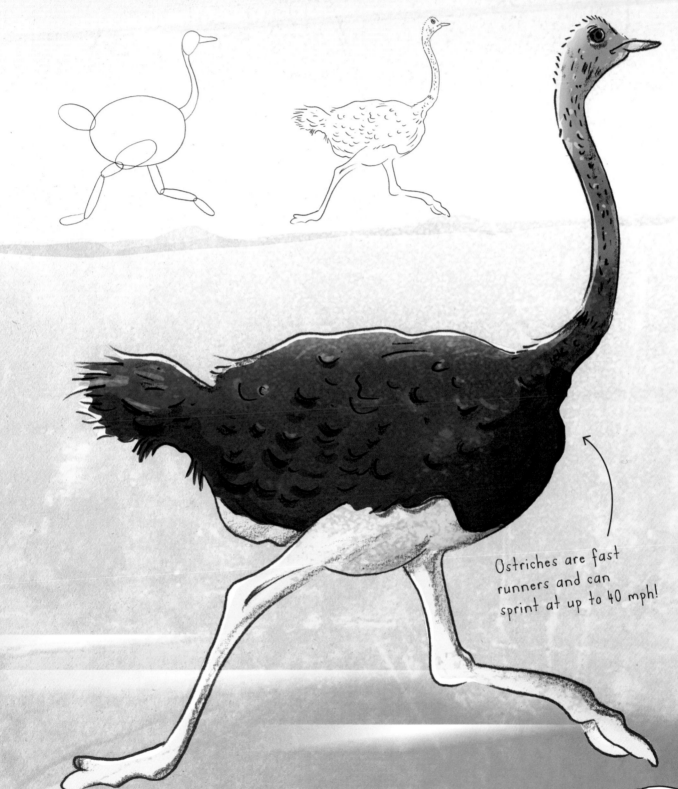

Ostriches are fast runners and can sprint at up to 40 mph!

UNICORN

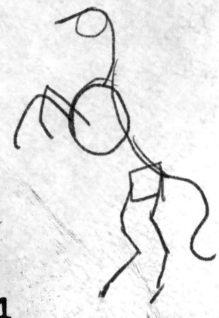

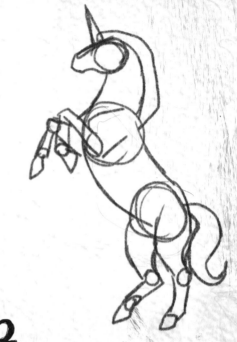

1 DRAW A STICK FIGURE SHOWING THE UNICORN IN AN ACTION POSE. WORK ON GETTING THE PROPORTIONS RIGHT. ADD A LONG, WAVY LINE FROM THE HEAD DOWN TO THE TIP OF THE TAIL.

2 FLESH OUT THE UNICORN'S HEAD, BODY, AND LIMBS. DRAW SMALL CIRCLES FOR THE LEG AND ANKLE JOINTS. USE WAVY LINES FOR THE MANE AND TAIL. ADD A SMALL TRIANGLE FOR A HORN.

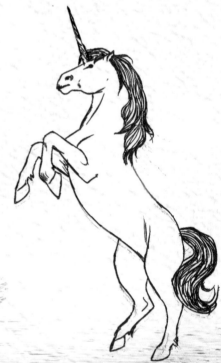

3 REFINE THE OUTLINE OF THE UNICORN. ERASE THE GUIDELINES. ADD FACIAL FEATURES AND DEFINE THE MANE.

4 GO OVER YOUR DRAWING WITH AN INK PEN, ADDING EXTRA LINES FOR DEFINITION. ADD LOTS OF WAVY LINES TO THE MANE AND TAIL FOR A HAIR TEXTURE. ADD A LITTLE SHADING TO THE HORN, TOO.

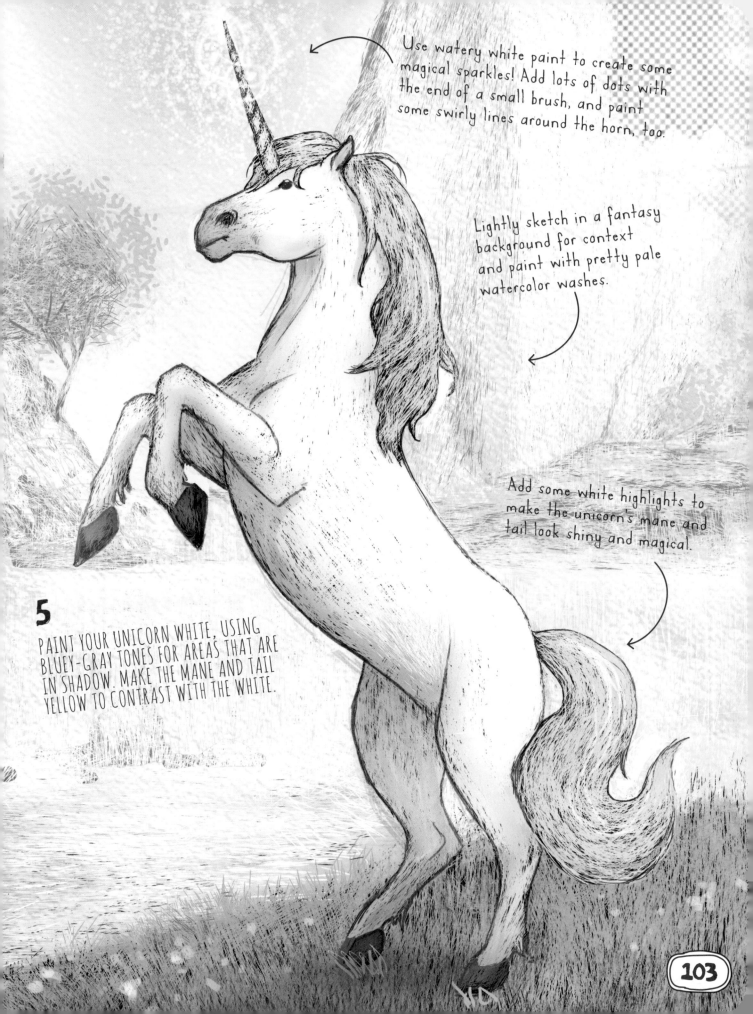

Use watery white paint to create some magical sparkles! Add lots of dots with the end of a small brush, and paint some swirly lines around the horn, too.

Lightly sketch in a fantasy background for context and paint with pretty pale watercolor washes.

Add some white highlights to make the unicorn's mane and tail look shiny and magical.

5

PAINT YOUR UNICORN WHITE, USING BLUEY-GRAY TONES FOR AREAS THAT ARE IN SHADOW. MAKE THE MANE AND TAIL YELLOW TO CONTRAST WITH THE WHITE.

BULLET TRAIN

vanishing point

perspective line

perspective line

1

FOR THIS DRAWING YOU'LL BE USING PERSPECTIVE TO ADD DEPTH AND REALISM TO YOUR BULLET TRAIN. DRAW TWO PERSPECTIVE LINES COMING TOGETHER TO ESTABLISH THE VANISHING POINT OF THE PICTURE. DRAW A LARGE OVAL AT THE OTHER END.

Add a couple more perspective lines to help build your drawing.

2

DRAW TWO MORE OVALS TO BUILD UP THE SHAPE OF THE DRIVER'S WINDOW AND THE BULLET TRAIN'S NOSE. THESE SHAPES NEED TO BE BIG, SINCE THIS PART OF THE TRAIN IS IN THE FOREGROUND.

Adding a simple curved guideline to the train's nose will help it to look more 3D.

3

ADD A SLIGHT CURVE TO THE THREE LOWER LINES, AS IF THE TRAIN IS TRAVELING ALONG A BENDED TRACK. SKETCH SOME GUIDELINES FOR THE POSITIONS OF THE DOORS AND WINDOWS, THEN WORK UP THE FENDER AND NOSE DETAIL, ADDING AN OVAL FOR THE DRIVER'S HEAD.

To make your train appear sleeker and more aerodynamic, alter the top perspective line to give it more of a curved shape.

4

DRAW MORE OVALS FOR THE PASSENGERS' HEADS. ADD MORE DECORATIVE DETAIL TO THE TRAIN'S EXTERIOR, AND SKETCH MORE LINES ON THE LIGHTS AND FENDER. CONTINUE THE LOWER GUIDELINES TO HELP YOU DRAW IN A SIMPLE TRACK.

Don't worry if your final line work is a little wobbly. It's a feeling of movement you want to get across, rather than an impression of technical perfection!

5

COLOR YOUR TRAIN, PAYING SPECIAL ATTENTION TO LIGHT AND SHADE. HERE, A LIGHTER FRONT SECTION REINFORCES THE SENSE OF PERSPECTIVE, MAKING THE TRAIN APPEAR TO COME OUT OF THE PAGE TOWARD US.

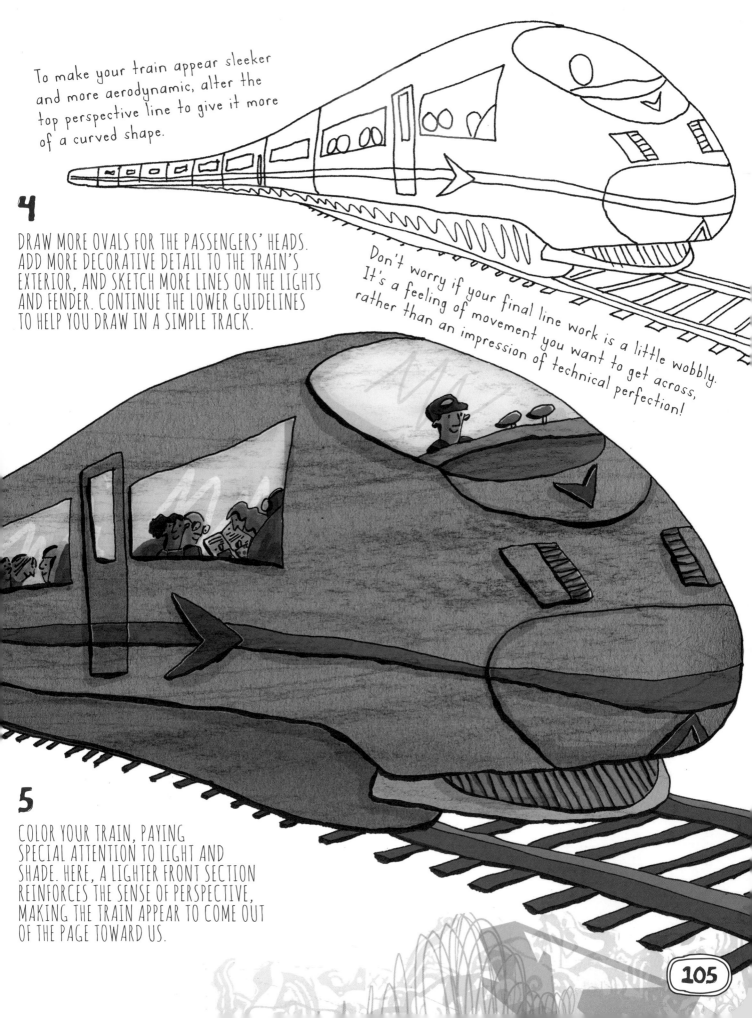

KING COBRA

1 BEGIN YOUR KING COBRA DRAWING BY PENCILING IN THREE ROUGH CIRCLES TO SHOW THE BASIC SHAPE OF ITS HEAD AND HOOD.

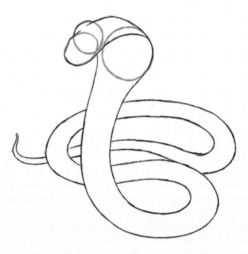

2 USING A SOFT PENCIL, ROUGH OUT THE OUTLINE OF THE COBRA. ENSURE THAT THE TAIL LOOPS UNDERNEATH ITSELF A FEW TIMES.

3 ADD SOME BASIC FACIAL DETAILS, INCLUDING AN EYE, TWO NOSTRILS, AND SHARP FANGS. ADD A MOUTH UNDERNEATH ITS FACE.

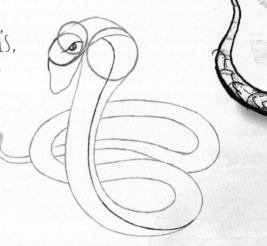

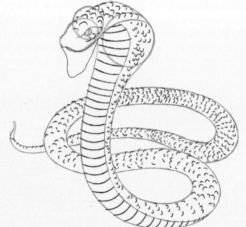

4 DRAW A SERIES OF HORIZONTAL LINES DOWN THE FRONT OF THE BODY. ADD A FEW LINES TO THE HEAD TO SHOW TEXTURED AREAS.

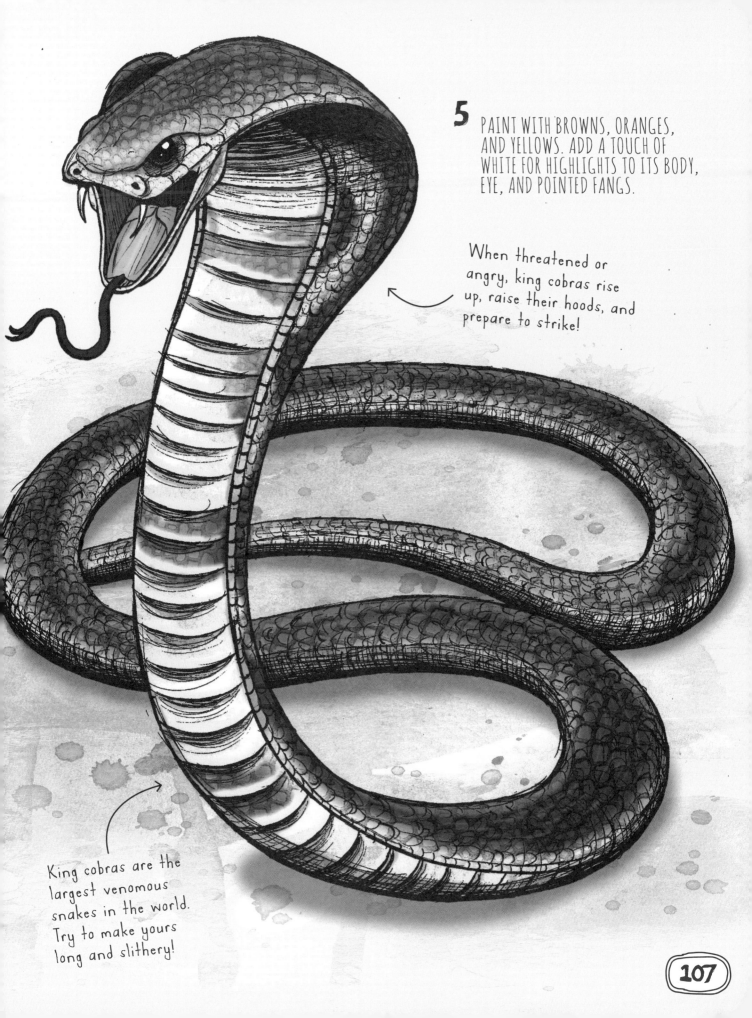

5 PAINT WITH BROWNS, ORANGES, AND YELLOWS. ADD A TOUCH OF WHITE FOR HIGHLIGHTS TO ITS BODY, EYE, AND POINTED FANGS.

When threatened or angry, king cobras rise up, raise their hoods, and prepare to strike!

King cobras are the largest venomous snakes in the world. Try to make yours long and slithery!

PAISLEY PATTERN

1

FIRST, DRAW ONE PIECE: SKETCH A CIRCLE WITH A BEAK SHAPE ON TOP TO FORM AN ANGLED TEARDROP.

2

DRAW ANOTHER TEARDROP INSIDE IT, FOLLOWING THE SAME SHAPE AS THE ONE ON THE OUTSIDE.

3

SKETCH A BRANCH AND LEAF PATTERN DESIGN INSIDE THE SMALLER TEARDROP.

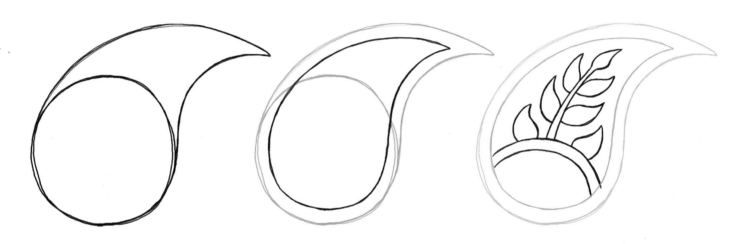

4

ADD MORE DETAIL, SUCH AS A WAVY OUTLINE, SHORT FINE LINES ON THE LEAVES, SMALL DOTS, AND OVERLAPPING CIRCLES, AS SHOWN.

5

SKETCH SEMICIRCLES IN THE BORDER BETWEEN THE TEARDROPS AND A WAVY SHAPE OVER THE TOP OF THE INNER TEARDROP.

6

DRAW OVER THE OUTLINES WITH A FINE PEN, AND ERASE THE PENCIL LINES. NOW HAVE FUN COLORING YOUR DESIGN!

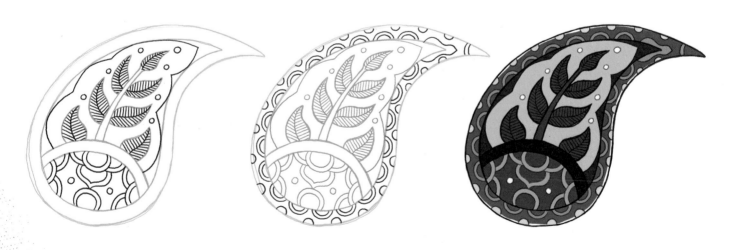

CREATE MORE TEARDROP SHAPES, LIKE THE ONES BELOW, EXPERIMENTING WITH DIFFERENT DESIGNS INSIDE. THEN PUT THEM TOGETHER TO MAKE THE PAISLEY PATTERN!

Paisley is a pretty, swirly Indian pattern often used on shawls, scarves, or ties. It's very trendy!

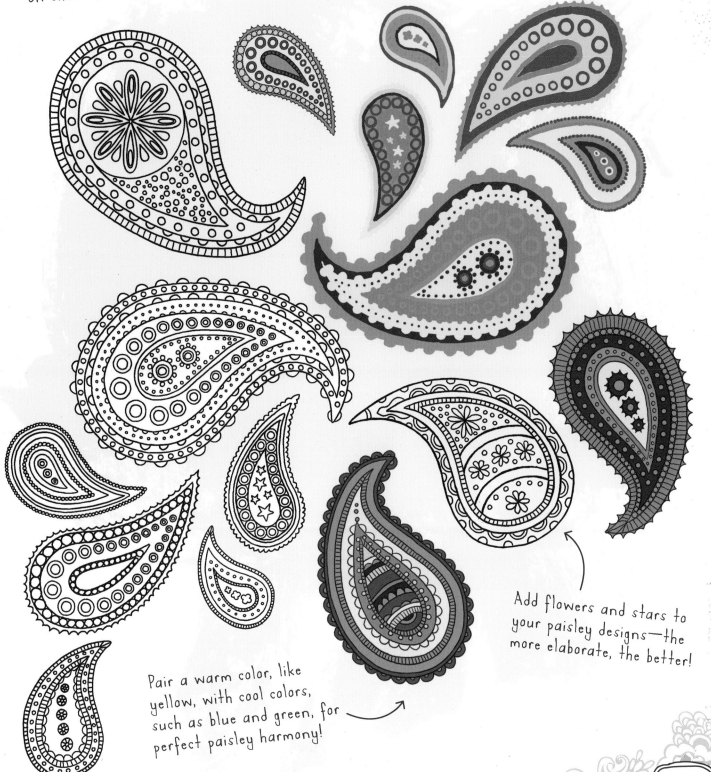

Add flowers and stars to your paisley designs—the more elaborate, the better!

Pair a warm color, like yellow, with cool colors, such as blue and green, for perfect paisley harmony!

SPACE ROCKET

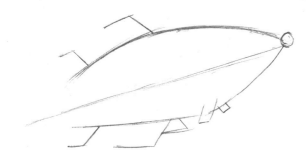

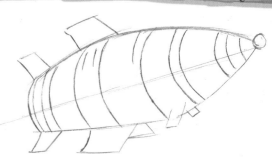

1 START WITH THE BASIC SHAPES OF THE ROCKET BODY AND THE LARGE OUTER FINS. THINK OF THE ROCKET AS A FOOTBALL SHAPE. DRAW A GUIDELINE ALONG THE CENTER TO HELP YOU.

2 NOW DRAW A NUMBER OF LINES THAT FOLLOW THE CURVE OF THE ROCKET'S BODY, AND DIVIDE IT INTO SECTIONS. THESE WILL BE THE PANELS AND HELP WITH POSITIONING OTHER ELEMENTS.

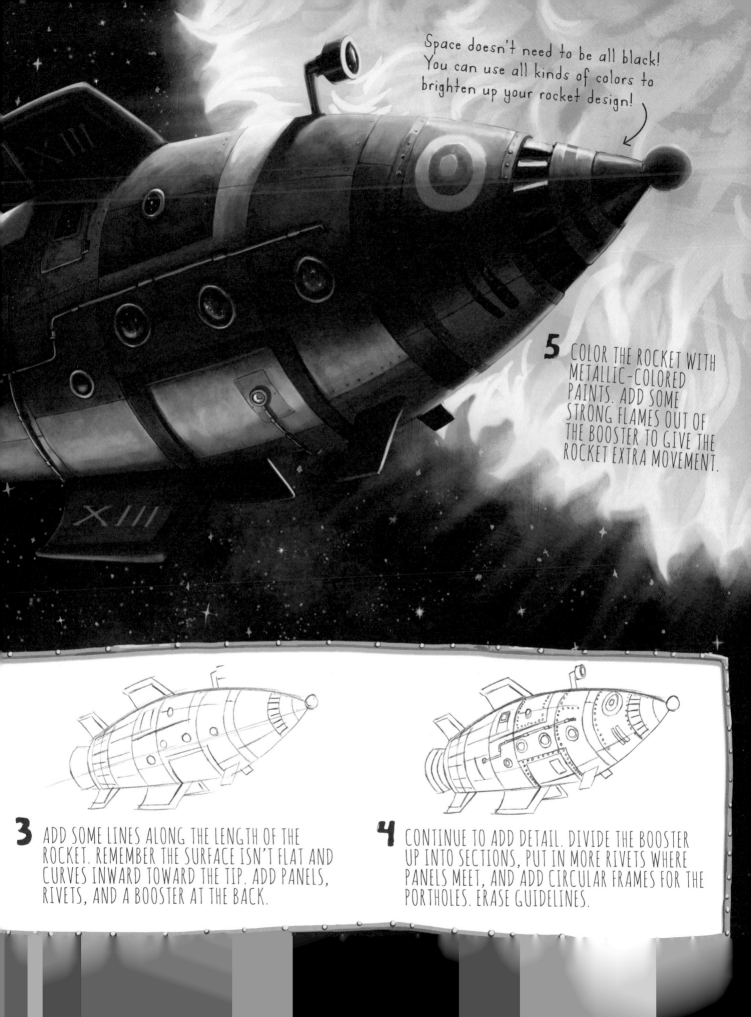

Space doesn't need to be all black! You can use all kinds of colors to brighten up your rocket design!

5 COLOR THE ROCKET WITH METALLIC-COLORED PAINTS. ADD SOME STRONG FLAMES OUT OF THE BOOSTER TO GIVE THE ROCKET EXTRA MOVEMENT.

3 ADD SOME LINES ALONG THE LENGTH OF THE ROCKET. REMEMBER THE SURFACE ISN'T FLAT AND CURVES INWARD TOWARD THE TIP. ADD PANELS, RIVETS, AND A BOOSTER AT THE BACK.

4 CONTINUE TO ADD DETAIL. DIVIDE THE BOOSTER UP INTO SECTIONS, PUT IN MORE RIVETS WHERE PANELS MEET, AND ADD CIRCULAR FRAMES FOR THE PORTHOLES. ERASE GUIDELINES.

ARMADILLO

1

BEGIN BY DRAWING A LARGE SQUASHED OVAL FOR THE BODY, A SMALL TAPERED HEAD, LONG TRIANGULAR TAIL, AND FOUR OVAL FEET.

2

ADD LEAF-SHAPED EARS AND A SMALL ROUND EYE. DRAW STRIPED BANDS ON THE BODY AND TAIL, THEN ADD SOME DETAIL TO THE FEET AND HEAD.

1

START WITH A LARGE OVAL FOR THE ARMADILLO'S BODY, THEN ADD A TAPERED HEAD AND FOUR SMALL SQUASHED OVALS FOR THE LEGS.

2

DRAW BASIC LINES ON THE BODY TO SHOW ITS ARMOR PATTERN. ADD CLAWS, EARS, AN EYE, AND A WAVY HORIZONTAL LINE ON ITS HEAD.

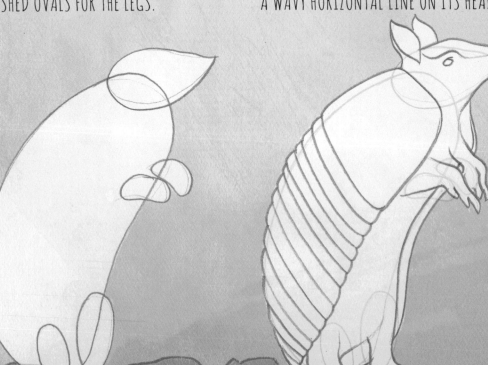

3

COLOR USING BROWN WATERCOLORS.
USE A HARD, DARK BROWN PENCIL TO
ADD THE SCALES IN THE BANDS AND
PATTERN ON THE HEAD.

Unlike other armadillos,
this nine-banded
armadillo isn't able to roll
into a ball for protection!

3

FOR THIS VERSION, PAINT THE UNDERSIDE WITH
BROWN WATERCOLORS AND BROWN PENCILS.
USE LIGHTER TONES FOR THE SHELL.

For the armadillo's armor
plating, draw evenly
spaced dark lines with
a hard pencil, then add
rows of fish-scale shapes
side by side.

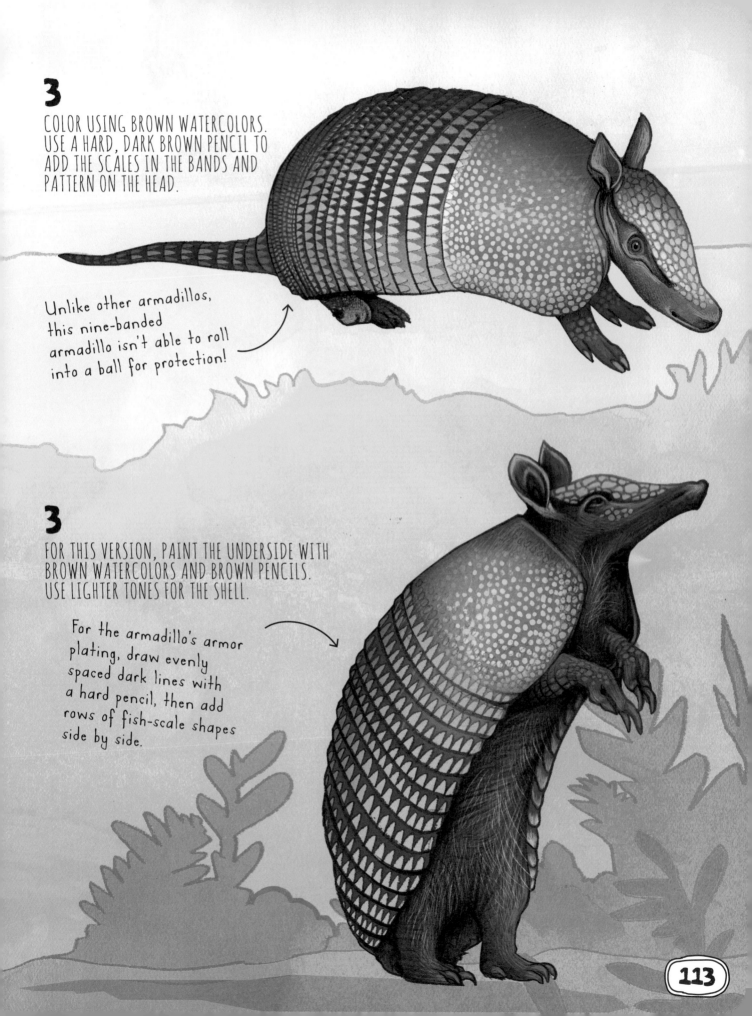

MASKS

TRADITIONAL MASKS ARE USED IN CEREMONIES, CELEBRATIONS, AND RITUALS.

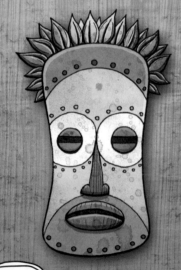

1

SKETCH A LONG OVAL SHAPE, THEN ADD A CURVED, ALMOST SEMICIRCULAR SHAPE ON TOP. ADD A CENTER LINE AS A GUIDE.

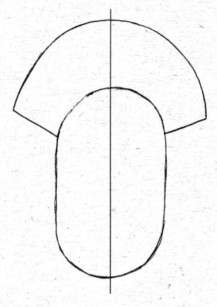

2

DRAW A THIN BORDER INSIDE THE SEMICIRCLE. ADD A NOSE, MOUTH, AND A SMALL MASK ON THE HEAD. SKETCH SOME TRIANGLES AROUND THE FACE.

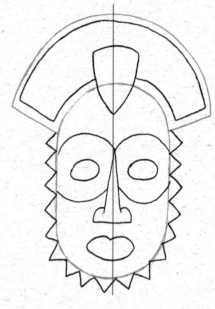

3

DRAW STRIPES ON THE HEADDRESS AND FACE. ADD SPIRALS BENEATH THE EYES, THEN SKETCH A FACE ON THE SMALL MASK.

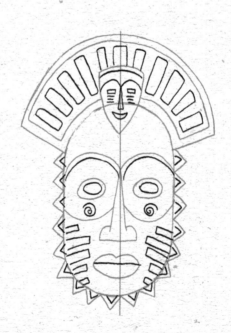

4

COLOR YOUR MASK IN BRIGHT COLORS. USE LIGHT AND DARK SHADES IN VERTICAL LINES TO SUGGEST A WOODLIKE TEXTURE.

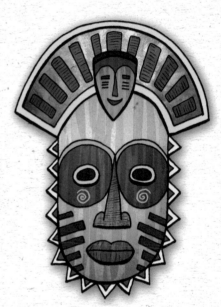

EXPERIMENT WITH DIFFERENT-SHAPED MASKS AND PATTERNS.

SPOTS AND STRIPES
Draw the outline of a mask, then sketch the facial features, making sure each side is symmetrical. Add contrasting patterns, such as spots and stripes.

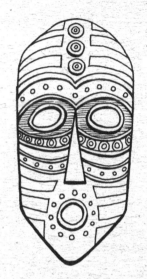

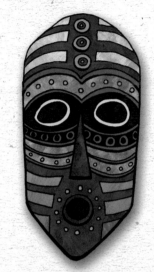

FEATHERS AND DIAGONALS
Sketch a feather shape at the top of your mask and chevrons down the center. Repeat and fan lots of feathers around the top of the mask.

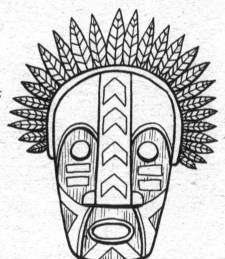

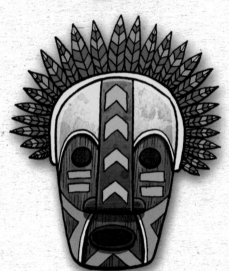

SHAPES AND CROSSES
Create a mask with eight panels, as shown. Decorate the mask with triangles, circles, diagonals, and rectangles.

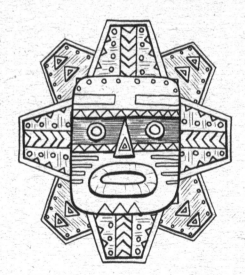

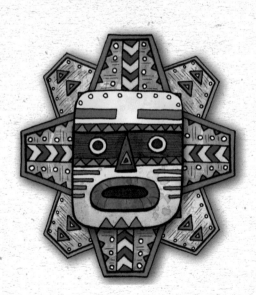

TOWERING BUILDINGS

Find a photo online to give you some inspiration. Look for buildings that have interesting architectural details.

1 DRAW SOME SIMPLE RECTANGLES CLOSE TOGETHER. THIS DRAWING USES PERSPECTIVE, SO THE VERTICAL LINES NEED TO COME CLOSER TOGETHER AT THE TOP TO GIVE THE IMPRESSION OF TALL, TOWERING BUILDINGS!

2 TO MAKE THE BUILDINGS LOOK 3D, ADD SOME EXTRA VERTICAL LINES TO THE SIDES OF THE RECTANGLES, KEEPING IN MIND THE ANGLE THAT YOU'RE VIEWING THE BUILDINGS FROM.

3 ADD ROWS OF SQUARES AND RECTANGLES FOR THE WINDOWS. THESE SHAPES NEED TO BECOME SMALLER AS YOU WORK UP THE BUILDING, GIVING THE IMPRESSION THAT THE UPPER FLOORS ARE FARTHER AWAY.

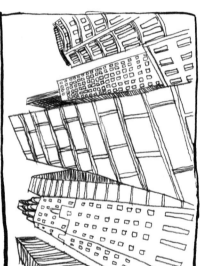

Paint areas of darker tones to suggest blurry reflections in glass windows.

4 LOOK AT THE TEXTURES AND MATERIALS OF REAL BUILDINGS, AND TRY TO IMITATE THE DETAIL USING SIMPLE LINES. ADD SHADING BY DRAWING REPEATED HORIZONTAL, VERTICAL, OR CROSSHATCHED LINES.

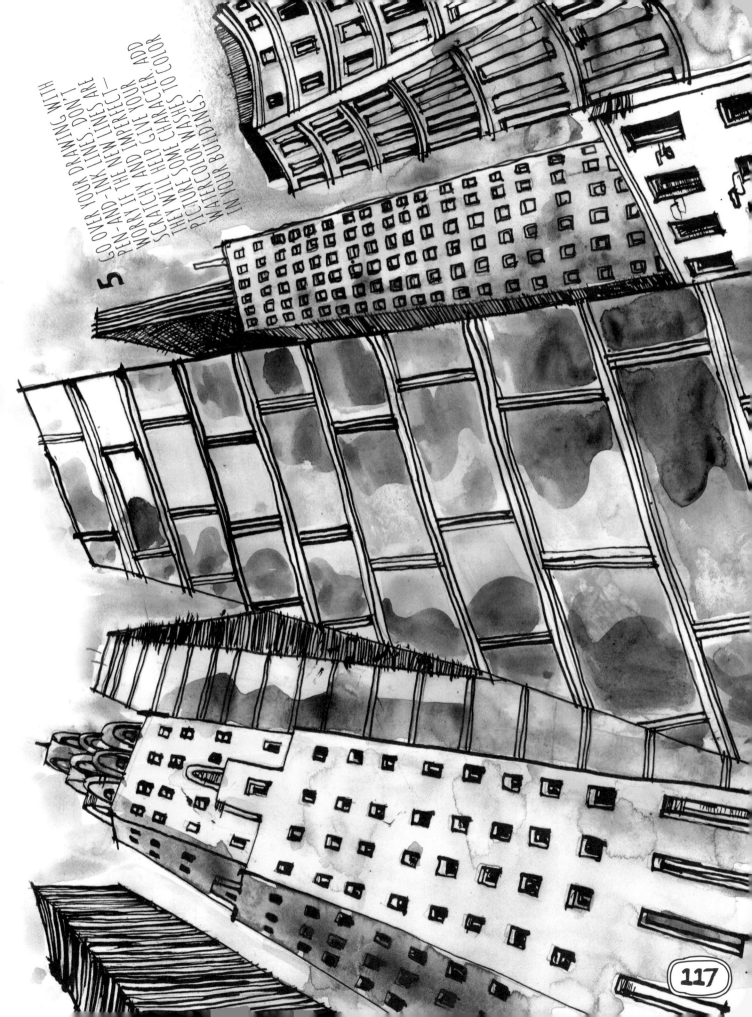

5 GO OVER YOUR DRAWING WITH PEN-AND-INK LINES. DON'T WORRY IF THE NEW LINES ARE SCRATCHY AND IMPERFECT— THEY WILL HELP GIVE YOUR PICTURE SOME CHARACTER. ADD WATERCOLOR WASHES TO COLOR IN YOUR BUILDINGS.

BEAVER

1

START WITH SIMPLE SHAPES—PENCIL A CIRCLE FOR THE HEAD, A U-SHAPED LINE FOR THE BODY, AND A CURVED LINE FOR THE TAIL.

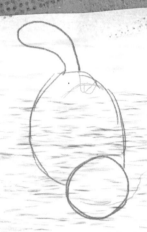

2

FIRM UP THE OUTLINE AND ADD GUIDELINES TO THE FACE. DRAW A CIRCLE FOR THE SNOUT, THEN PENCIL IN THE EYES, EARS, AND NOSTRILS.

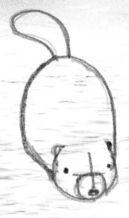

1

FOR THIS VERSION, DRAW A CIRCLE FOR A HEAD AND ADD BASIC GUIDELINES FOR THE SPINE, TAIL, AND LEGS.

2

USING THE GUIDE SHAPES AND LINES, WORK UP THE BODY, LEGS, TAIL, AND SNOUT. ADD ROUGH CLAWS TO THE HANDS.

3

WITH A SOFT PENCIL, BREAK UP THE OUTLINE TO SHOW FUR. ADD DETAIL TO THE FACE AND HANDS, AND START SHADING.

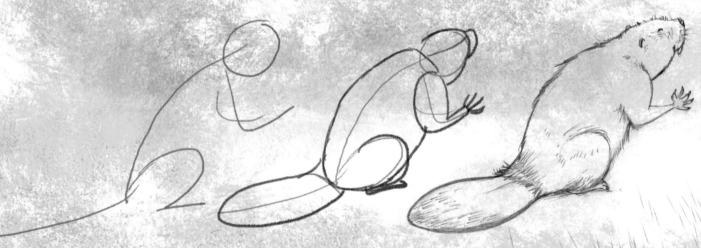

3

DRAW LINES TO CREATE TEXTURE ON THE FUR. DRAW TWO BUCK TEETH HOLDING A TWIG. SKETCH WATER LINES AROUND THE BEAVER.

4

COLOR WITH BROWN, ORANGE, AND GRAY PENCILS. ADD A TOUCH OF YELLOW AROUND THE FACE AND GO OVER THE DETAILS IN BLACK.

4

COLOR WITH BROWN AND GRAY PENCILS. ADD A LITTLE ORANGE AND WHITE TO THE FUR AND WHITE TO THE TAIL.

Beavers use their large, strong teeth to gnaw on wood. Try adding a fallen tree and sawdust to your drawing!

Beavers have large paddle-shaped tails and webbed feet to help them swim!

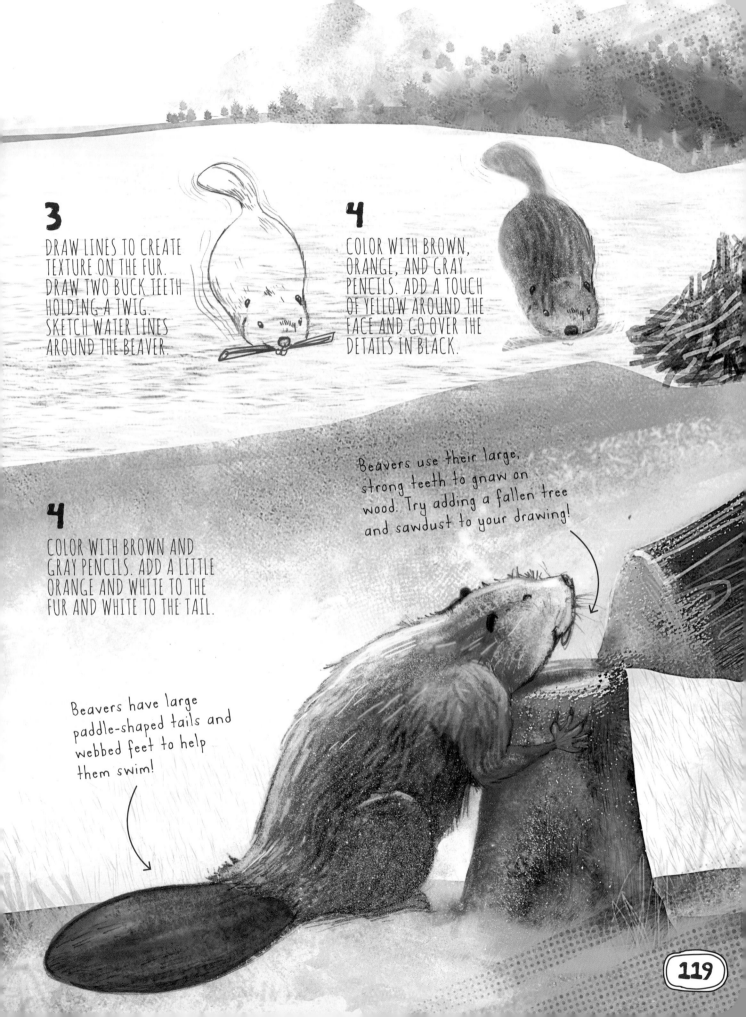

SAILBOAT

1 DRAW TWO BASIC TRIANGLES FOR THE SAILS, THEN A LONG, CURVED SHAPE WITH A HOOK FOR THE TOP OF THE BOAT, AS SHOWN.

2 SKETCH THIN CYLINDER SHAPES AT THE TOP AND SIDES OF THE SAILS AND BOAT. DRAW A RECTANGULAR-SHAPED CABIN UNDER THE SAILS.

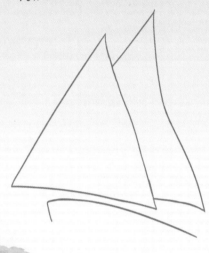

Add small overlapping shapes to start creating splashy waves.

3 ATTACH A LONG FLAGPOLE TO THE MAST, THEN DRAW ROPE RINGS ON THE MAST AND SPAR. ADD A SMALL CYLINDER AT THE FRONT OF THE BOAT, AND MAKE RAILINGS USING LONG AND SHORT LINES.

4 DRAW A WAVY, FLAPPING FLAG, AND ADD ROPES TO JOIN THE SAILS TO THE BOAT. SKETCH SMALL CIRCLES AND RECTANGLES ON THE ROPES TO CREATE THE APPEARANCE OF RIGGING.

Add slightly curved lines in each corner of the sails for material creases and tension.

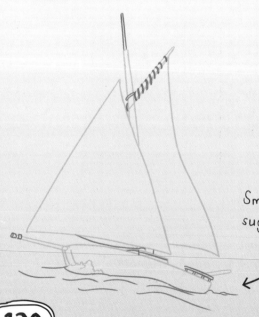

Smooth, curved lines suggest rolling waves.

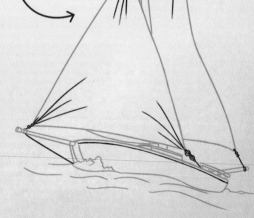

5 DRAW SOME WAVY LINES ON THE SAILS FOR MOVEMENT AND TO SUGGEST WHERE THE MATERIAL HAS BEEN JOINED TOGETHER. SKETCH MORE ROLLING WAVES TO THE FRONT OF THE BOAT.

6 ADD SHORT, WIGGLY LINES ON THE SAILS FOR TIES. NOW PAINT THE PICTURE, APPLYING A LIGHT, FADEAWAY TECHNIQUE ON THE SAILS FOR A 3D EFFECT.

A curved line on the hull or outside of the boat gives the impression of wooden planks.

For the background, use a smooth watercolor wash, so that the boat pops against the soft horizon.

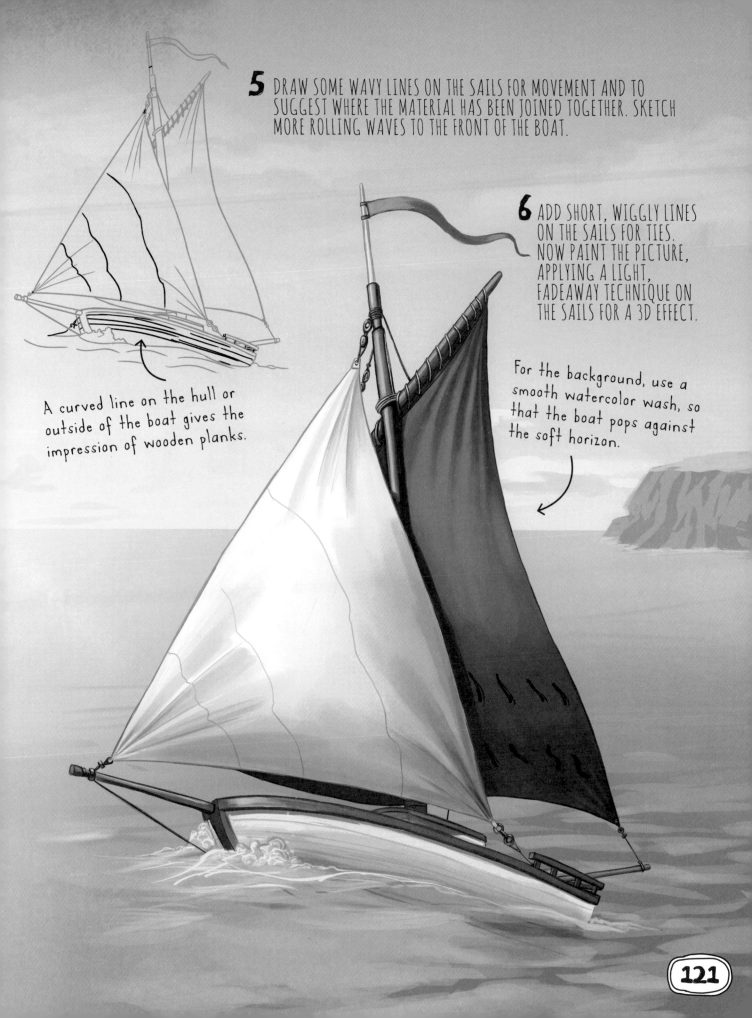

SKYSCRAPERS

1

USING A PENCIL, DRAW A SERIES OF BLOCKS IN A ROW TO FORM A SKYLINE.

2

ADD EXTRA SHAPES TO YOUR BLOCKS TO MAKE THE BUILDINGS MORE INTERESTING.

Will you base your skyscrapers on real buildings, make up imaginary ones, or do a mixture of both?

3

ADD SOME GUIDELINES TO HELP YOU DRAW DETAILS SUCH AS WINDOWS AND ORNATE DECORATION.

4

USING A FINE-LINE PEN, DRAW OVER YOUR PENCIL LINES, AND FILL IN THE DETAILS OF THE BUILDINGS. ERASE THE PENCIL LINES WHEN YOU HAVE FINISHED.

Gather some inspiration from pictures of real buildings.

5

ADD A WASH OF COLOR OVER YOUR BUILDINGS USING WATERCOLOR PAINTS.

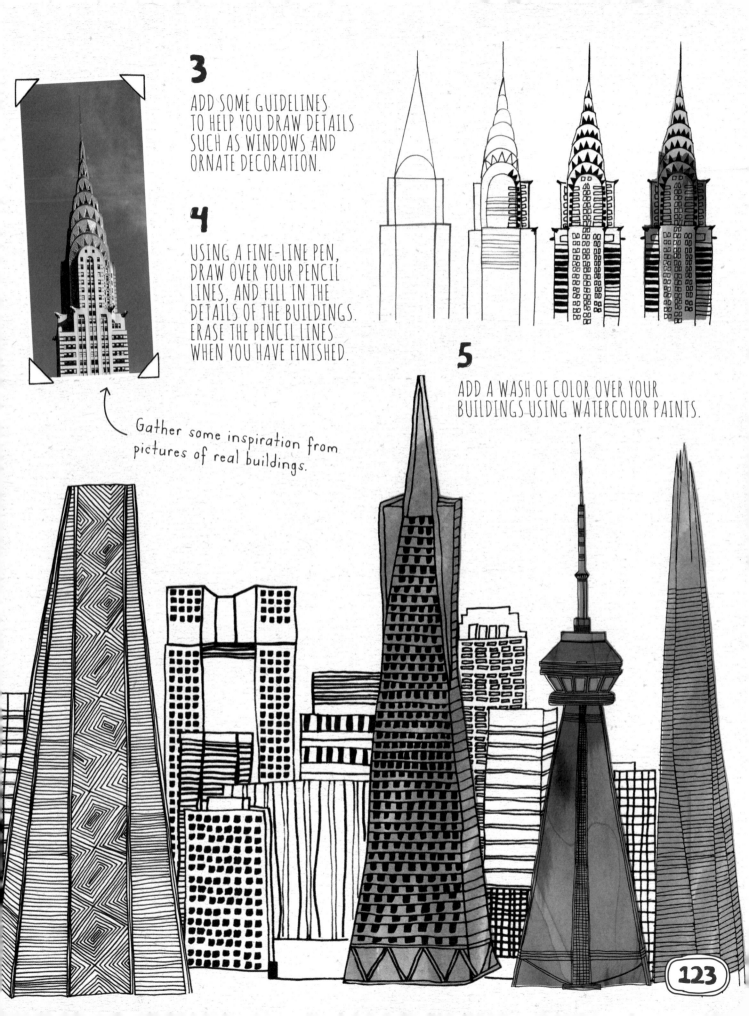

MEERKAT

MEERKATS LIVE IN LARGE FAMILY GROUPS, SO ONCE YOU HAVE MASTERED ONE, TRY DRAWING LOTS TOGETHER!

1

DRAW A CIRCLE FOR THE HEAD, OVAL BODY, AND RECTANGULAR-SHAPED ARMS AND LEGS. ADD GUIDELINES FOR THE FACE AND TAIL.

2

USE THE GUIDE SHAPES TO DEFINE THE OUTLINE. ADD IN FACIAL DETAILS USING THE GUIDELINES AND SKETCHY LINES FOR THE FUR.

3

SHADE DARKER AREAS AROUND THE EYES, EARS, AND NOSE. ADD SHADOWS UNDER THE ARMS AND SEPARATE THE PAWS INTO FINGERS.

4

ADD A LITTLE SHINE TO THE
MEERKAT'S NOSE AND DARK
SHADING ON ITS TAIL AND
STOMACH AREA.

5

TO COLOR, KEEP THINGS SIMPLE
WITH BROWN AND GRAY PENCILS ON
THE MEERKAT'S FUR. ADD IN SOME
HIGHLIGHTS WITH A WHITE PENCIL.

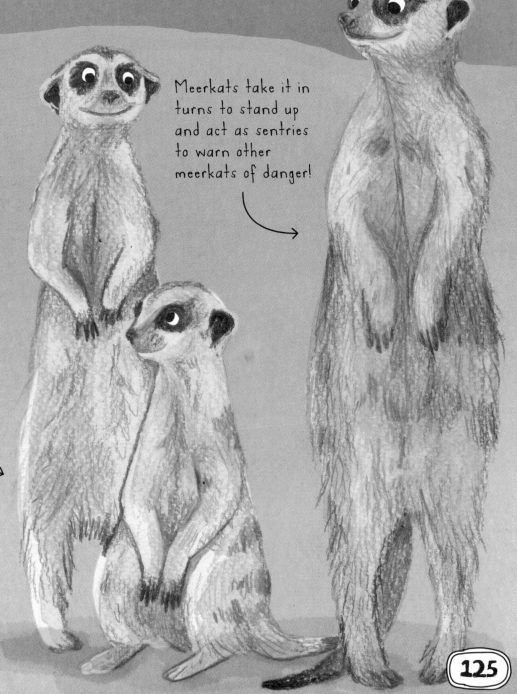

Meerkats take it in
turns to stand up
and act as sentries
to warn other
meerkats of danger!

Meerkats have fluffy
fur, so use a soft brush
or pencil to achieve the
right sort of effect!

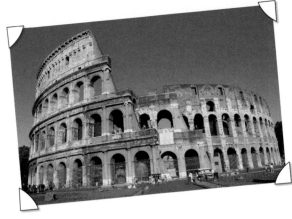

The Colosseum is a famous amphitheater in Rome, Italy. It's not as tricky to draw as it looks! Start with a photo for reference.

1

USING A LIGHT PENCIL, SKETCH THE TWO MAIN BASIC SHAPES OF THE COLOSSEUM, AS SHOWN, REFERRING TO YOUR PHOTO AS YOU GO.

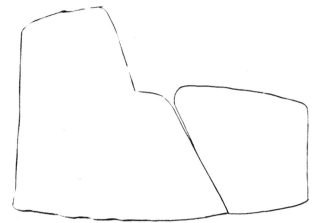

2

LOOSELY DRAW HORIZONTAL LINES WITHIN THE SHAPES, CURVING THEM SLIGHTLY TO FOLLOW THE FRAME OF THE COLOSSEUM.

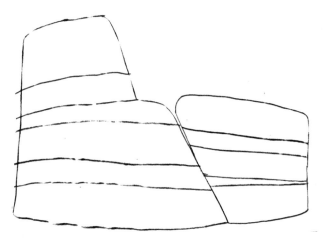

3

NOW ADD VERTICAL LINES TO CREATE A BASIS FOR THE WINDOWS.

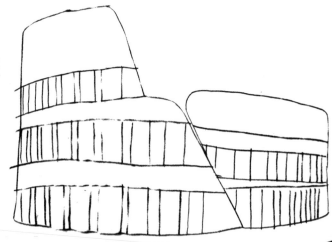

4

START FILLING IN THE DETAILS. CREATE THE ARCHED SHAPE OF THE WINDOWS AND ENTRANCEWAYS, THEN ADD IN SOME BRICKWORK FOR TEXTURE AND DEFINITION.

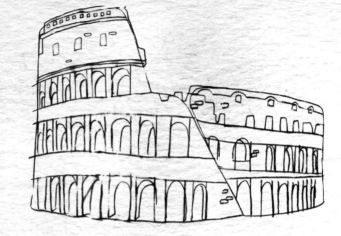

5

GO OVER YOUR OUTLINES IN PEN AND INK, THEN ERASE THE PENCIL LINES. KEEP THE LINE WORK LOOSE AND IMPERFECT TO CREATE THE FEEL OF A PARTIALLY RUINED BUILDING.

Draw jagged edges around the building to further suggest ruin and damage.

6

COLOR WITH LIGHT WATERCOLOR BRUSHWORK, AND ADD SHADOWING IN THE WINDOWS TO CREATE DEPTH. DRAW AND PAINT SOME SMALL PEOPLE AT THE BOTTOM TO GIVE AN OVERALL IMPRESSION OF SIZE AND GRANDEUR.

STREETDANCER

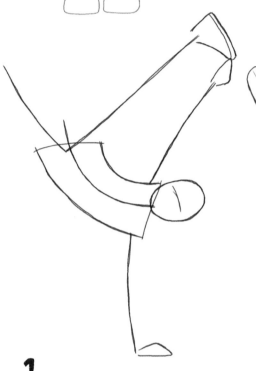

1
USE SIMPLE LINES TO SKETCH THE BASIC POSE. DRAW AN OVAL FOR THE HEAD, WITH CURVED LINES FOR THE TORSO AND ARMS. ADD A BIG V SHAPE FOR THE LEGS, AND A FOOT.

2
DRAW THE DANCER'S JEANS, USING THE GUIDES TO HELP YOU. KEEP THE LINE WORK LOOSE, AND ROUND OFF WHERE THE LEFT KNEE IS BENT. DRAW THE SHAPE OF THE ARMS.

3
SKETCH THE SHIRT AND AN ELLIPSE AT THE BOTTOM OF THE PANT. ADD A SEMICIRCLE FOR THE CAP WITH AN ELLIPSE FOR THE BRIM. DRAW A FOOT BEHIND THE BENT LEG.

SILHOUETTES

To draw cool silhouettes of streetdancers, find photos of dancers in different poses. Then simply trace over their outlines and color them in.

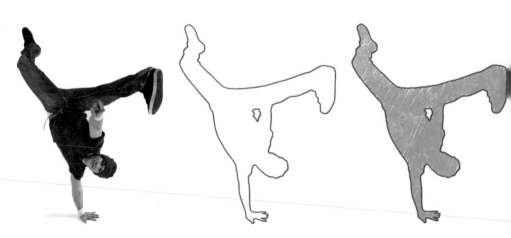

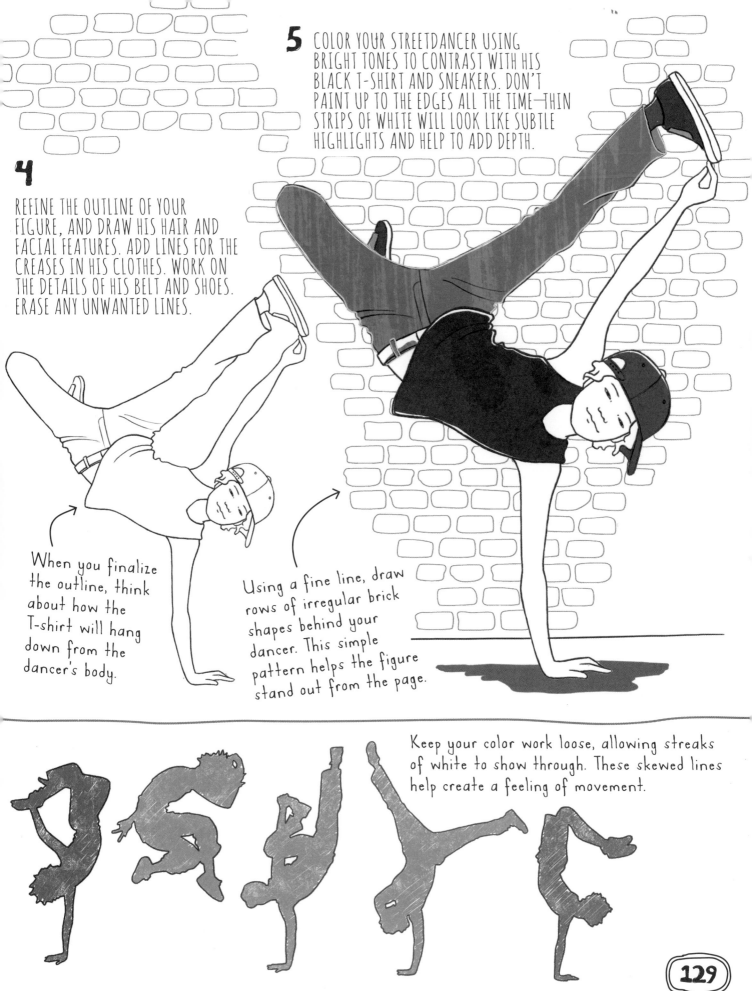

5 COLOR YOUR STREETDANCER USING BRIGHT TONES TO CONTRAST WITH HIS BLACK T-SHIRT AND SNEAKERS. DON'T PAINT UP TO THE EDGES ALL THE TIME—THIN STRIPS OF WHITE WILL LOOK LIKE SUBTLE HIGHLIGHTS AND HELP TO ADD DEPTH.

4

REFINE THE OUTLINE OF YOUR FIGURE, AND DRAW HIS HAIR AND FACIAL FEATURES. ADD LINES FOR THE CREASES IN HIS CLOTHES. WORK ON THE DETAILS OF HIS BELT AND SHOES. ERASE ANY UNWANTED LINES.

When you finalize the outline, think about how the T-shirt will hang down from the dancer's body.

Using a fine line, draw rows of irregular brick shapes behind your dancer. This simple pattern helps the figure stand out from the page.

Keep your color work loose, allowing streaks of white to show through. These skewed lines help create a feeling of movement.

1

DRAW A LARGE TEARDROP SHAPE FOR THE BODY AND A SMALL ONE FOR THE HEAD. JOIN WITH CURVED LINES. ADD A POINTED TAIL, AND VERTICAL CURVED LINES FOR WINGS.

2

FILL OUT THE BODY SHAPE AND ADD THE BEAK, FEET, AND FEATHER DETAIL TO THE TAIL. USING THE WING GUIDE, WORK UP THE OUTSTRETCHED WINGS.

3

DRAW AN EYE AND NOSTRIL ON THE FACE. ADD SOME FEATHER DETAIL TO THE WINGS, WITH SMALL C-SHAPED FEATHERS ON THE SIDE OF THE GOOSE'S BODY.

GOOSE

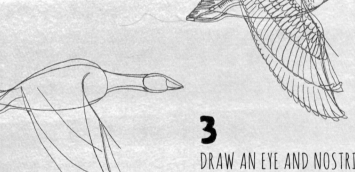

1

DRAW A LARGE TEARDROP SHAPE FOR THE BODY AND A SMALL ONE FOR THE HEAD. JOIN WITH CURVED LINES. ADD A POINTED TAIL AND DOWNWARD SLOPING LINES FOR WINGS.

2

FILL OUT THE BODY SHAPE AND ADD THE BEAK, FEET, AND FEATHER DETAIL TO THE TAIL. USING THE WING GUIDE, WORK UP THE OUTSTRETCHED WINGS.

3

DRAW AN EYE AND NOSTRIL ON THE FACE. BUILD UP THE WING FEATHERS IN FIVE DIAGONAL STRIPS. ADD SMALL C-SHAPED FEATHERS ON THE BODY.

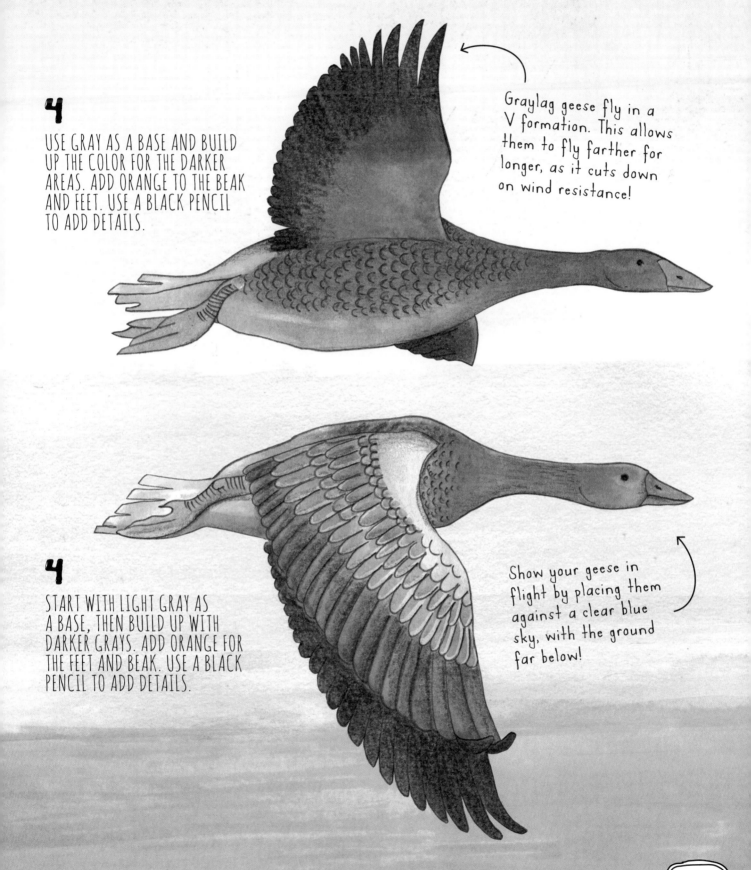

4

USE GRAY AS A BASE AND BUILD UP THE COLOR FOR THE DARKER AREAS. ADD ORANGE TO THE BEAK AND FEET. USE A BLACK PENCIL TO ADD DETAILS.

Graylag geese fly in a V formation. This allows them to fly farther for longer, as it cuts down on wind resistance!

4

START WITH LIGHT GRAY AS A BASE, THEN BUILD UP WITH DARKER GRAYS. ADD ORANGE FOR THE FEET AND BEAK. USE A BLACK PENCIL TO ADD DETAILS.

Show your geese in flight by placing them against a clear blue sky, with the ground far below!

PORTRAIT

1 SKETCH AN ANGLED OVAL SHAPE. DRAW A CURVED, VERTICAL LINE AND THREE HORIZONTAL GUIDELINES, LINING UP WITH THE EAR AS SHOWN. ADD NECK LINES.

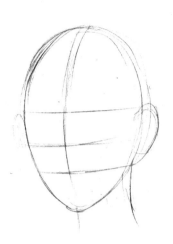

2 USE THE GUIDELINES TO POSITION THE FACIAL FEATURES. NOTICE HOW THE EYES ARE LEVEL WITH THE TOP OF THE EAR AND THE MOUTH WITH THE BOTTOM.

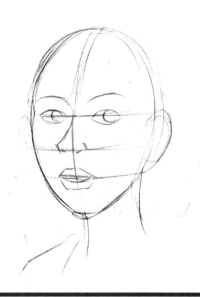

5 DEFINE THE HAIR SHAPE, PARTICULARLY WHERE IT MEETS THE COLLAR. ADD LIGHT PATCHES OF SHADING FOR TEXTURE. ADD CLOTHING DETAIL.

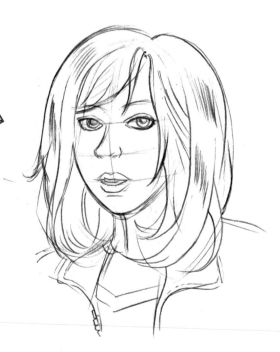

6 FIGURE OUT WHERE THE SHADOWS SHOULD BE, AND SHADE IN THOSE AREAS. REFINE THE DETAIL OF THE EYES, NOSE, MOUTH, AND HAIR.

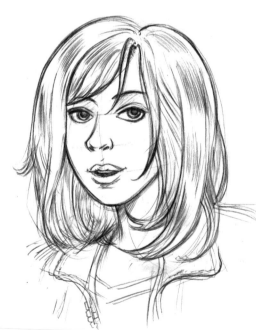

Keep your wrist relaxed as you draw. It will make it easier to sketch nice, smooth curves.

3 SKETCH THE OUTLINE OF THE HAIR USING LONG, SWEEPING CURVES. REMEMBER JUST TO FOCUS ON THE OVERALL SHAPE AT THIS STAGE.

4 ADD A LITTLE MORE DETAIL TO THE FACIAL FEATURES, AND USE MORE CURVED LINES TO SHOW HOW THE HAIR FALLS ACROSS THE FACE.

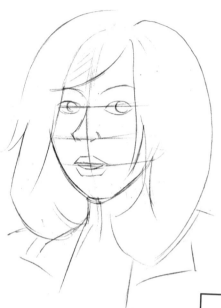

Stick with a light pencil until you're happy with the overall shape of your portrait.

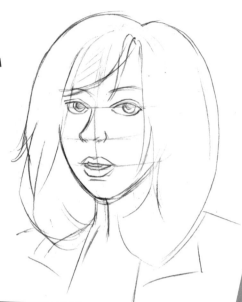

7 PAINT YOUR PORTRAIT USING WATERCOLORS. CHOOSE A BASE TONE FOR THE SKIN, THEN ADD BOTH LIGHTER AND DARKER SHADES ON TOP TO EMPHASIZE THE SHAPES OF THE FEATURES.

Try to keep your painting technique fairly loose. It will help give your final portrait more life and character!

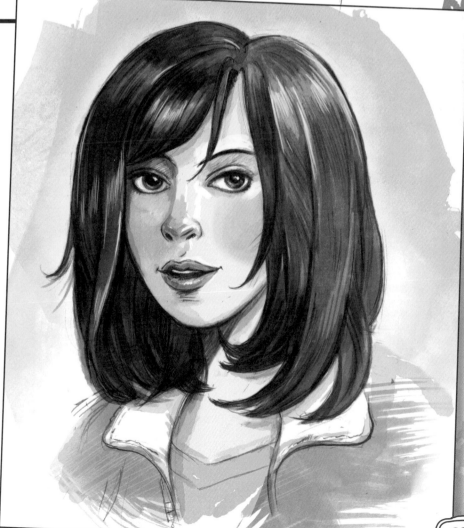

MOTORCYCLE STUNT RIDER

2

BEGIN JOINING THE DIFFERENT SHAPES TOGETHER. ADD MUDGUARDS, A SEAT, CHAIN, AND FRAME TO BUILD UP THE MOTORCYCLE. ADD HANDS AND FEET TO THE RIDER.

1

SKETCH SIMPLE SHAPES AS GUIDES. USE CIRCLES FOR THE HEAD, WHEELS, AND MOTOR, AND RECTANGLES FOR THE BODY, LEGS, ARMS, AND MOTORCYCLE.

3

START ADDING SOME DETAIL. DRAW THE HELMET, AND ADD RIMS TO THE OUTSIDES OF THE WHEELS AND AXLES IN THE CENTERS OF THE WHEELS.

Look for pictures of motorcycles in magazines for inspiration and to understand the shape. Each make of stunt motorcycle will have different details.

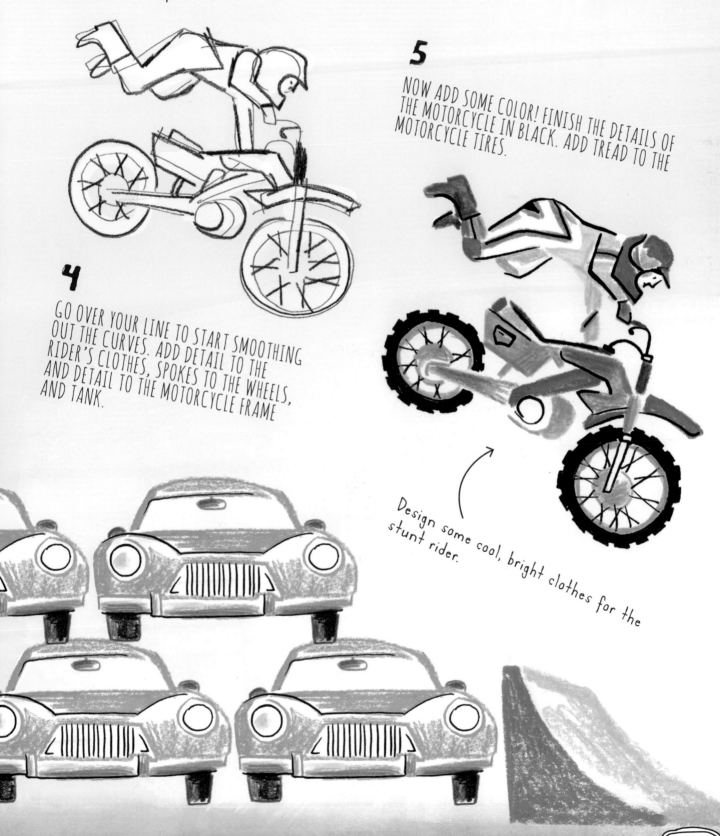

5

NOW ADD SOME COLOR! FINISH THE DETAILS OF THE MOTORCYCLE IN BLACK. ADD TREAD TO THE MOTORCYCLE TIRES.

4

GO OVER YOUR LINE TO START SMOOTHING OUT THE CURVES. ADD DETAIL TO THE RIDER'S CLOTHES, SPOKES TO THE WHEELS, AND DETAIL TO THE MOTORCYCLE FRAME AND TANK.

Design some cool, bright clothes for the stunt rider.

SHARK

BASKING SHARK

Draw a large oval for the head, with guidelines for the open mouth and nose. Sketch the body, and smaller ovals and sausage shapes for the fins. Paint gray with white highlights.

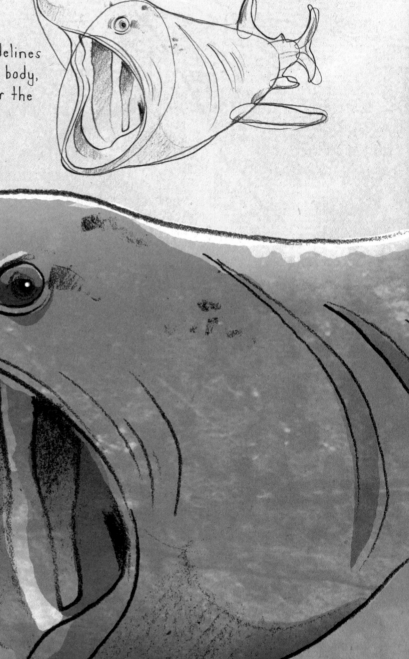

These gentle giants swim with their mouths open to filter-feed on plankton.

SHORTFIN MAKO

Pencil a long squashed oval for the body, with small ovals and sausage shapes for the tail and fins. Paint shades of gray with white highlights.

The vertically elongated tail helps propel this shark through the water!

GREAT HAMMERHEAD

Sketch large squashed ovals for the head and body. Add small ovals and sausage shapes for its fins. Paint blue and gray, with white highlights.

Wide-set eyes give this shark a larger visual range.

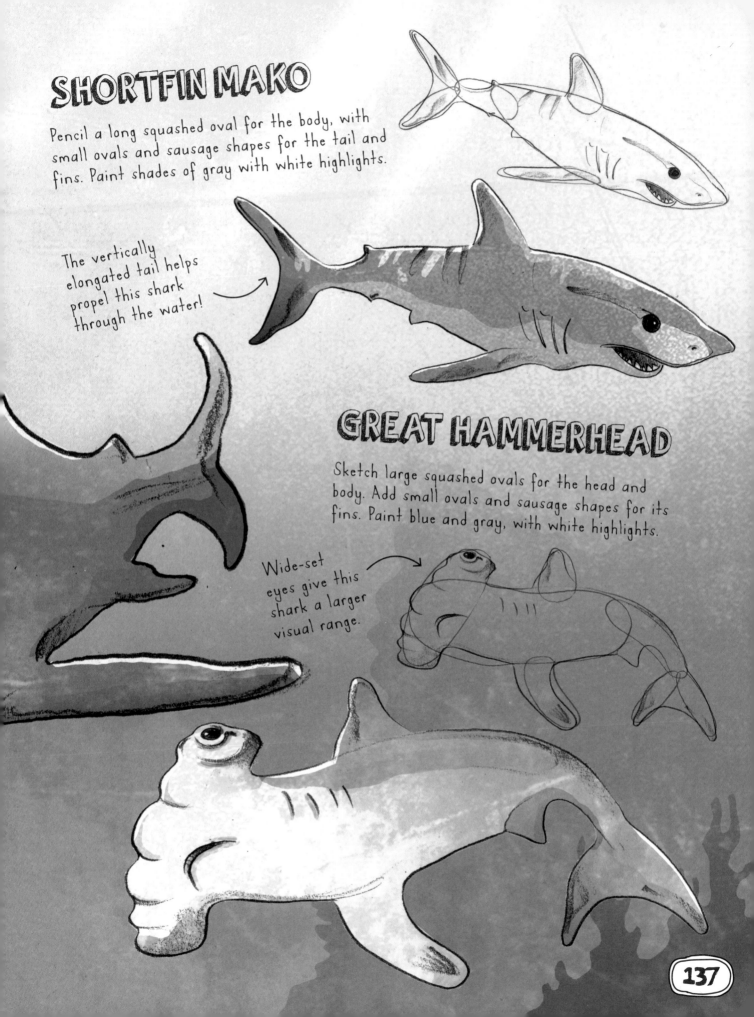

WATERFALL

1 USE STRAIGHT LINES TO DRAW THE BASIC SHAPE OF THE WATERFALL AND SURROUNDING CLIFF FACES. THE WATERFALL LOOKS NARROWER AT THE TOP BECAUSE IT IS FARTHER AWAY FROM US.

2 ADD FOLIAGE TO THE SIDES OF THE CLIFFS BY DRAWING GROUPS OF LEAF SHAPES. SKETCH A LARGE ROCK AT THE BASE OF THE WATERFALL WITH A ROUGH CURVE.

To create the effect of water spray, rub your finger along the end of your paintbrush and flick dots of white paint onto the paper.

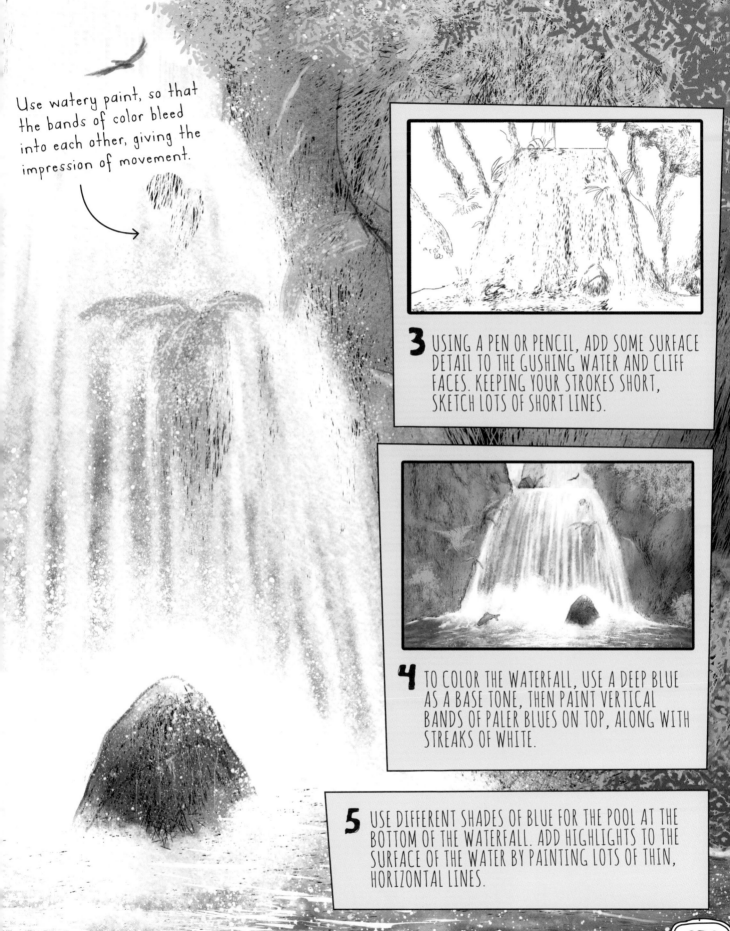

Use watery paint, so that the bands of color bleed into each other, giving the impression of movement.

3 USING A PEN OR PENCIL, ADD SOME SURFACE DETAIL TO THE GUSHING WATER AND CLIFF FACES. KEEPING YOUR STROKES SHORT, SKETCH LOTS OF SHORT LINES.

4 TO COLOR THE WATERFALL, USE A DEEP BLUE AS A BASE TONE, THEN PAINT VERTICAL BANDS OF PALER BLUES ON TOP, ALONG WITH STREAKS OF WHITE.

5 USE DIFFERENT SHADES OF BLUE FOR THE POOL AT THE BOTTOM OF THE WATERFALL. ADD HIGHLIGHTS TO THE SURFACE OF THE WATER BY PAINTING LOTS OF THIN, HORIZONTAL LINES.

AERIAL DISPLAY

1 DRAW AN ELONGATED OVAL SHAPE FOR THE MAIN BODY OF THE PLANE WITH A PENCIL. ADD TWO SMALL WING SHAPES AT ONE END.

It is always easier to draw a light outline to start with.

It's important that the features are the same on both sides.

2 DRAW IN TWO LARGE WINGS. THEY SHOULD BE COMPLETELY SYMMETRICAL. SKETCH IN FOUR ENGINES ONTO THE WINGS, AND ADD A BIT OF DETAIL TO THE SMALL BOTTOM WINGS.

3 ADD A TARGET DESIGN TO THE WINGS. THIS GIVES SOME INTEREST TO THE PLANE. AGAIN, THESE SHOULD BE SYMMETRICAL. ADD WIGGLY LINES AT THE BOTTOM FOR THE PLANE'S VAPOR TRAIL.

The trail should look soft and fluffy, so use soft, light strokes.

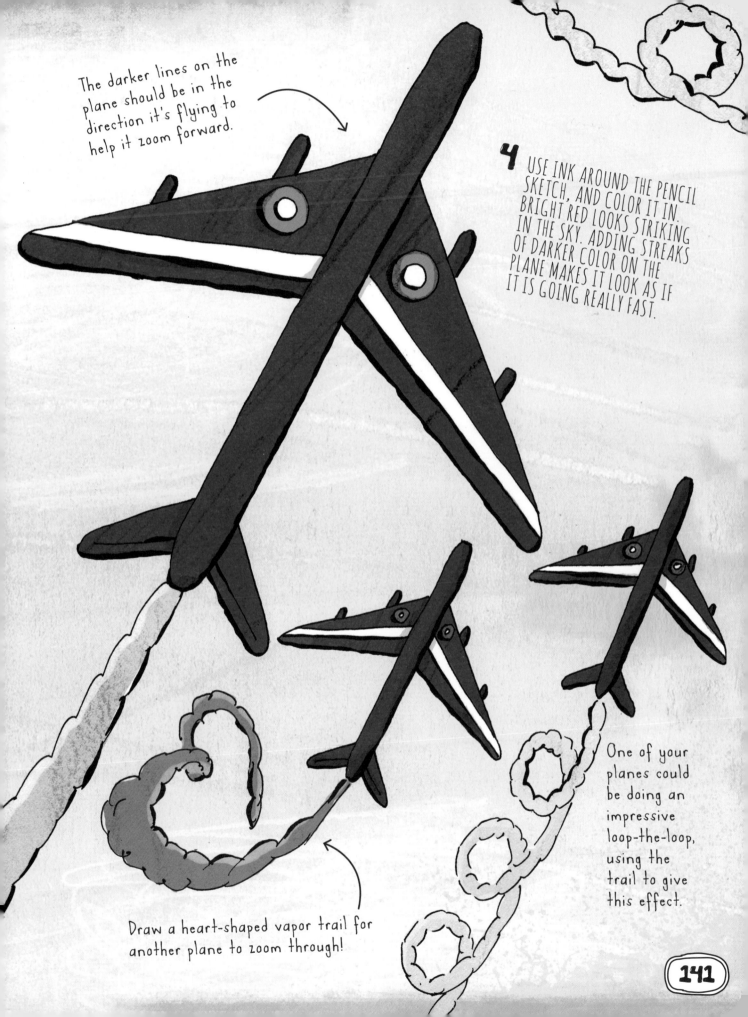

The darker lines on the plane should be in the direction it's flying to help it zoom forward.

4 USE INK AROUND THE PENCIL SKETCH, AND COLOR IT IN. BRIGHT RED LOOKS STRIKING IN THE SKY. ADDING STREAKS OF DARKER COLOR ON THE PLANE MAKES IT LOOK AS IF IT IS GOING REALLY FAST.

One of your planes could be doing an impressive loop-the-loop, using the trail to give this effect.

Draw a heart-shaped vapor trail for another plane to zoom through!

141

SAFARI PRINTS

ANIMALS HAVE ALL KINDS OF COAT COLORS AND PATTERNS. TRY YOUR HAND AT THESE DIFFERENT DRAWING TECHNIQUES TO PERFECT YOUR OWN SAFARI PRINTS.

LEOPARD

First draw irregular squashed shapes, then add splodge shapes around the edges of each one. Color with yellow, orange, and brown.

ZEBRA

Create a series of loose horizontal lines using a soft black pencil. Then paint the lines black.

CHEETAH

Mix up C shapes, jagged ovals, and smaller splodge shapes. Then add slits in the centers. Color with yellow, orange, and brown.

GIRAFFE

Draw interlocking shapes with spaces in between. Try to make each shape a different size. Color each shape reddish-brown, with creamy yellow in between.

TIGER

Use a soft pencil to draw two stretched and connected lines for each stripe. First color orange, then add the black.

FUR TEXTURES

For animals with long fur, draw the ends of the hair to make the fur look thicker.

Draw lines close together for animals that have short fur to create texture.

SHOES

DRAW DIFFERENT STYLES OF FOOTWEAR, THEN CREATE YOUR OWN PATTERNED FASHIONS!

1
USE CURVED LINES TO DRAW THE SIMPLE SHAPE OF A SNEAKER.

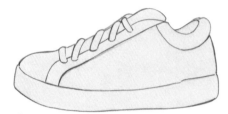

2
ADD IN THE RUBBER SOLE, THE TONGUE, SHOELACES, AND EDGING, AS SHOWN.

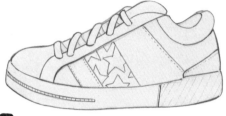

3
DRAW LINES TO SUGGEST DIFFERENT FABRICS ON THE SIDES AND AROUND THE BACK. SKETCH DASHED LINES FOR STITCHING, AND ADD A PATTERN.

ONCE YOU'VE MASTERED THE BASIC SHOE, TRY THESE TECHNIQUES ...

OXFORD SHOE

Vary the shape of your shoe and include Oxford-type stitching using circles and zigzags.

Draw shapes on your shoe to suggest multiple fabrics.

Create laces from short and long lines, and ovals.

This zigzag pattern uses small, teethlike lines to frame the fabric.

PLATFORM

Exaggerate the shoe's arch, heel, and sole to create a high-heeled platform shoe.

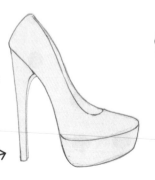

This zigzag pattern uses bold, contrasting colors for the overall pattern of the shoe.

TRY BUILDING UP SIMPLE SHAPES TO CREATE COOL SHOE PATTERNS.

THE CHECKERED LOAFER

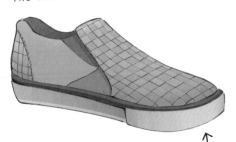

Horizontal and vertical lines create an eye-catching, two-tone checkered pattern.

Contrasting and complementary colors help make patterns, such as stars, spots, and zigzags, pop.

THE STARRY HIGH-TOP SNEAKER

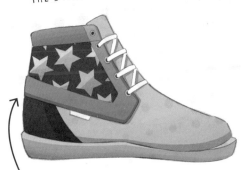

Isolate your pattern to just one part of the shoe for a pattern pop!

THE BALLET PUMP

Repeat semicircles for a rainbow pattern.

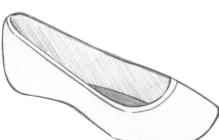

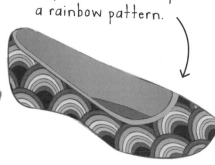

Sketch a long oval shape, then draw curved lines around it to create a ballet shoe.

Break up a spotted pattern with a chunky rectangular band.

THE KITTEN HEEL

Draw a simple shoe shape and add a small heel.

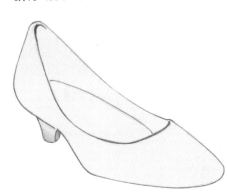

Use curved shapes, spiraling outward from the center, for a rose pattern.

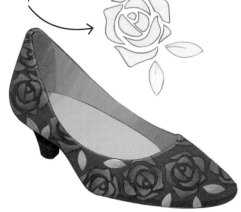

Curvy rectangles make this simple shoe buckle for a higher-heeled shoe.

CYBORG

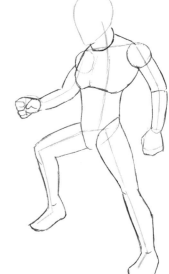

1

DRAW A STICK FIGURE TO SHOW THE BASIC POSE AND PROPORTIONS. SKETCH A SLIGHT CURVE FOR THE BACK AND HORIZONTAL LINES FOR THE HIPS AND SHOULDERS. ADD ARMS AND LEGS AND AN OVAL SHAPE FOR THE HEAD.

2

TO FLESH OUT THE LIMBS, DRAW CYLINDERS AROUND THE STICK LINES, MAKING THE LINES CURVE OUTWARD TO SUGGEST BULGING MUSCLES. ADD IN THE CHEST MUSCLES, PLUS A CIRCLE TO SUGGEST A PUMPED-UP SHOULDER!

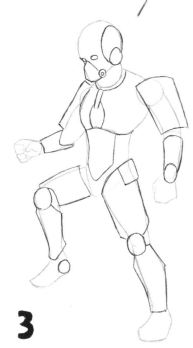

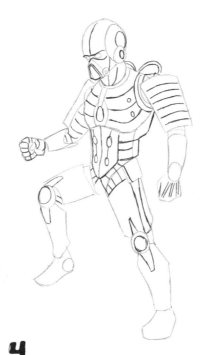

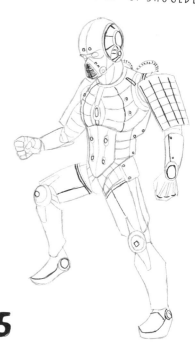

3

ERASE THE STICK LINES. DRAW THE CYBORG'S ARMOR BY SKETCHING SHAPES THAT MIMIC THE BODY PARTS UNDERNEATH, BUT LARGER TO GIVE THE IMPRESSION OF WEIGHT AND THICKNESS. USE CIRCLES FOR THE WRIST, KNEE, AND ANKLE JOINTS.

4

WORK ON THE ARMOR DETAIL. ADD CIRCULAR LIGHTS, AND DRAW CURVED LINES ON THE CHEST AND SHOULDER AREAS. CREATE A SCI-FI FEEL BY ADDING TUBING AND MORE ELABORATE KNEE JOINTS. ADD MORE DETAIL TO THE MASK AND HELMET.

5

REFINE THE DETAIL FURTHER. DRAW RIVETS ON THE ARMOR, LINES ON THE MASK, AND A CRISSCROSS PATTERN ON THE SHOULDER PLATE. ADD LINES TO DIVIDE PARTS OF THE ARMOR INTO SMALLER SECTIONS, SUCH AS THE HELMET AND UPPER LEG AREAS.

6

PAINT YOUR CYBORG WITH COOL COLORS. TO MAKE THE CYBORG LOOK METALLIC, USE NARROW BANDS OF DIFFERENT TONES, ESPECIALLY FOR THE HIGHLIGHTS, TO SHOW LIGHT REFLECTING OFF A SHINY SURFACE.

Draw rocks using a mix of smooth and angular lines to form spiky peaks. Add plenty of shadows for dramatic contrast.

Add small, dark lines to the armor to suggest wear and tear.

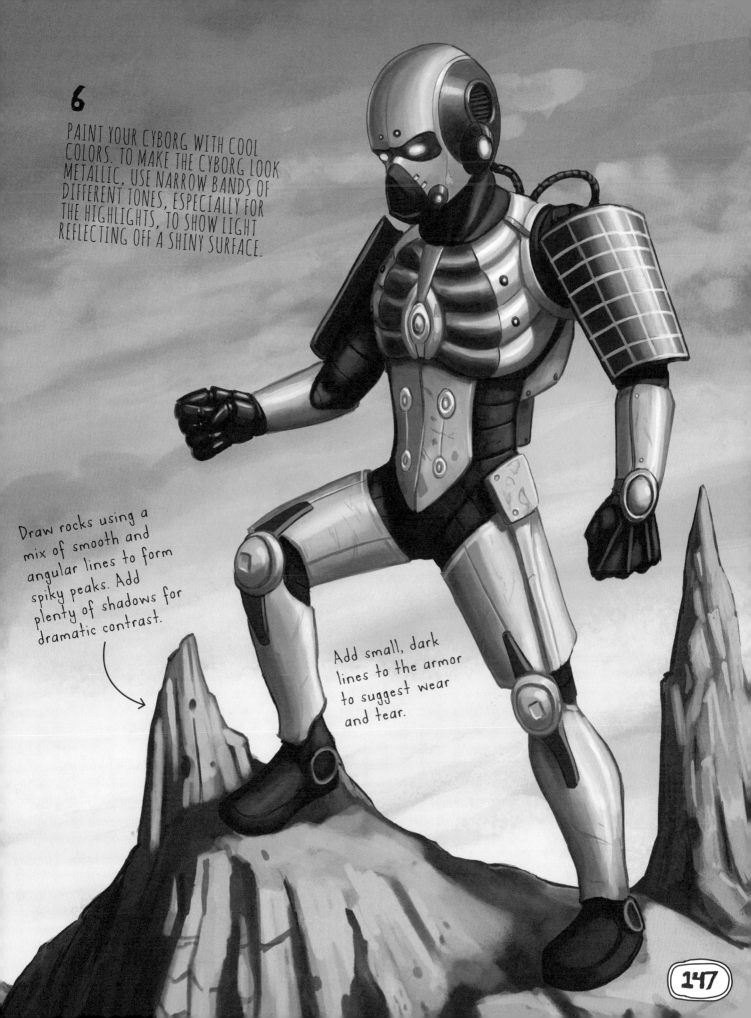

TREE FROG

THIS RAINFOREST-DWELLING AMPHIBIAN IS A RED-EYED TREE FROG. IT FLASHES ITS BULGING RED EYES TO SCARE AWAY PREDATORS!

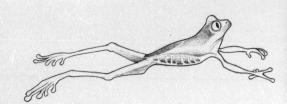

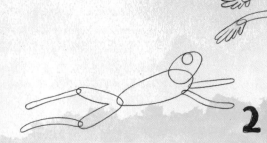

3 ADD ROUNDED PADS TO THE TIPS OF EACH TOE AND A VERTICAL SLIT FOR THE PUPIL. USE A HARD PENCIL TO REFINE THE OUTLINE.

2 CONNECT THE HEAD, BODY, AND LEGS WITH A FLUID OUTLINE AND PENCIL IN LONG-TOED FEET. ADD A CURVED EYE.

1 BEGIN WITH SQUASHED OVALS FOR THE BODY AND HEAD. ADD A CIRCULAR EYE AND SAUSAGE SHAPES FOR THE FOUR LEGS.

1 START WITH A LARGE OVAL FOR THE BODY AND HEAD. ADD A LARGE ROUND EYE AND THIN PIPE SHAPES FOR THE SKINNY LEGS.

2 ADD LARGE FEET WITH SPLAYED TOES, A SECOND EYE, AND A THIN MOUTH. CONNECT ALL OF THE SHAPES WITH A FLUID OUTLINE.

3 SKETCH A THIN VERTICAL SLIT FOR A PUPIL AND DARK SHADING AROUND THE EYES. ADD A PATTERN TO THE BODY.

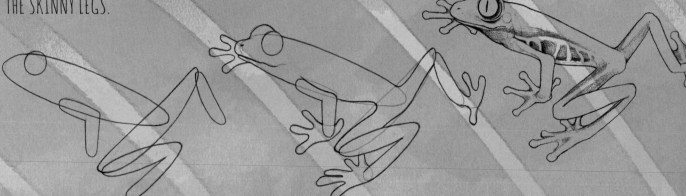

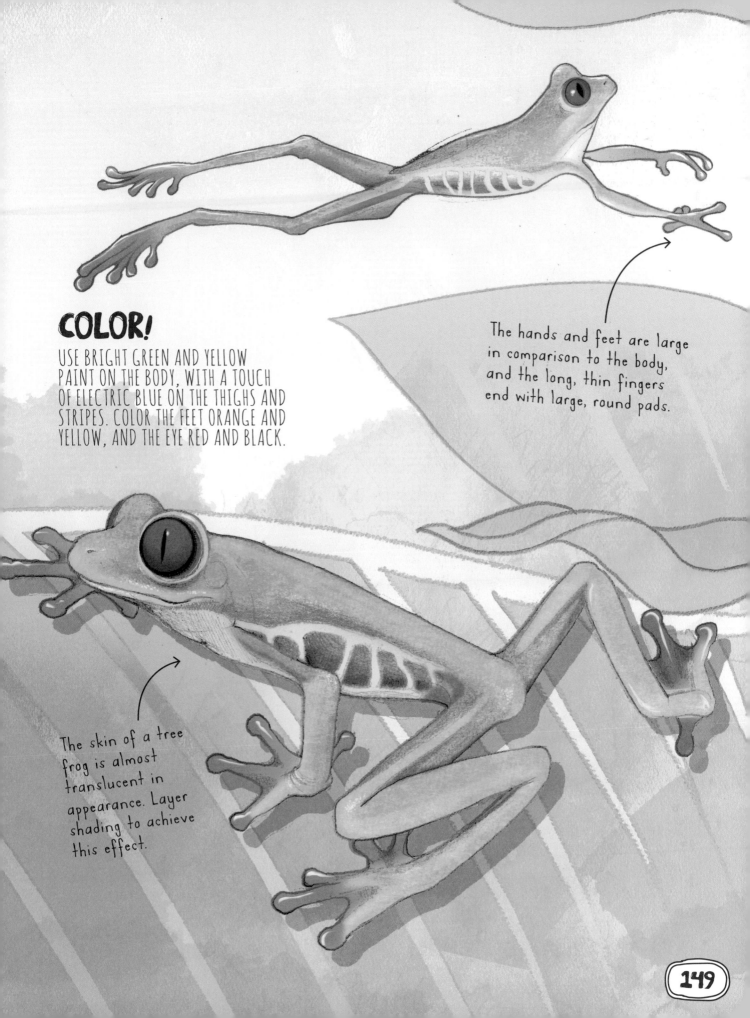

COLOR!

USE BRIGHT GREEN AND YELLOW PAINT ON THE BODY, WITH A TOUCH OF ELECTRIC BLUE ON THE THIGHS AND STRIPES. COLOR THE FEET ORANGE AND YELLOW, AND THE EYE RED AND BLACK.

The hands and feet are large in comparison to the body, and the long, thin fingers end with large, round pads.

The skin of a tree frog is almost translucent in appearance. Layer shading to achieve this effect.

149

3D TREASURE MAP

1 START WITH A TRAPEZOID SHAPE (A RECTANGLE WITH THE SIDES SLANTING INWARD). ADD RIPPED EDGES FOR AN OLDER, WORN-AND-TORN LOOK. DRAW A CURVED ISLAND SHAPE IN THE MIDDLE.

2 SKETCH RIPPLING LINES AROUND THE ISLAND FOR THE SEA. SHADE IN SOME CLIFF EDGES TO RAISE THE ISLAND OUT OF THE WATER. ADD A PATHWAY WITH A BIG "X" AT THE END.

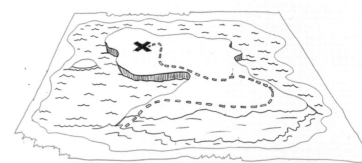

3

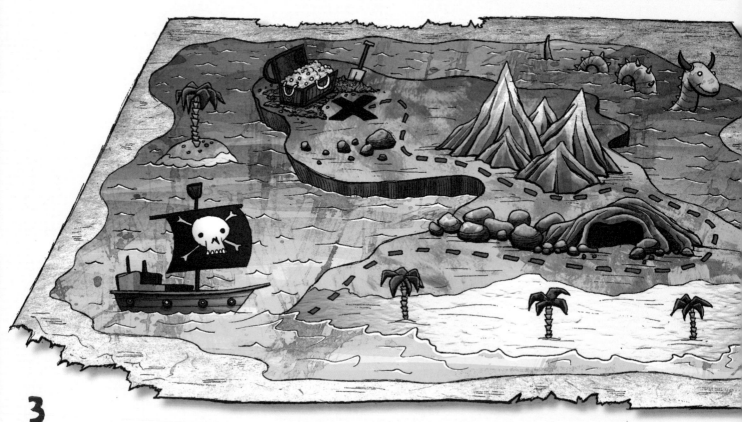

ADD MORE DETAILS, SUCH AS A PIRATE SHIP, TREASURE CHEST, CAVE, SEA MONSTER, MOUNTAINS, AND TREES, TO GIVE YOUR MAP MORE CHARACTER AND INTEREST. GET CREATIVE WITH THIS! COLOR AND SHADE YOUR MAP.

MAP FEATURES

MOUNTAINS

Draw jagged triangle shapes. Add smaller triangles and lines inside your basic mountains, then shade them for a 3D effect.

CAVES

Start with a rough semicircle for the cave. Draw a smaller semicircle for the opening. Add shading in and around the cave for depth.

PIRATE SHIP

Sketch curved lines and rectangles to create the ship, mast, and flag. Add wavy water lines, and don't forget the skull and crossbones!

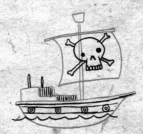

PALM TREES

Repeat small, upside-down trapezoid shapes for the trunk. Then draw droopy, pointed leaves on top. Add shading to the trunk and leaves.

SEA MONSTER

Draw an oval-shaped head and two curved lines for the neck. Sketch semicircles for the body, then triangles for the tail, spikes, and horns. Add the eyes, mouth, and water lines.

TREASURE CHEST

Start with a basic cuboid shape, then draw a rectangular lid with two semicircles on either side. Add lines to the chest for texture, and sketch circles and semicircles for the treasure!

T-SHIRTS

A T-SHIRT IS THE PERFECT FASHION ITEM— A BLANK CANVAS FOR ANY KIND OF DESIGN YOU CAN IMAGINE. PRACTICE DRAWING THE BASIC SHAPES FIRST, THEN GET CREATIVE!

DRAW A BASIC CREW-NECK T-SHIRT SHAPE USING A PENCIL OR PEN AND INKS. ADD CREASES TO THE ARMPIT AREAS. DRAW EXTRA STITCHING LINES IF YOU LIKE, SUCH AS AROUND THE NECK AND SLEEVES.

FOR A TANK-STYLE TOP, LEAVE OFF THE ARMS AND DRAW LINES CURVING INWARD ON EACH SIDE. AND AN EXTRA LINE FOR INTEREST.

FOR A MORE FEMININE-LOOKING DESIGN, DRAW A SHALLOW V-NECK WITH THIN, VERTICAL STRAPS ATTACHED TO THE TOP.

ANOTHER POPULAR T-SHIRT SHAPE IS THE V-NECK SHIRT.

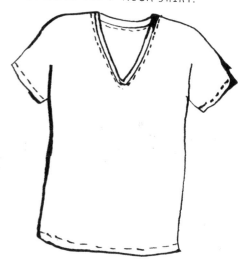

Draw simple dashed lines like these for the stitching detail. Add these lines around the base, neck, and sleeves.

DRAW A POCKET BY SKETCHING A SQUARE WITH A POINTED BASE. ADD EXTRA LINES OF DETAIL.

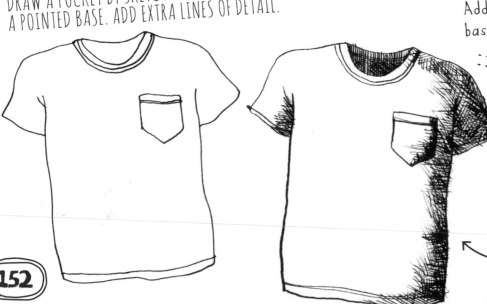

To add depth, use simple crosshatching for the areas that would be in the shadows. Here, the light source is coming in from the left.

HERE ARE SOME T-SHIRT DESIGNS TO GIVE YOU INSPIRATION.

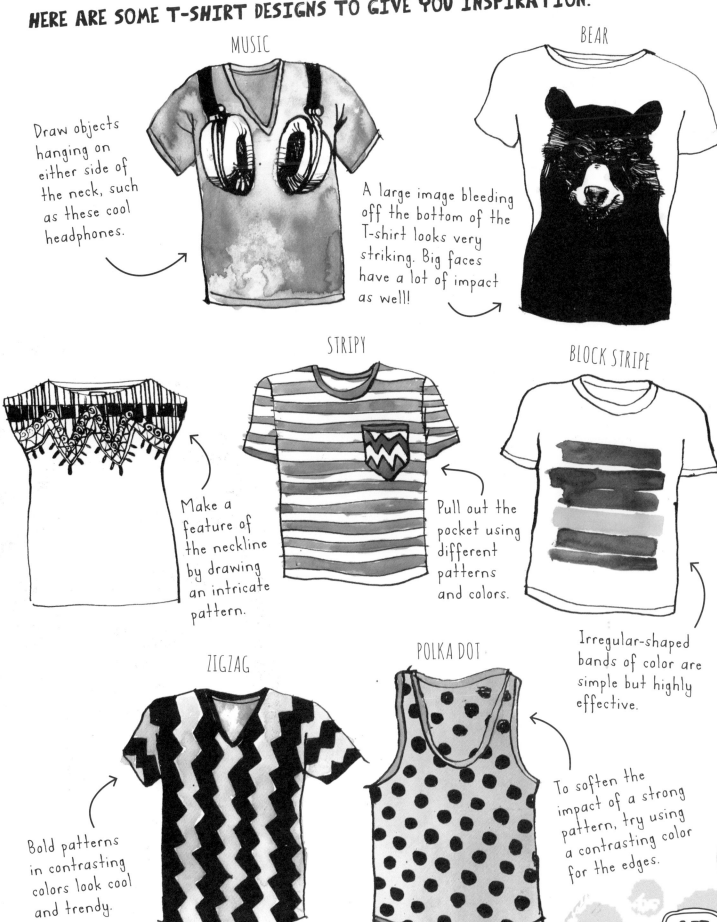

MUSIC

Draw objects hanging on either side of the neck, such as these cool headphones.

BEAR

A large image bleeding off the bottom of the T-shirt looks very striking. Big faces have a lot of impact as well!

STRIPY

Make a feature of the neckline by drawing an intricate pattern.

Pull out the pocket using different patterns and colors.

BLOCK STRIPE

Irregular-shaped bands of color are simple but highly effective.

ZIGZAG

Bold patterns in contrasting colors look cool and trendy.

POLKA DOT

To soften the impact of a strong pattern, try using a contrasting color for the edges.

153

ZEBRA

COMMON PLAINS ZEBRAS, SUCH AS THIS ONE, HAVE TAILS THAT ARE ALMOST HALF A YARD IN LENGTH!

All zebras have different stripe markings, so make yours look just the way you want it to!

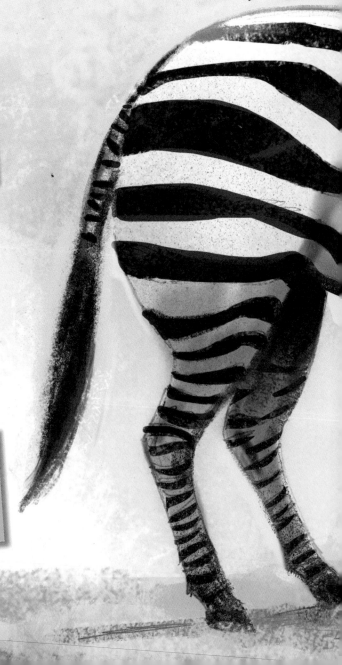

1 DRAW A BASIC SHAPE FOR THE ZEBRA. ADD AN OBLONG FOR THE BODY, A SMALL CIRCLE FOR THE HEAD, AND LINES FOR THE LEGS, NECK, AND TAIL.

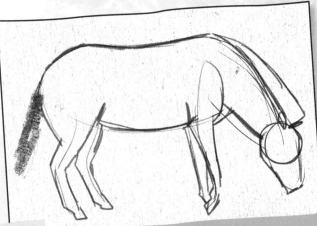

2 ADD SOME ROUGH LINES TO CONNECT UP ALL THE SHAPES. ADD THE MANE AND TAIL. AT THIS STAGE THE OUTLINE CAN BE QUITE ROUGH.

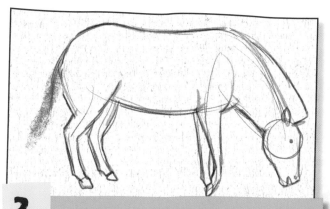

3 ONCE YOU'RE HAPPY WITH THE OVERALL OUTLINE, BEGIN TO ADD SOME DETAILS INCLUDING THE ZEBRA'S EYE, NOSTRIL, MOUTH, AND HOOVES.

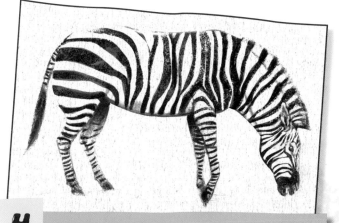

4 USE A SOFT PENCIL TO SKETCH IN THE STRIPES ALONG THE ZEBRA'S BODY. KEEP THEM LOOSE AND CHANGE THEM IF THEY DON'T LOOK RIGHT.

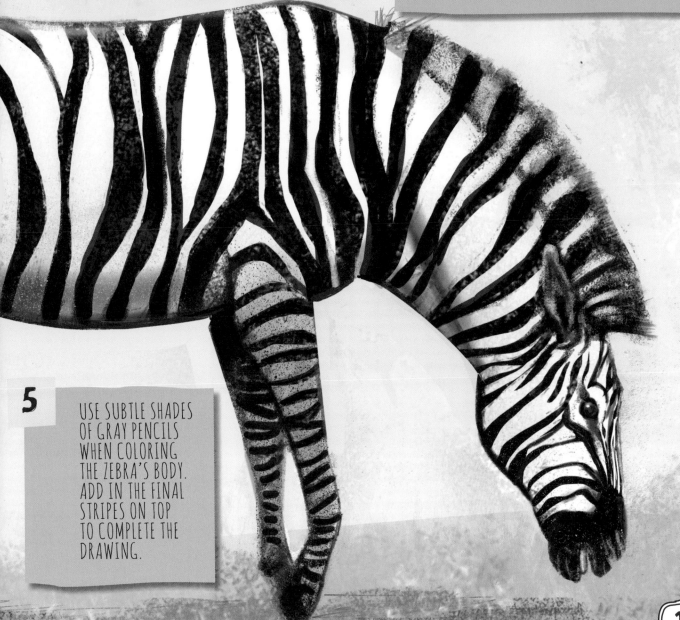

5 USE SUBTLE SHADES OF GRAY PENCILS WHEN COLORING THE ZEBRA'S BODY. ADD IN THE FINAL STRIPES ON TOP TO COMPLETE THE DRAWING.

WEREWOLF

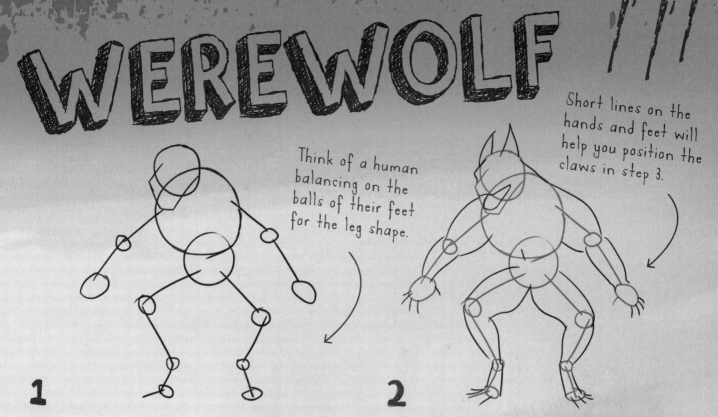

Think of a human balancing on the balls of their feet for the leg shape.

Short lines on the hands and feet will help you position the claws in step 3.

1
SKETCH CIRCLES FOR THE HEAD, BODY, HANDS, FEET, AND BODY JOINTS, AND STRAIGHT LINES FOR THE ARMS AND LEGS, AS SHOWN. ADD A RECTANGULAR-SHAPED SNOUT.

2
DRAW FLUID LINES AROUND YOUR GUIDES TO SUGGEST BULKY MUSCLES. SKETCH TWO TRIANGLES FOR EARS, AND ADD IN THE MOUTH.

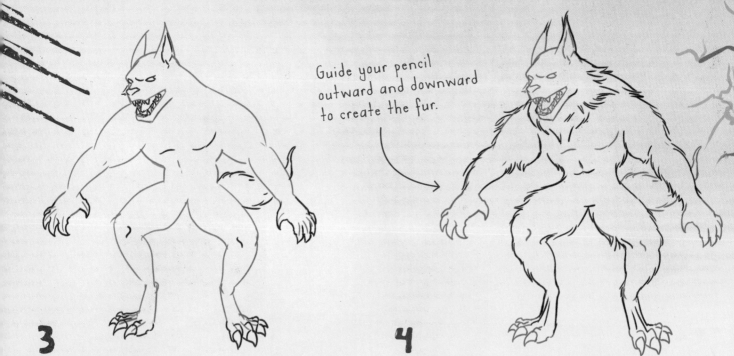

Guide your pencil outward and downward to create the fur.

3
ADD CLAWS, EYES, AND A DOGLIKE NOSE. SKETCH A SCRUFFY TAIL USING SHORT, FLICKY LINES. DRAW SMALL TRIANGLES FOR TEETH AND CURVED LINES ON THE CHEST AND KNEES. ERASE THE LINES FROM STEP 1.

4
APPLY THE SAME FLICKY LINES YOU USED FOR THE TAIL TO ADD IN THE WEREWOLF'S FUR. STRAIGHT LINES ON THE FEET WILL GIVE THE IMPRESSION OF STRETCHED TENDONS. ERASE THE ROUGH LINES FROM STEP 2.

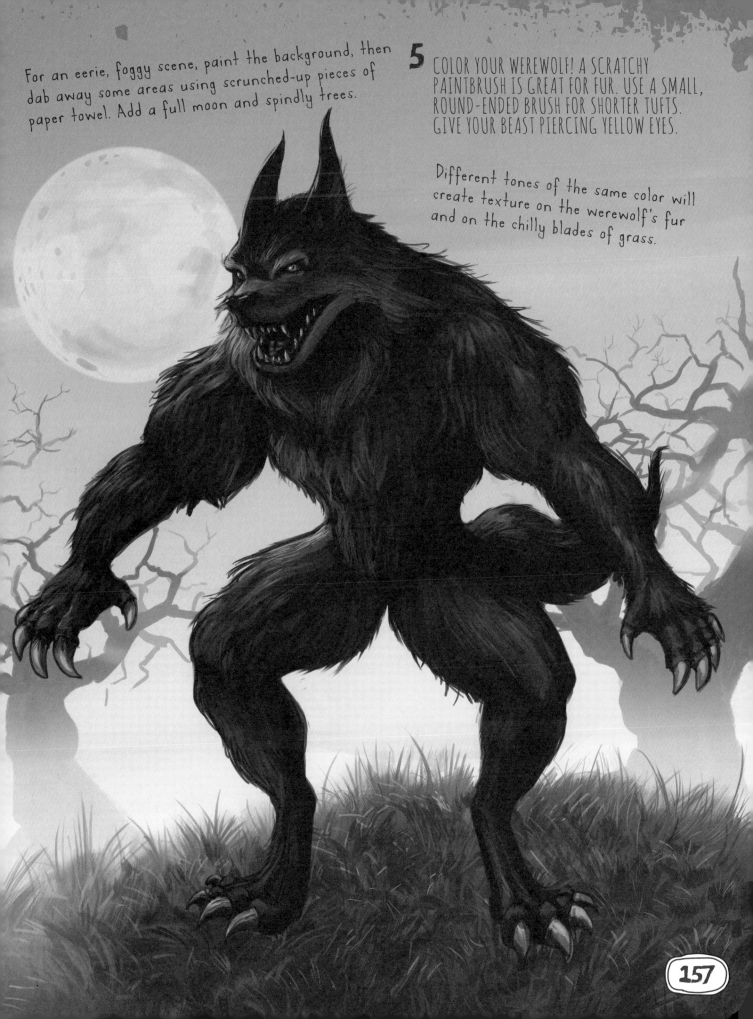

For an eerie, foggy scene, paint the background, then dab away some areas using scrunched-up pieces of paper towel. Add a full moon and spindly trees.

5 COLOR YOUR WEREWOLF! A SCRATCHY PAINTBRUSH IS GREAT FOR FUR. USE A SMALL, ROUND-ENDED BRUSH FOR SHORTER TUFTS. GIVE YOUR BEAST PIERCING YELLOW EYES.

Different tones of the same color will create texture on the werewolf's fur and on the chilly blades of grass.

157

Frames

TRY DRAWING FRAMES FOR YOUR PICTURES USING SIMPLE SHAPES TO BUILD UP PATTERNS.

FOR A ZIG-ZAG PATTERN, DRAW TWO LONG PARALLEL LINES, THEN DRAW ZIG-ZAG LINES BETWEEN THEM.
BUILD UP A COMPLEX PATTERN BY ADDING DETAIL AND SHADING LINES IN THE TRIANGLES YOU'VE CREATED.

THIS PATTERN IS SIMILAR TO THE ONE ABOVE, BUT THIS TIME USE CONSECUTIVE CURVES AND REMOVE THE
TOP LINE TO GIVE A DIFFERENT, ROUNDED STYLE. ADD DETAIL INSIDE THE CURVES FOR SOPHISTICATION.

FOR ANOTHER INTERESTING PATTERN, DIVIDE THE SPACE BETWEEN THE PARALLEL LINES INTO SMALL SQUARES.
TRY DIFFERENT PATTERNS IN EACH ONE, OR REPEAT SOME OF THE DESIGNS TO BUILD UP A BIGGER PATTERN.

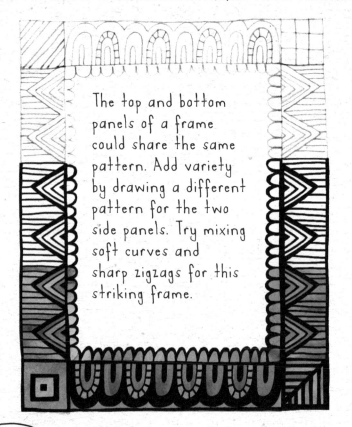

The top and bottom panels of a frame could share the same pattern. Add variety by drawing a different pattern for the two side panels. Try mixing soft curves and sharp zigzags for this striking frame.

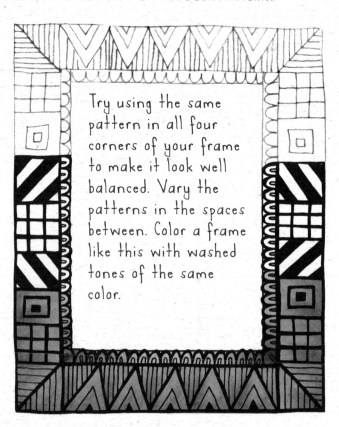

Try using the same pattern in all four corners of your frame to make it look well balanced. Vary the patterns in the spaces between. Color a frame like this with washed tones of the same color.

Round

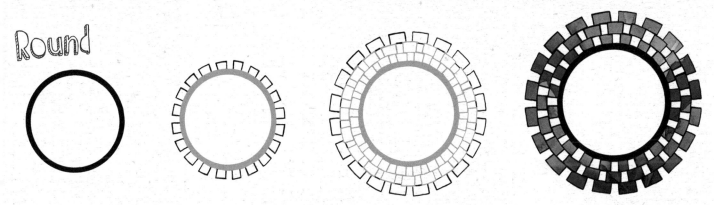

Start by drawing a thick circle. Add squares around the outside, leaving spaces in between. On the next layer, add squares, building on the spaces in the first layer. Do the same for the third layer. Mix different tones of watercolor paints to color the squares, leaving white space in between.

Oval

Draw an oval shape with a larger oval around the outside. Draw lines close together inside. Add larger ovals, and divide them up into equal sections, as shown. Add curves around the outside of the frame, looping from line to line. Color with watercolor paints and varying tones.

Star

To make a star-shaped frame, draw two interlocking triangles, one on top of the other. Add larger stars around the outside. In light pencil, draw curves around the outside. Paint the frame. When it's dry, ink over the lines varying the thickness to make it interesting. Add pretty detail!

159

LLAMA

Draw a squashed oval body, circular head, and guidelines for the legs. Work up the outline and facial details. Color with yellow and brown washes. Add gray highlights.

Llama wool is soft, oil-free, and lightweight, so it is great for all kinds of things!

WOOLLY ANIMALS

ALPACA

Sketch a squashed oval head, U-shaped body, and triangular ears. Refine the outline and facial details. Color with a white and brown wash. Then use orange and gray pencils to add highlights.

Alpaca fleece is soft and fine. It is similar to sheep's wool, but it is warmer and lighter.

ANGORA GOAT

Pencil a rough square for the body, with a circle for a head. Draw the overall outline and add details. Color with light brown, yellow, and gray pencils.

The wool, or fleece, taken from Angora goats is called "mohair." It makes a silklike yarn.

SHEEP

The fleece of a sheep is quite greasy—it is full of a substance called lanolin (wool wax).

Draw a large circle for the body and two circles for the head. Add the outline and details. Use a light yellow wash, then add texture with brown and gray pencils.

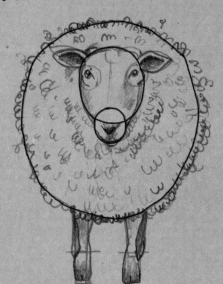

HOVER CAR

DESIGN YOUR VERY OWN CAR THAT FLIES THROUGH THE AIR!
HERE ARE A FEW IDEAS TO INSPIRE YOU ...

BODY SHAPE

Start with the outline of your car. The bodywork is roughly a box shape, with two arches cut out from the side. It's up to you whether or not your car has a roof!

INVERTED WHEELS

Think about how your car will hover. This hover car has special wheels that change into rocket boosters— they flip downward and the thrust lifts the vehicle into the air.

To draw a simple rocket booster, sketch a hat shape with a broad oval brim at the bottom.

Add spokes at the bottom of the rocket booster, plus any extra design details you like.

Finish off by adding lots of short, curved lines to the brim to make it look like tubing.

162

WINDSHIELD AND DRIVER

Draw a rectangle with curved corners for the windshield. Build up the driver's body shape using curved lines and ovals.

Add more details to the driver, such as his hair and facial features. Add the seats!

Add the finer details. A few angled lines on the windshield make it look like glass.

FIERY THRUST

Rocket flames make this car look really exciting. If you like, you could also draw smoke blasting out from underneath. What other cool features could your hover car have?

HEADLIGHTS

All cars need lights. This car has two big oval-shaped headlights with smaller signal lights underneath. Make yours retro like this, or give übermodern a try!

HAIRSTYLES

LEARN HOW TO DRAW A VARIETY OF HAIRSTYLES TO USE ON YOUR PORTRAITS. EXPERIMENT WITH COLOR AND TEXTURE!

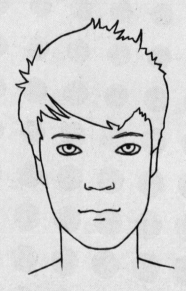

Think about the direction of the hair. Use long, confident strokes for someone who has longer hair, like this.

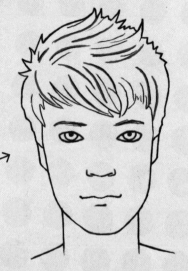

1

FOR A BASIC BOY'S HAIRSTYLE, START BY THINKING HOW THE HAIR WILL FALL ON THE FACE. DRAW THE BASIC OUTLINE ON THE TOP OF THE HEAD, LIKE THIS.

2

SKETCH IN THE HAIR DETAIL. MAKE SURE LINES ARE CLOSE TOGETHER, AND VARY THE LIGHTNESS AND DARKNESS TO SHOW SHADING, USING DIFFERENT PENCILS TO ACHIEVE THIS VARIATION.

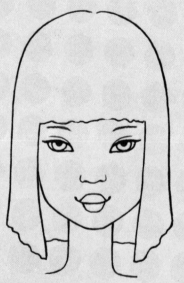

For longer hair, make sure that the strokes of hair are of similar length. Add a little shape to them to show movement.

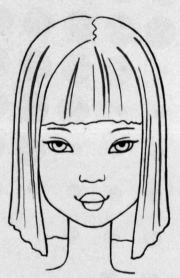

1

FOR A BASIC GIRL'S HAIRSTYLE, AGAIN START WITH A ROUGH OUTLINE FOR THE SHAPE OF THE GIRL'S HAIR ON A SIMPLE FACE, LIKE THIS.

2

SKETCH IN THE HAIR WITH DOWNWARD PENCIL STROKES. THINK ABOUT THE SHADOWS AND HIGHLIGHTS.

NOW TRY THESE COOL HAIRSTYLES!

WAVY

Use flowing lines for curls and waves.

CURLY

For tight curls, use lots of little scribbled circles next to each other.

AFRO

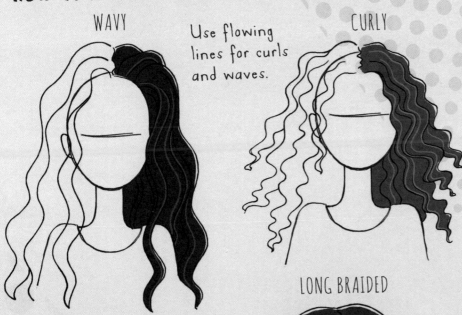

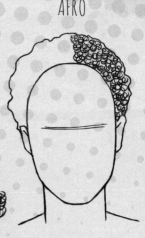

RINGLETS

The ringlet is a series of spiral shapes, like this.

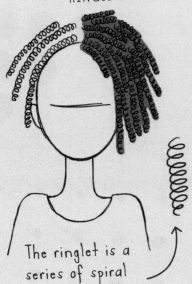

LONG BRAIDED

For a braid, draw a line with leaf shapes coming off it.

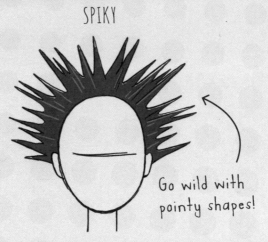

BEEHIVE

This style is basically a whole other head shape on top of the girl's head!

Try leaving out the bangs and adding a headband or tiara. Use your pencil lines to show the direction of the updo.

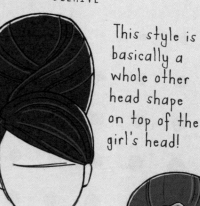

COLORFUL EXTENSIONS

You can choose loads of different colors for your hairstyle!

SPIKY

Go wild with pointy shapes!

ASYMMETRICAL

TIGER

TIGERS ARE AMBUSH HUNTERS. DRAW YOURS HIDING AMONG THE LEAVES, READY TO JUMP OUT AND ATTACK ITS PREY!

1

DRAW A CIRCLE. ADD A VERTICAL LINE AND TWO HORIZONTAL LINES. DRAW A V-SHAPED LINE TO HELP YOU DRAW TWO EARS. ADD CURVED LINES FOR THE CHIN AND SIDES OF THE FACE.

2

PENCIL A V-SHAPED NOSE AND W-SHAPED SNOUT. DRAW EYES ON THE UPPER LINE, CLOSE TO THE W-SHAPED LINE. NOW ADD A FEW LINES FOR THE TIGER'S BODY.

3

ADD PUPILS AND DRAW WINGED SHAPES AROUND THEM TO START SHOWING THE TIGER'S MARKINGS. USE THE CIRCLE SHAPE TO DEFINE THE EDGES OF THE TIGER'S FACE.

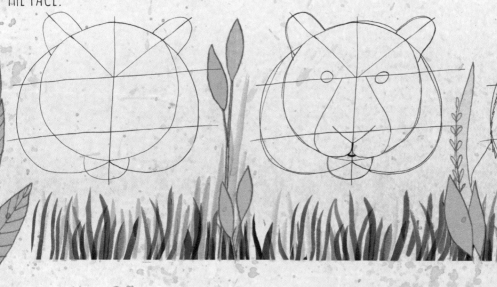

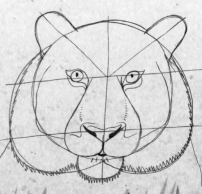

4

DRAW LINES UNDER THE NOSE FOR THE WHISKERS. ADD FUR MARKINGS AROUND THE EDGE OF THE FACE AND A FEW STRIPES TO THE BODY.

5

START TO SHADE IN THE BLACK STRIPES AND WORK UP THE HAIR AROUND THE FACE. NEXT, ADD DOTS ALONG THE LINES ON THE NOSE.

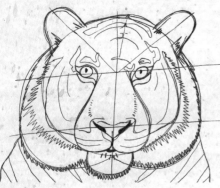

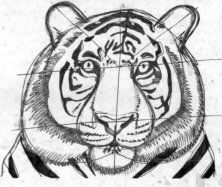

6

FIRST, GIVE THE FACE AN ORANGE WATERCOLOR WASH. THEN USE WHITE TO COLOR THE AREA AROUND THE EYES, EDGES OF FUR, SNOUT, AND CHIN. ADD PINK TO THE NOSE AND GREEN TO THE EYES. USE A WHITE PENCIL TO ADD WHISKERS.

Each tiger's stripes are unique, just like human fingerprints. So don't worry if yours doesn't look exactly like this one!

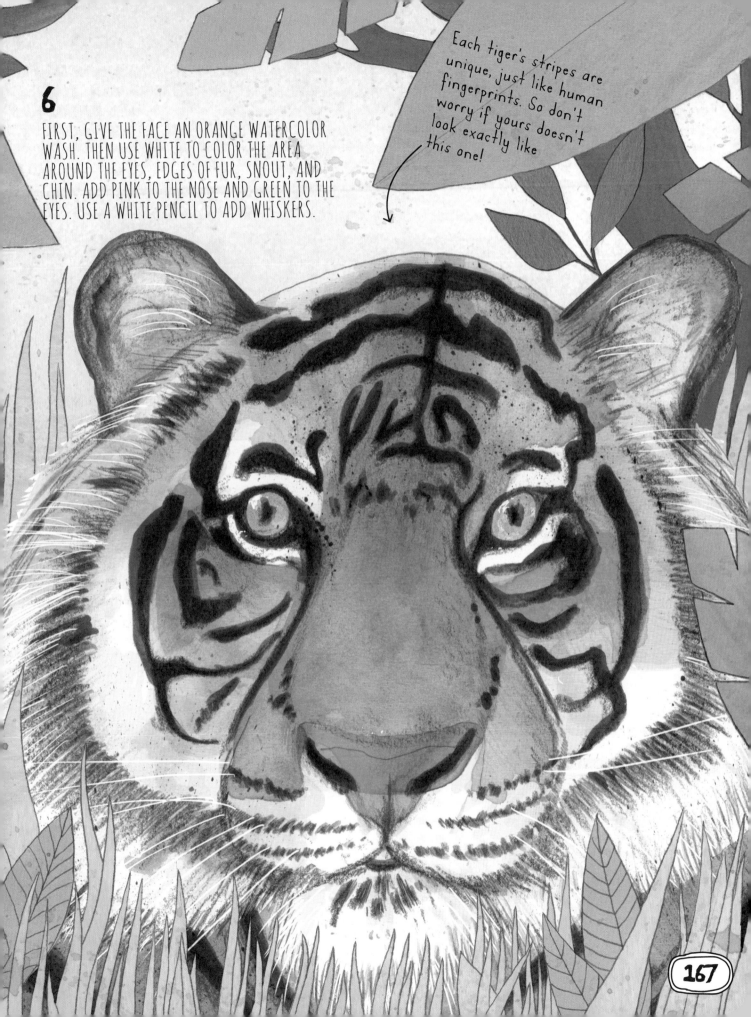

VINTAGE BICYCLE

1 BREAK THE BICYCLE INTO SIMPLE SHAPES. DRAW TWO CIRCLES FOR THE WHEELS, THEN USE A RULER TO CONNECT THEM. DRAW TWO ANGLED LINES FOR THE FRAME AND A SHORT LINE FOR THE SEAT.

2 USE RECTANGLES, STRAIGHT LINES, AND CURVED LINES TO ADD MORE DETAIL TO THE FRAMEWORK AND TO CREATE HANDLEBARS AND A SHOPPING BASKET, AS SHOWN.

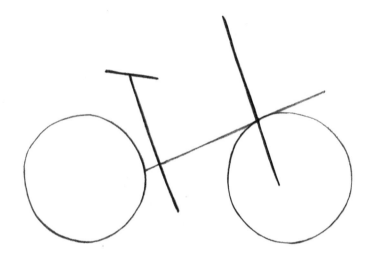
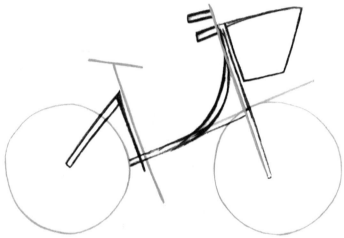

3 SKETCH A RECTANGLE FOR THE SEAT AND A SPIRAL FOR ITS SPRING. DRAW MORE CIRCLES FOR THE WHEELS, CHAIN WHEEL, AND HUB. ADD A CYLINDER-SHAPED CHAIN AND A TRIANGULAR HEADLIGHT.

4 FOR THE SPOKES, DRAW LINES RADIATING OUT FROM THE WHEEL HUB AND CHAIN. THEN START TO GO OVER YOUR LINES WITH A WATER-RESISTANT INK PEN. ERASE ANY PENCIL MARKS.

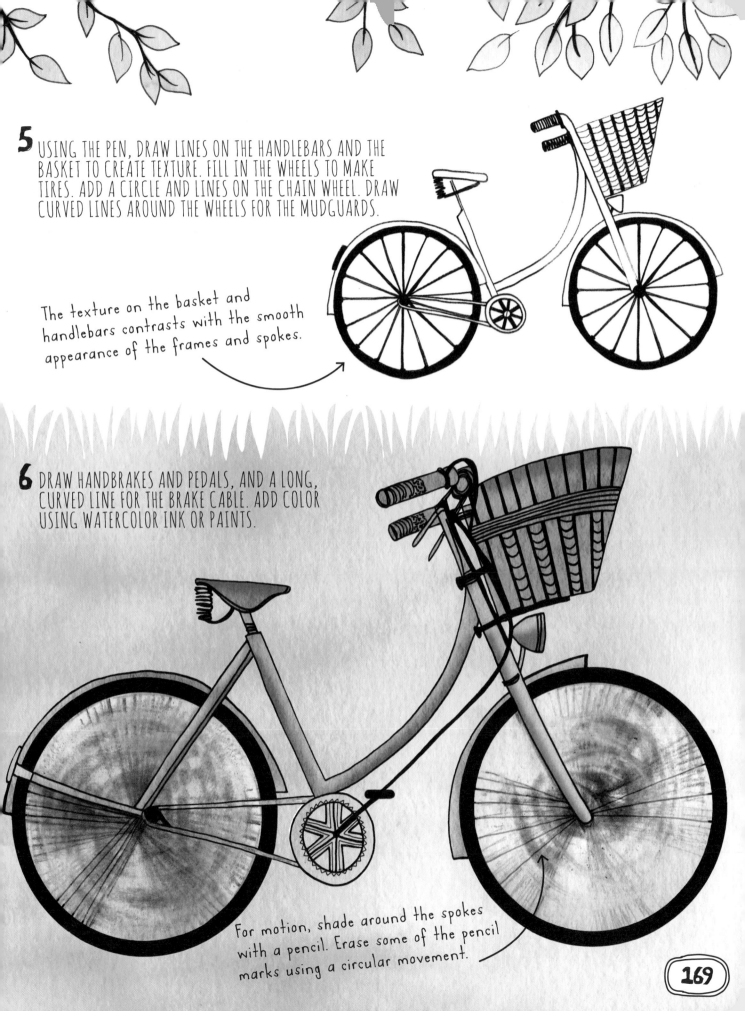

5 USING THE PEN, DRAW LINES ON THE HANDLEBARS AND THE BASKET TO CREATE TEXTURE. FILL IN THE WHEELS TO MAKE TIRES. ADD A CIRCLE AND LINES ON THE CHAIN WHEEL. DRAW CURVED LINES AROUND THE WHEELS FOR THE MUDGUARDS.

The texture on the basket and handlebars contrasts with the smooth appearance of the frames and spokes.

6 DRAW HANDBRAKES AND PEDALS, AND A LONG, CURVED LINE FOR THE BRAKE CABLE. ADD COLOR USING WATERCOLOR INK OR PAINTS.

For motion, shade around the spokes with a pencil. Erase some of the pencil marks using a circular movement.

169

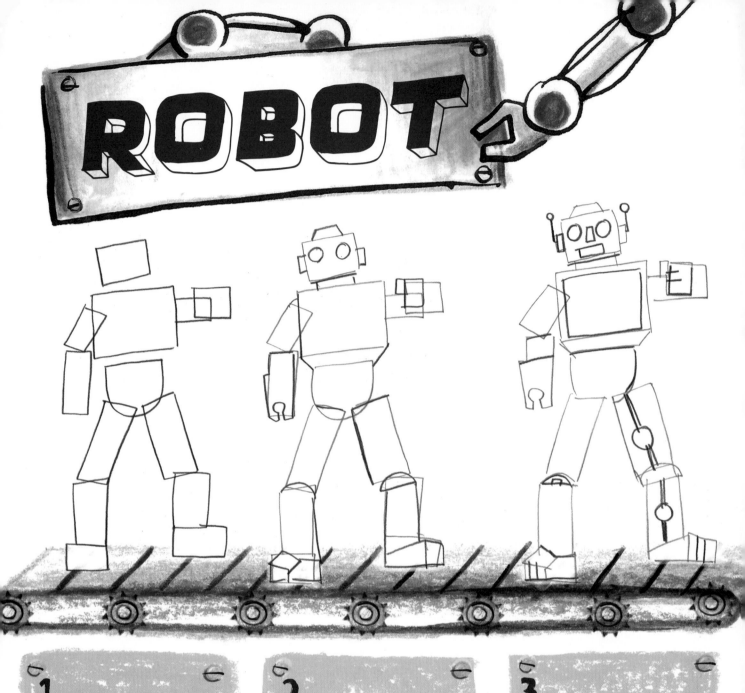

ROBOT

1

USING A LIGHT PENCIL, DRAW SQUARES AND RECTANGLES TO BEGIN THE ROUGH SHAPES OF YOUR ROBOT. INCLUDE A HEAD, BODY, ARMS, LEGS, AND FEET.

2

DRAW THE EYES AND CONNECT THE SQUARES TO MAKE THE ROBOT LOOK MORE SOLID. ADD SHAPES ON THE FEET TO ADD DIMENSION TO THE ROBOT.

3

START ADDING SOME DETAIL. USE SIMPLE SHAPES FOR A FACE, HEADPHONES, AND ANTENNAE. ADD CLAW HANDS TO THE ARMS AND DETAIL TO THE LEGS.

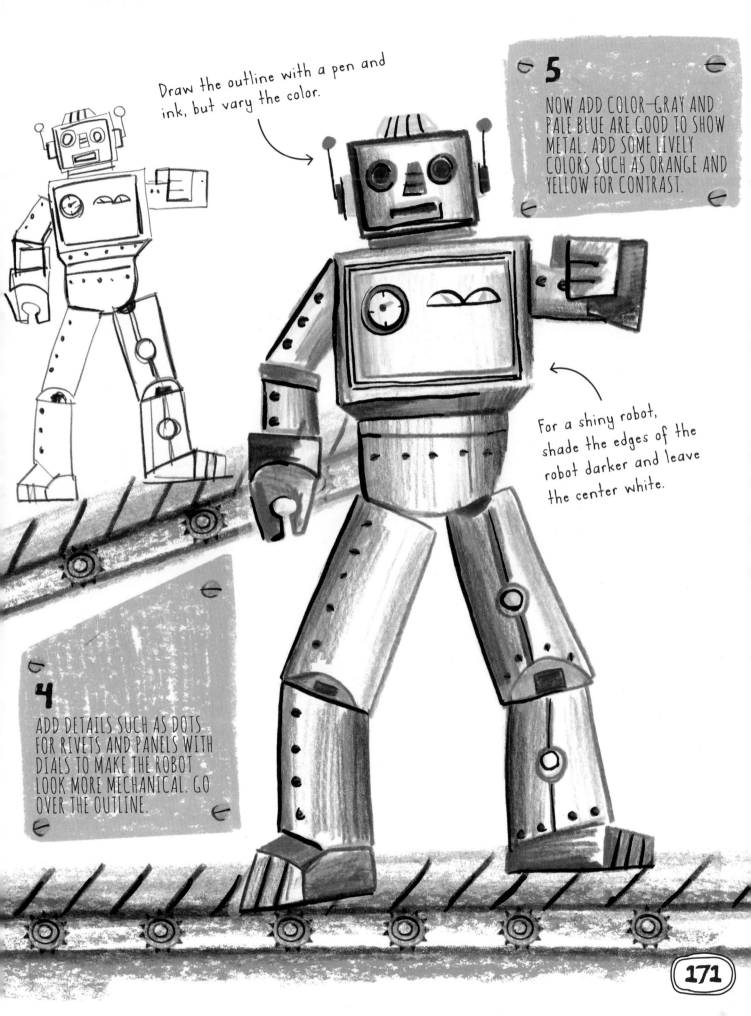

Draw the outline with a pen and ink, but vary the color.

5

NOW ADD COLOR—GRAY AND PALE BLUE ARE GOOD TO SHOW METAL. ADD SOME LIVELY COLORS SUCH AS ORANGE AND YELLOW FOR CONTRAST.

For a shiny robot, shade the edges of the robot darker and leave the center white.

4

ADD DETAILS SUCH AS DOTS FOR RIVETS AND PANELS WITH DIALS TO MAKE THE ROBOT LOOK MORE MECHANICAL. GO OVER THE OUTLINE.

CHIMPANZEE

CHIMPS ARE MOSTLY FOUND IN RAINFORESTS AND WET SAVANNAS. ALTHOUGH OFTEN ON THE GROUND, THEY SPEND MOST OF THEIR TIME FEEDING AND SLEEPING IN TREES!

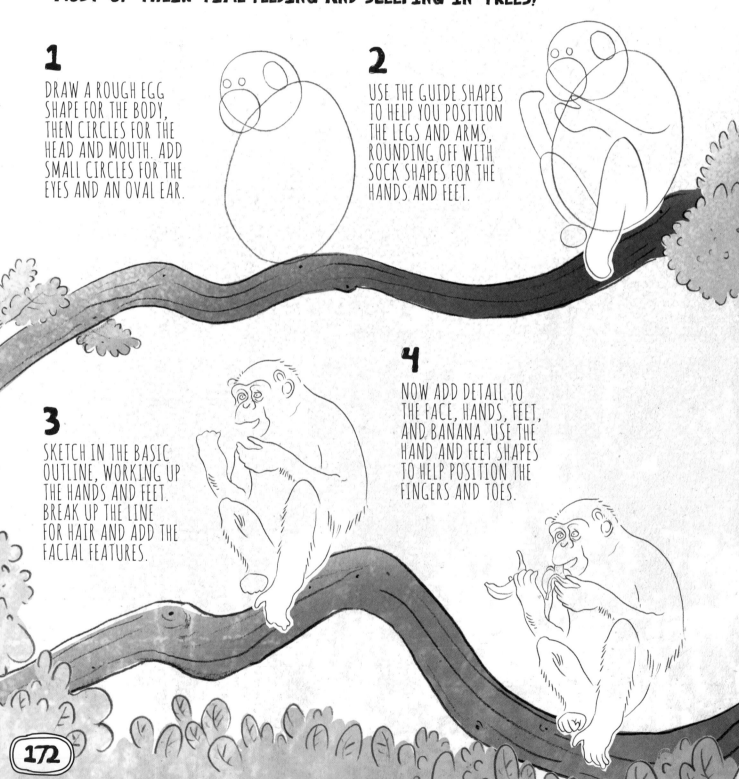

1
DRAW A ROUGH EGG SHAPE FOR THE BODY, THEN CIRCLES FOR THE HEAD AND MOUTH. ADD SMALL CIRCLES FOR THE EYES AND AN OVAL EAR.

2
USE THE GUIDE SHAPES TO HELP YOU POSITION THE LEGS AND ARMS, ROUNDING OFF WITH SOCK SHAPES FOR THE HANDS AND FEET.

3
SKETCH IN THE BASIC OUTLINE, WORKING UP THE HANDS AND FEET. BREAK UP THE LINE FOR HAIR AND ADD THE FACIAL FEATURES.

4
NOW ADD DETAIL TO THE FACE, HANDS, FEET, AND BANANA. USE THE HAND AND FEET SHAPES TO HELP POSITION THE FINGERS AND TOES.

5

TO COLOR, USE A GRAY WATERCOLOR WASH ALL OVER, THEN ADD HAIR STROKES WITH A BLACK PENCIL. USE A PINK PENCIL ON THE FACE, EARS, HANDS, FEET, AND PATCHES OF THE BODY.

Add a lush jungle habitat to your drawing, with a tree branch for the chimpanzee to sit on!

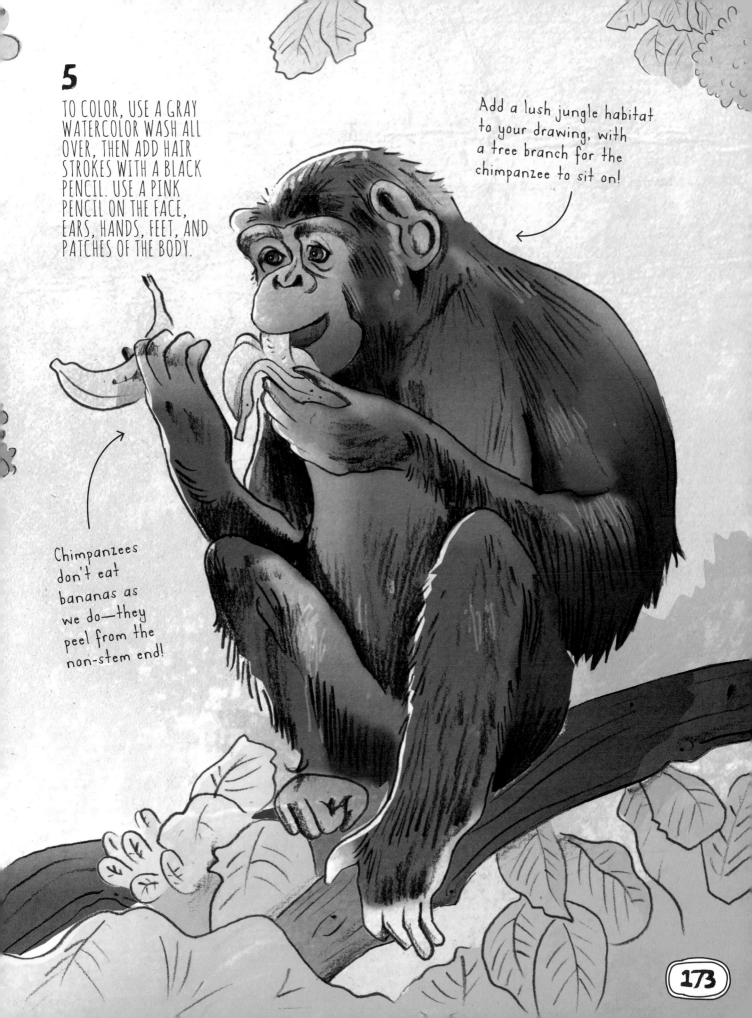

Chimpanzees don't eat bananas as we do—they peel from the non-stem end!

173

CENTAUR

1

USE STRAIGHT AND CURVED LINES TO DRAW A SIMPLE STICK FIGURE LIKE THIS.

2

DRAW CIRCLES AND OVALS TO BUILD UP THE CENTAUR'S BODY SHAPE. THEN SKETCH IN THE ROUGH OUTLINE OF ITS BODY.

3

USE SAUSAGE SHAPES FOR THE LEGS, AND SKETCH CIRCLES AND OVALS FOR THE VARIOUS JOINTS. USE LONG, WAVY LINES TO DRAW THE TAIL.

Only start adding detail when you're happy with the basic shapes of the different body parts.

4

START ON THE MORE DETAILED AREAS, SKETCHING IN THE HANDS, HAIR, AND FACIAL FEATURES. ADD A BELT, BAG STRAP, HEADBAND, AND QUIVER OF ARROWS.

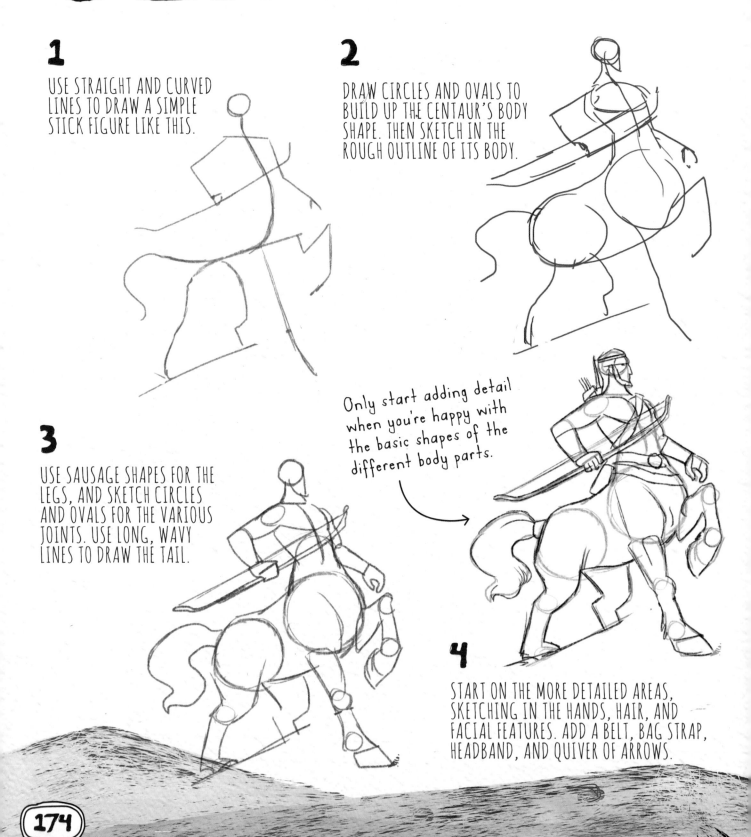

6

TO ADD COLOR, USE A DARK BROWN FOR THE LOWER BODY, WITH LIGHTER SHADES FOR THE HIGHLIGHTS. PICK A SKIN COLOR FOR THE FACE AND CHEST, USING DARKER TONES TO HELP DEFINE THE SHAPES OF THE MUSCLES.

5

ERASE THE GUIDES. REFINE YOUR PENCIL OUTLINES, AND ADD MORE DETAIL TO THE UPPER BODY. USE SHADING TO GIVE THE TAIL AND LOWER BODY A HAIRY TEXTURE.

Use long, wavy, overlapping pencil strokes to create a hairy texture.

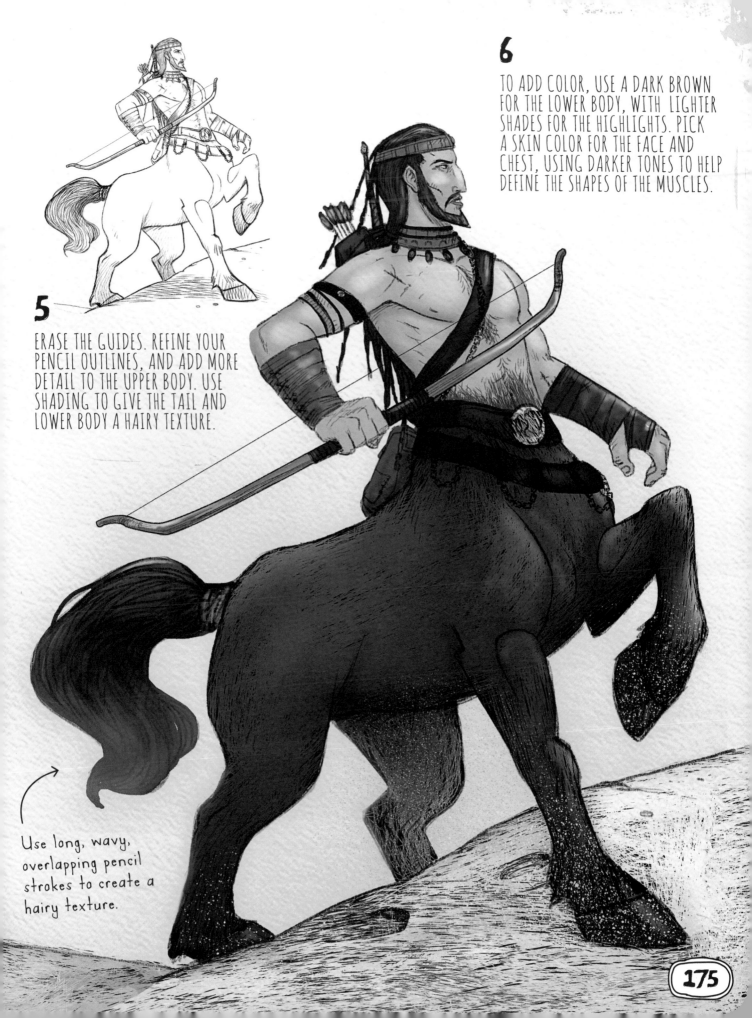

SPEEDBOAT

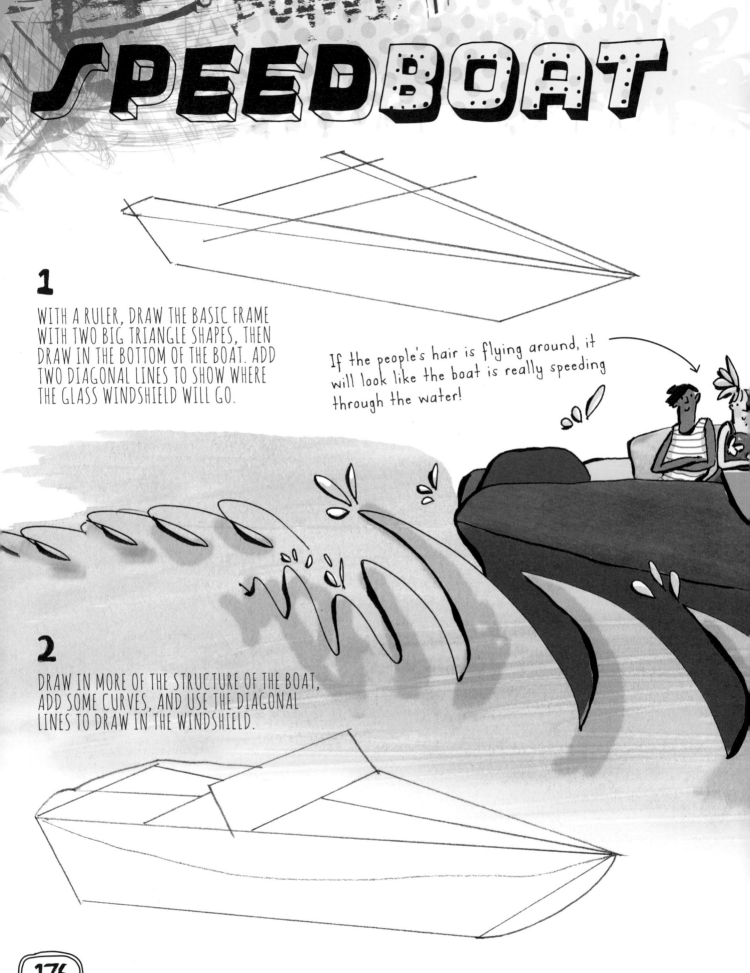

1

WITH A RULER, DRAW THE BASIC FRAME WITH TWO BIG TRIANGLE SHAPES, THEN DRAW IN THE BOTTOM OF THE BOAT. ADD TWO DIAGONAL LINES TO SHOW WHERE THE GLASS WINDSHIELD WILL GO.

If the people's hair is flying around, it will look like the boat is really speeding through the water!

2

DRAW IN MORE OF THE STRUCTURE OF THE BOAT, ADD SOME CURVES, AND USE THE DIAGONAL LINES TO DRAW IN THE WINDSHIELD.

3

ERASE THE LINES YOU DON'T NEED, AND ADD SOME CURVES AND DETAILS. ROUGHLY SKETCH IN WHERE THE PEOPLE WILL SIT IN THE SPEEDBOAT, A STEERING WHEEL, AND MOTOR.

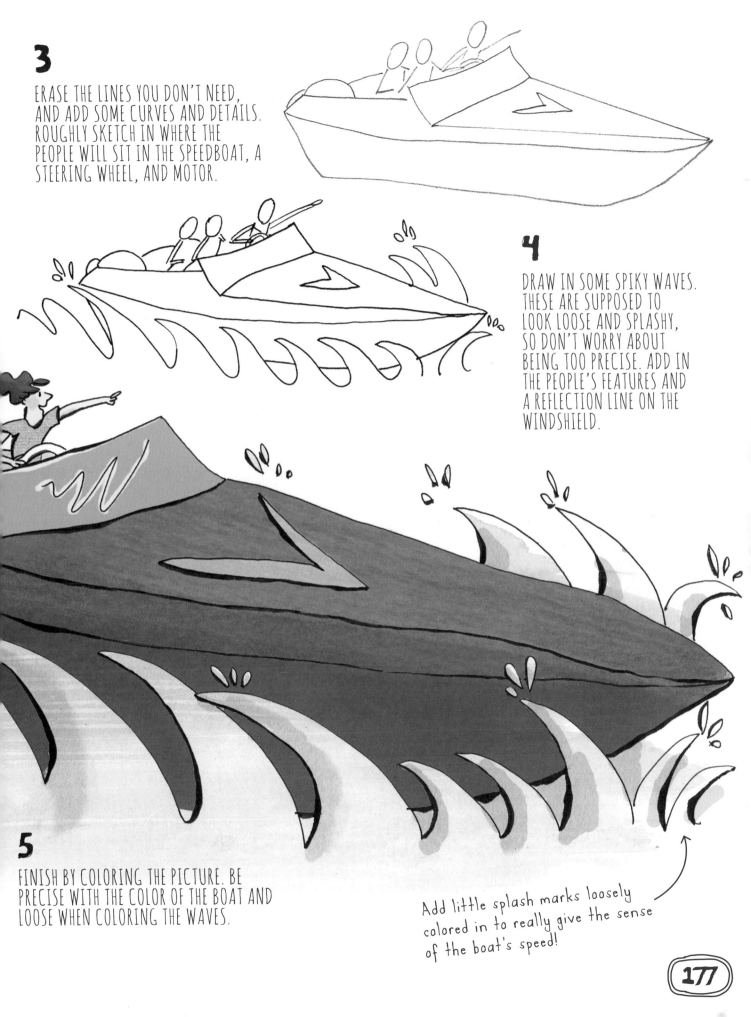

4

DRAW IN SOME SPIKY WAVES. THESE ARE SUPPOSED TO LOOK LOOSE AND SPLASHY, SO DON'T WORRY ABOUT BEING TOO PRECISE. ADD IN THE PEOPLE'S FEATURES AND A REFLECTION LINE ON THE WINDSHIELD.

5

FINISH BY COLORING THE PICTURE. BE PRECISE WITH THE COLOR OF THE BOAT AND LOOSE WHEN COLORING THE WAVES.

Add little splash marks loosely colored in to really give the sense of the boat's speed!

GREAT WHITE SHARK

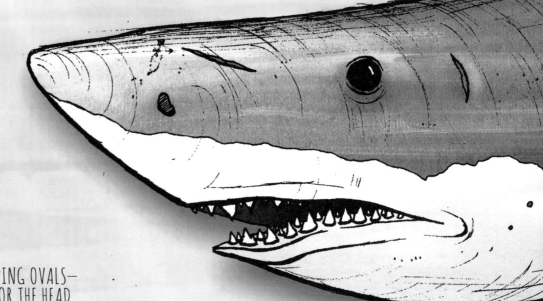

1

START WITH TWO OVERLAPPING OVALS—
A SLIGHTLY POINTED ONE FOR THE HEAD
AND A ROUND ONE FOR THE BODY. ADD
A POINTED OVAL FOR THE TAIL.

2

USE A SOFT PENCIL TO DRAW AROUND
THE SHAPES AND FORM THE OVERALL
OUTLINE. ADD LINES FOR THE MOUTH
AND BASIC POINTED FINS.

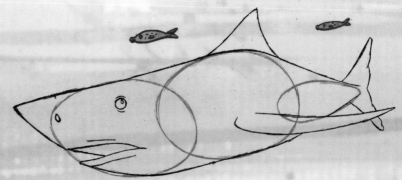

3

COLOR YOUR SHARK WITH A BLUE AND GRAY WASH. ADD WHITE HIGHLIGHTS AND USE A GRAY PENCIL FOR SHADING AND A FEW SCARS.

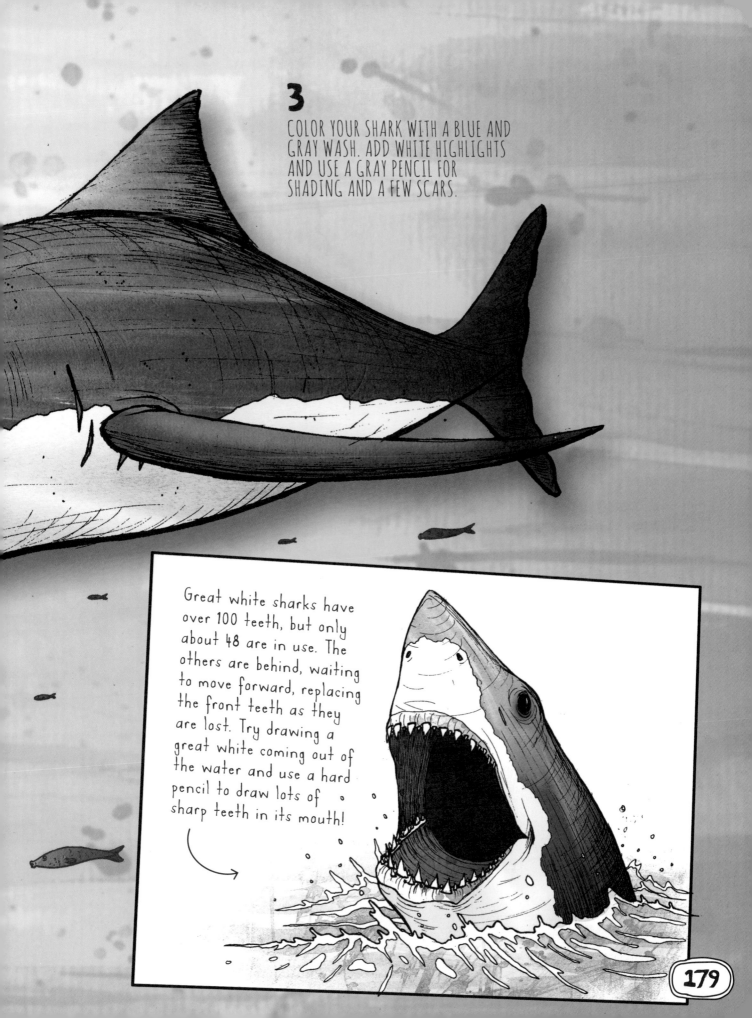

Great white sharks have over 100 teeth, but only about 48 are in use. The others are behind, waiting to move forward, replacing the front teeth as they are lost. Try drawing a great white coming out of the water and use a hard pencil to draw lots of sharp teeth in its mouth!

FEATHERS

1 SKETCH THREE OVERLAPPING ROUGH OVALS. THEN ADD A THIN, CURVED STICK DOWN THE CENTER FOR THE FEATHER'S SHAFT AND QUILL.

2 DRAW A WAVY OUTLINE AROUND THE OVAL SHAPES, ADDING GAPS AND SPIKY PARTS FOR A FEATHERY OUTER TEXTURE. ERASE THE GUIDELINES.

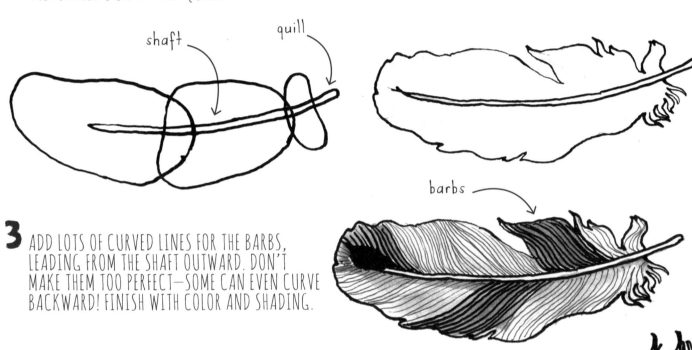

shaft

quill

barbs

3 ADD LOTS OF CURVED LINES FOR THE BARBS, LEADING FROM THE SHAFT OUTWARD. DON'T MAKE THEM TOO PERFECT—SOME CAN EVEN CURVE BACKWARD! FINISH WITH COLOR AND SHADING.

PEACOCK FEATHER
Start with a lollipop shape. Add wavy barbs around the outside and an oval and pie shape in the middle. Color with rich greens, yellows, and blues.

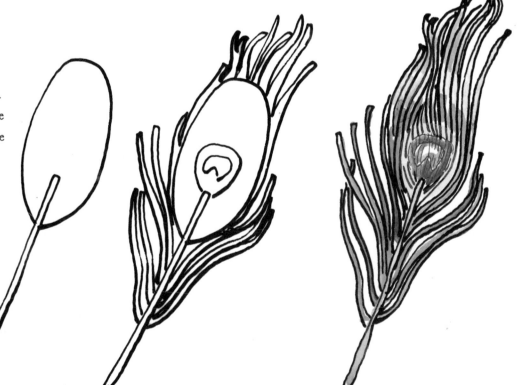

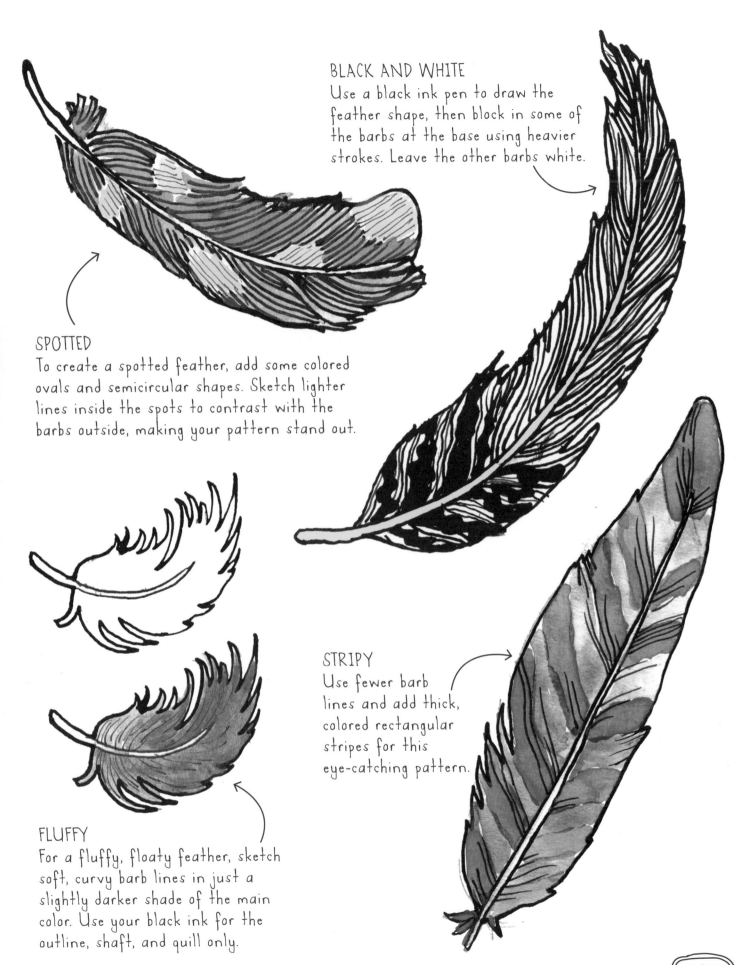

BLACK AND WHITE
Use a black ink pen to draw the feather shape, then block in some of the barbs at the base using heavier strokes. Leave the other barbs white.

SPOTTED
To create a spotted feather, add some colored ovals and semicircular shapes. Sketch lighter lines inside the spots to contrast with the barbs outside, making your pattern stand out.

STRIPY
Use fewer barb lines and add thick, colored rectangular stripes for this eye-catching pattern.

FLUFFY
For a fluffy, floaty feather, sketch soft, curvy barb lines in just a slightly darker shade of the main color. Use your black ink for the outline, shaft, and quill only.

DrAGON

Try adding a castle to the background. Build up your design by joining basic shapes together, such as boxes, cones, and cylinders.

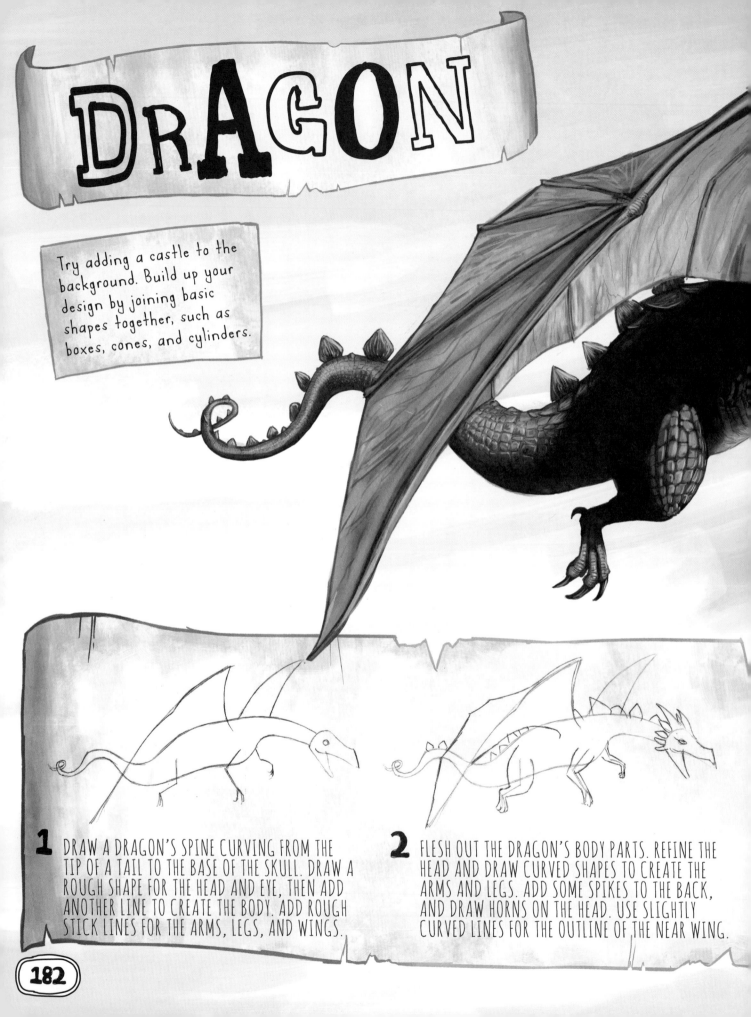

1 DRAW A DRAGON'S SPINE CURVING FROM THE TIP OF A TAIL TO THE BASE OF THE SKULL. DRAW A ROUGH SHAPE FOR THE HEAD AND EYE, THEN ADD ANOTHER LINE TO CREATE THE BODY. ADD ROUGH STICK LINES FOR THE ARMS, LEGS, AND WINGS.

2 FLESH OUT THE DRAGON'S BODY PARTS. REFINE THE HEAD AND DRAW CURVED SHAPES TO CREATE THE ARMS AND LEGS. ADD SOME SPIKES TO THE BACK, AND DRAW HORNS ON THE HEAD. USE SLIGHTLY CURVED LINES FOR THE OUTLINE OF THE NEAR WING.

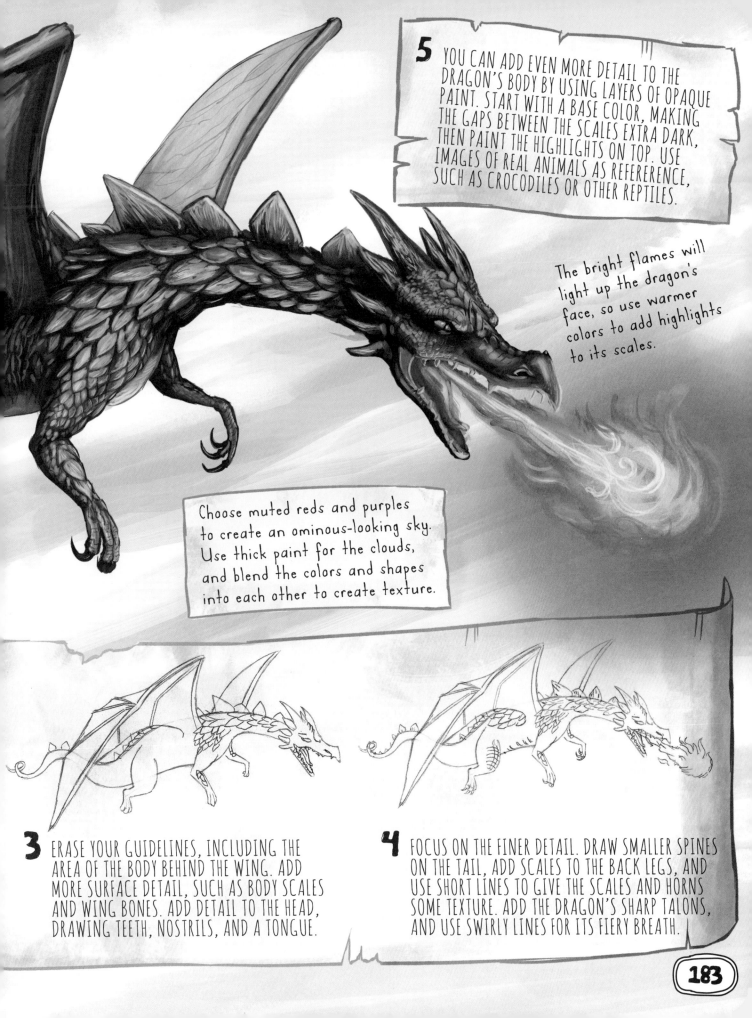

5 YOU CAN ADD EVEN MORE DETAIL TO THE DRAGON'S BODY BY USING LAYERS OF OPAQUE PAINT. START WITH A BASE COLOR, MAKING THE GAPS BETWEEN THE SCALES EXTRA DARK, THEN PAINT THE HIGHLIGHTS ON TOP. USE IMAGES OF REAL ANIMALS AS REFERERENCE, SUCH AS CROCODILES OR OTHER REPTILES.

The bright flames will light up the dragon's face, so use warmer colors to add highlights to its scales.

Choose muted reds and purples to create an ominous-looking sky. Use thick paint for the clouds, and blend the colors and shapes into each other to create texture.

3 ERASE YOUR GUIDELINES, INCLUDING THE AREA OF THE BODY BEHIND THE WING. ADD MORE SURFACE DETAIL, SUCH AS BODY SCALES AND WING BONES. ADD DETAIL TO THE HEAD, DRAWING TEETH, NOSTRILS, AND A TONGUE.

4 FOCUS ON THE FINER DETAIL. DRAW SMALLER SPINES ON THE TAIL, ADD SCALES TO THE BACK LEGS, AND USE SHORT LINES TO GIVE THE SCALES AND HORNS SOME TEXTURE. ADD THE DRAGON'S SHARP TALONS, AND USE SWIRLY LINES FOR ITS FIERY BREATH.

GRASSHOPPER

THE MOST FREQUENTLY SEEN GRASSHOPPER, THE COMMON FIELD GRASSHOPPER, IS A LARGE INSECT FOUND ACROSS EUROPE, ASIA, AND NORTH AFRICA!

A grasshopper's two back legs are long and powerful for jumping, so don't worry if they look out of proportion compared to the body!

1

BEGIN BY DRAWING A LONG, VERTICAL SAUSAGE SHAPE, THEN ADD A SMALL SQUASHED CIRCLE ON TOP OF IT FOR THE GRASSHOPPER'S HEAD.

2

DRAW TWO LINES—ONE TO DIVIDE THE SAUSAGE SHAPE VERTICALLY AND ONE ANGLED LINE NEAR THE TOP. ROUGH OUT THE POSITIONS OF THE LEGS.

Common field grasshoppers live on a diet of grass, leaves, herbs, shrubs, and bark. Try adding a blade of grass for your grasshopper to munch on!

3

WORK UP THE OUTLINE AND MAKE THE SEGMENTS AND PLATES ON THE BODY BOLDER. DRAW IN AN ALMOND-SHAPED EYE AND A COUPLE OF LONG ANTENNAE ON ITS HEAD.

4

SHADE THE BODY WITH A GREEN PEN. DRAW CROSSHATCHED LINES ON THE WINGS IN A DARKER GREEN OR BROWN. SHADE IN THE EYE A COPPER COLOR.

STREET ART

TRY DRAWING SOME GRAFFITI ART—WHERE IT'S ALLOWED, OF COURSE! BEFORE YOU ATTEMPT A MORE DETAILED COMPOSITION, PRACTICE DRAWING THESE SIMPLE 3D SHAPES WITH A BLACK PEN OR INK.

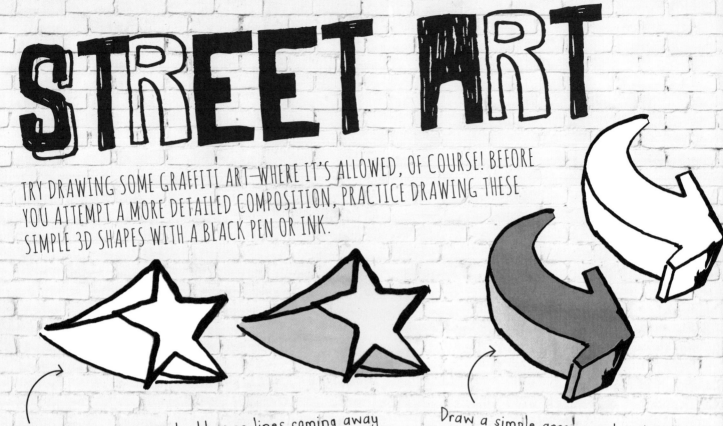

Draw a star shape, and add some lines coming away from three of the points, as shown. Create a 3D effect by making the star a lighter color than its tail.

Draw a simple arrow, and make it look 3D by adding lines underneath that follow the same basic shape.

A doughnut is basically an oval shape. Draw a hole in the middle, and add some messy frosting and perhaps a few sprinkles.

The popsicle is simply a rectangular shape curved at the top. Draw a line below to achieve the 3D effect, and add a stick and a little shading.

This waffle cone is a semicircle attached to a triangle. Use some simple crosshatching to create the cone texture, then add an ice-cream peak on top.

GRAFFITI AREA

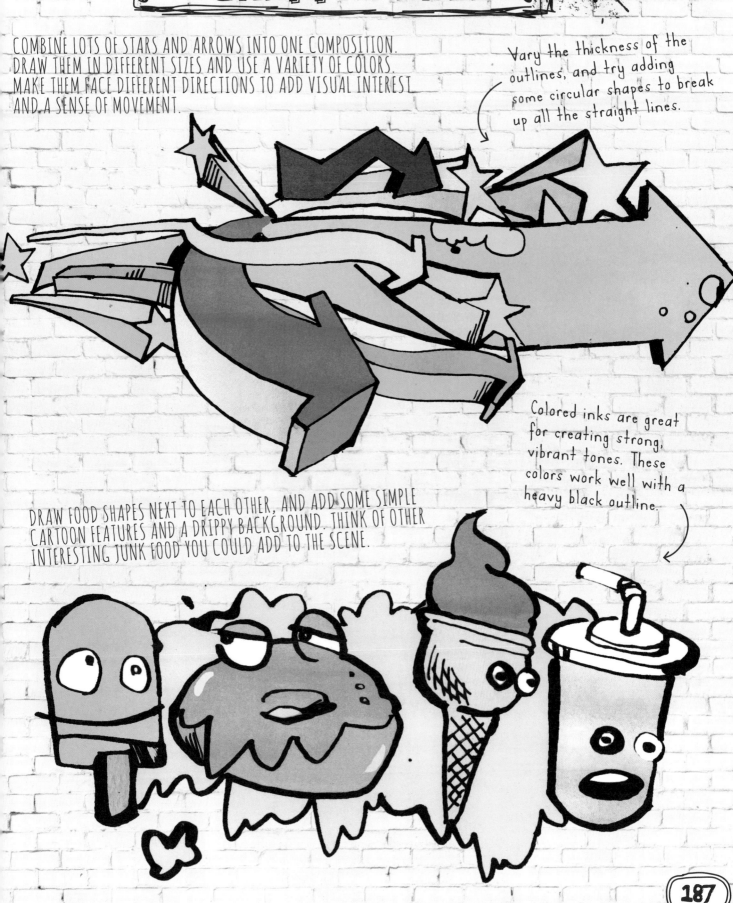

COMBINE LOTS OF STARS AND ARROWS INTO ONE COMPOSITION. DRAW THEM IN DIFFERENT SIZES AND USE A VARIETY OF COLORS. MAKE THEM FACE DIFFERENT DIRECTIONS TO ADD VISUAL INTEREST AND A SENSE OF MOVEMENT.

Vary the thickness of the outlines, and try adding some circular shapes to break up all the straight lines.

Colored inks are great for creating strong, vibrant tones. These colors work well with a heavy black outline.

DRAW FOOD SHAPES NEXT TO EACH OTHER, AND ADD SOME SIMPLE CARTOON FEATURES AND A DRIPPY BACKGROUND. THINK OF OTHER INTERESTING JUNK FOOD YOU COULD ADD TO THE SCENE.

COOL SHADES

TRY SKETCHING A SIMPLE PAIR OF GLASSES, THEN GET CREATIVE AND VARY THESE FOR SOME OF YOUR OWN COOL DESIGNS.

1 SKETCH TWO ROUNDED LENS SHAPES, THEN DRAW AN EXTRA LINE AROUND EACH ONE TO CREATE THE FRAMES. ADD A BRIDGE WHERE THE SHADES SIT ON THE NOSE, PLUS AN EXTRA BAR ABOVE THAT, IF YOU WANT.

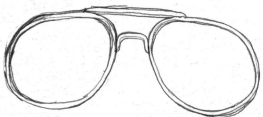

2 DRAW THE ARMS OF YOUR GLASSES. THEY WILL BE PARTIALLY VISIBLE THROUGH THE SHADES, SO ADD A CROSSHATCH EFFECT ON THE LENSES, LEAVING CERTAIN AREAS WHITE TO GIVE THE EFFECT OF REFLECTIONS ON THE GLASS.

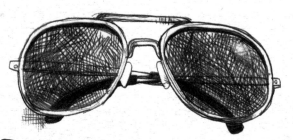

3 TRY DRAWING THE SAME PAIR OF GLASSES FROM A SIDEWAYS PERSPECTIVE WITH THE ARMS STRAIGHTENED OUT, LIKE THIS. THE LENS AND ARM NEAREST TO US WILL NEED TO LOOK SLIGHTLY BIGGER.

NOW THINK ABOUT HOW YOUR SHADES WILL LOOK ON SOMEONE'S FACE. HOW REFLECTIVE OR TRANSPARENT WILL THEY BE?

You could draw your shades as flat, black circles. Add narrow bands of white for reflections.

When drawing shades in profile, the nearer lens will look more like an ellipse. The other will only be partially visible.

To draw highly reflective glasses, add white, wavy bands on top of a dark base color.

SHADES CAN BE PLAIN OR PATTERNED, AND CAN COME IN ALL KINDS OF SHAPES AND SIZES ...

STANDARD SHAPE

STANDARD FRAMES ARE BASICALLY SQUARES WITH CURVED EDGES. EXPERIMENT WITH DIFFERENT SHAPES, CHOOSING HEAVY BLACK FRAMES, OR EVEN ONES WITH AN UNUSUAL STRIPED EFFECT!

SECRET AGENT

STRIPY

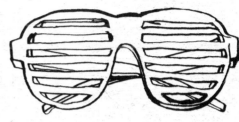

PATTERNED SHADES

A SIMPLE REPEATED MOTIF IS GOOD FOR DECORATING YOUR FRAMES, SUCH AS THESE THIN LINES. YOU COULD ALSO TRY GIVING YOUR FRAMES A MOTTLED PAINT EFFECT.

HALF-PATTERNED FRAMES

PATTERNED LENSES

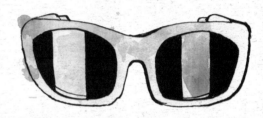

SHAPED FRAMES

PLAY AROUND WITH DIFFERENT SHAPES AND STYLES. FROM POINTY EDGES TO LOVE HEARTS, THEY CAN BE ANY SHAPE YOU LIKE.

DIAMANTÉ BLING

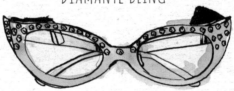

LOVE HEARTS

POP IDOL

SQUARE

STARS

STATEMENT SHADES

EVEN A BASIC STYLE OF FRAME CAN BE LIVENED UP BY ADDING QUIRKY DETAILS OR A REFLECTIVE PATTERN TO THE LENSES.

WACKY WINDSHIELD WIPERS

SKI CHIC

KOMODO DRAGON

1

DRAW A SMALL CIRCLE FOR THE HEAD AND A LARGER CIRCLE FOR THE BODY. ADD ROUGH GUIDELINES FOR THE SPINE, LEGS, AND TAIL.

2

USING A SOFT PENCIL, SKETCH AROUND THE GUIDE SHAPES AND LINES TO CREATE AN OUTLINE OF THE BULKY BODY.

The Komodo dragon's thick, muscular tail is as long as its body!

3

NEXT, USE A HARD PENCIL TO FURTHER REFINE THE OUTLINE. ADD CLAWS ON EACH FOOT, AND EYES, NOSTRILS, AND MOUTH ON THE FACE.

THE KOMODO DRAGON IS THE LARGEST AND MOST POWERFUL LIZARD. ITS NATURAL HABITAT IS THE INDONESIAN ISLAND OF KOMODO, SO DRAW YOURS ON A BEACH!

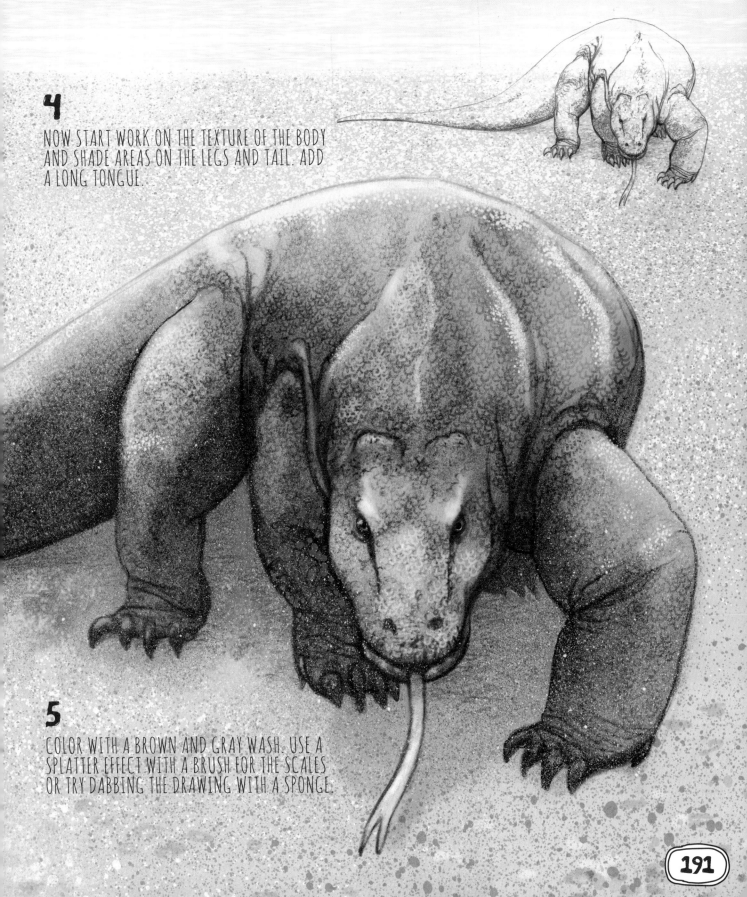

4
NOW START WORK ON THE TEXTURE OF THE BODY AND SHADE AREAS ON THE LEGS AND TAIL. ADD A LONG TONGUE..

5
COLOR WITH A BROWN AND GRAY WASH. USE A SPLATTER EFFECT WITH A BRUSH FOR THE SCALES OR TRY DABBING THE DRAWING WITH A SPONGE.

WEATHER

DIFFERENT ELEMENTS CAN GIVE THE SAME SCENE A VERY DIFFERENT FEEL!

RAIN

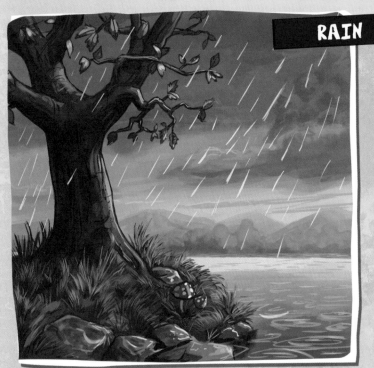

DRAW LONG, SLOPING LINES TO CREATE RAIN. PAINT THEM A LIGHT COLOR TO MAKE THEM STAND OUT AGAINST DARK STORM CLOUDS.

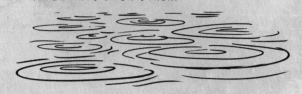

PAINT THE TREE AND GRASS WITH DARK TONES.

DRAW RIPPLES ON WATER BY SKETCHING CONCENTRIC CIRCLES THAT RADIATE OUTWARD AND MERGE INTO EACH OTHER.

WIND

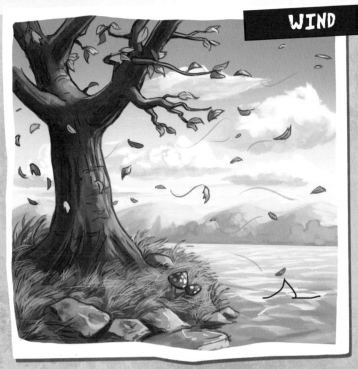

THE WIND MAKES THE TREES, FLOWERS, AND GRASS BEND IN THE SAME DIRECTION.

USER BRIGHTER COLORS FOR THE TREE AND GRASS FOR A SUNNY BUT BLUSTERY DAY.

DRAW LEAVES DANCING IN THE AIR TO GIVE THE IMPRESSION OF A STRONG BREEZE. GIVE SOME OF THEM WAVY TRAILS TO ADD MOVEMENT.

ELECTRIC STORM

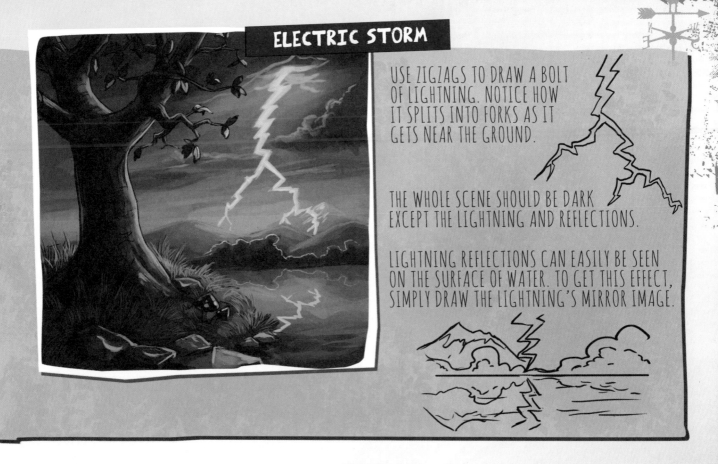

USE ZIGZAGS TO DRAW A BOLT OF LIGHTNING. NOTICE HOW IT SPLITS INTO FORKS AS IT GETS NEAR THE GROUND.

THE WHOLE SCENE SHOULD BE DARK EXCEPT THE LIGHTNING AND REFLECTIONS.

LIGHTNING REFLECTIONS CAN EASILY BE SEEN ON THE SURFACE OF WATER. TO GET THIS EFFECT, SIMPLY DRAW THE LIGHTNING'S MIRROR IMAGE.

SNOW AND ICE

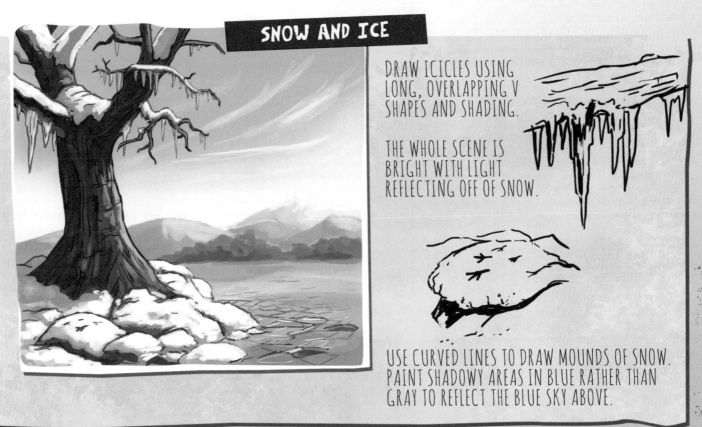

DRAW ICICLES USING LONG, OVERLAPPING V SHAPES AND SHADING.

THE WHOLE SCENE IS BRIGHT WITH LIGHT REFLECTING OFF OF SNOW.

USE CURVED LINES TO DRAW MOUNDS OF SNOW. PAINT SHADOWY AREAS IN BLUE RATHER THAN GRAY TO REFLECT THE BLUE SKY ABOVE.

GYROCOPTER

A GYROCOPTER LOOKS SIMILAR TO A HELICOPTER AND WAS INVENTED SO PEOPLE COULD FLY THROUGH THE AIR SAFELY AT A SLOW SPEED. DRAW ONE YOURSELF, AS SLOWLY—OR QUICKLY—AS YOU LIKE!

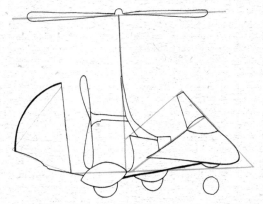

1

SKETCH OUT THE BASIC SHAPES OF THE GYROCOPTER WITH A PENCIL: USE A RULER TO HELP YOU DRAW A T SHAPE, AND ADD TWO OTHER TRIANGLE SHAPES AT EITHER SIDE, PLUS AN L SHAPE TO CONNECT ONE OF THE TRIANGLES.

2

DRAW IN THE OTHER DETAILS TO YOUR FLYING MACHINE IN PENCIL. THERE ARE LOTS OF CURVED SHAPES FOR THE WHEELS, WINGS, AND BODY. ADD TWO PROPELLERS AT THE TOP OF THE GYROCOPTER, TOO.

5

DRAW IN BLACK DOTS AROUND THE FLYING MACHINE. THIS IS A QUICK AND EASY WAY TO MAKE THE DRAWING LOOK INCREDIBLY DETAILED AND TECHNICAL.

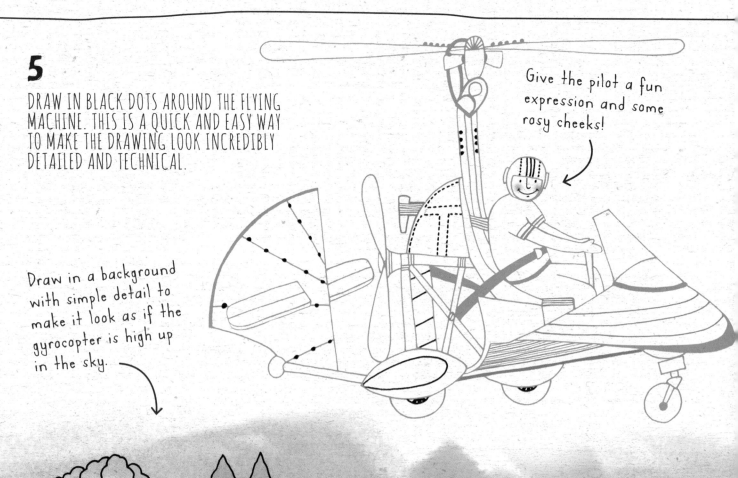

Give the pilot a fun expression and some rosy cheeks!

Draw in a background with simple detail to make it look as if the gyrocopter is high up in the sky.

3

ADD DETAIL TO THE GYROCOPTER TO MAKE IT LOOK REAL.
DRAW IN THE PILOT, THEN DRAW IN THE SAFETY BELT
AND THE MECHANISM THAT RUNS THE TOP PROPELLER.

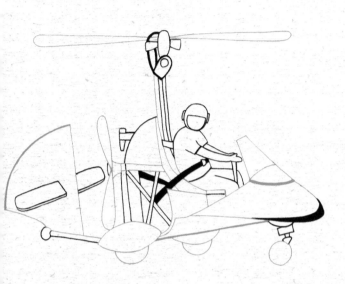

4

ADD MORE DETAIL IN STAGES. BUILD UP THE FINER
TECHNICAL BITS, SUCH AS THE LINES ON THE
WINGS AND THE PARTS AROUND THE PROPELLERS.

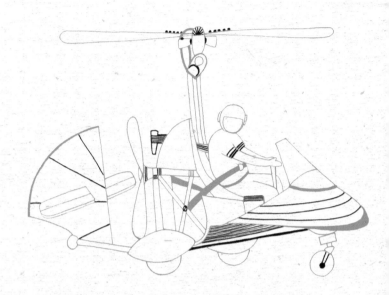

6

USE A FINE-TIP PEN TO
COMPLETE THE DRAWING.
USING DIFFERENT
THICKNESSES OF PEN IS
USEFUL TO ADD VARIETY
TO THE DRAWING. IF YOU
DON'T HAVE DIFFERENT
PENS, JUST USE A THIN
PEN AND GO OVER SOME
LINES A FEW TIMES TO
THICKEN THEM UP.

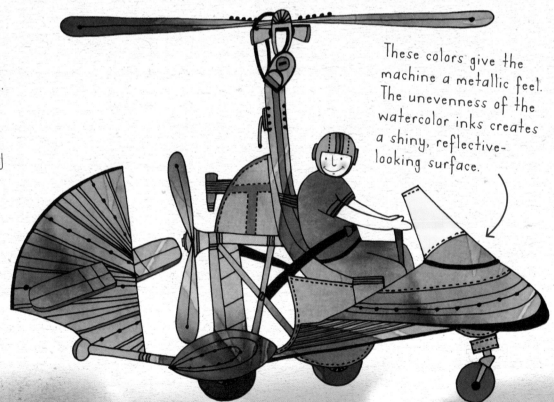

These colors give the
machine a metallic feel.
The unevenness of the
watercolor inks creates
a shiny, reflective-
looking surface.

BROWN BEAR

1

START WITH ONE CIRCLE FOR THE BEAR'S HEAD AND ONE FOR ITS REAR. CONNECT WITH ROUGH LINES. ADD IN FOUR LEG SHAPES, TWO EARS, AND A SHORT SNOUT.

THIS BROWN BEAR IS TRYING TO CATCH SALMON MIDAIR AS THEY JUMP UP THE WATERFALLS!

2

CREATE THE OUTLINE OF THE BEAR BY DRAWING ROUGH PENCIL MARKS TO GIVE THE IMPRESSION OF FUZZY FUR. ADD IN ROUGH EYES AND A SMALL NOSE, AND WORK UP THE MOUTH.

3

ERASE THE GUIDELINES AND FILL THE BEAR'S BODY WITH LOTS OF LINES TO SHOW FUR. ADD IN MORE DETAILS, SUCH AS A FEW TEETH AND SHADING UNDERNEATH ITS BODY.

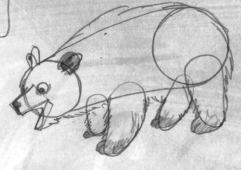

These salmon are moving upstream to lay their eggs. Add a few to your drawing for your hungry bear!

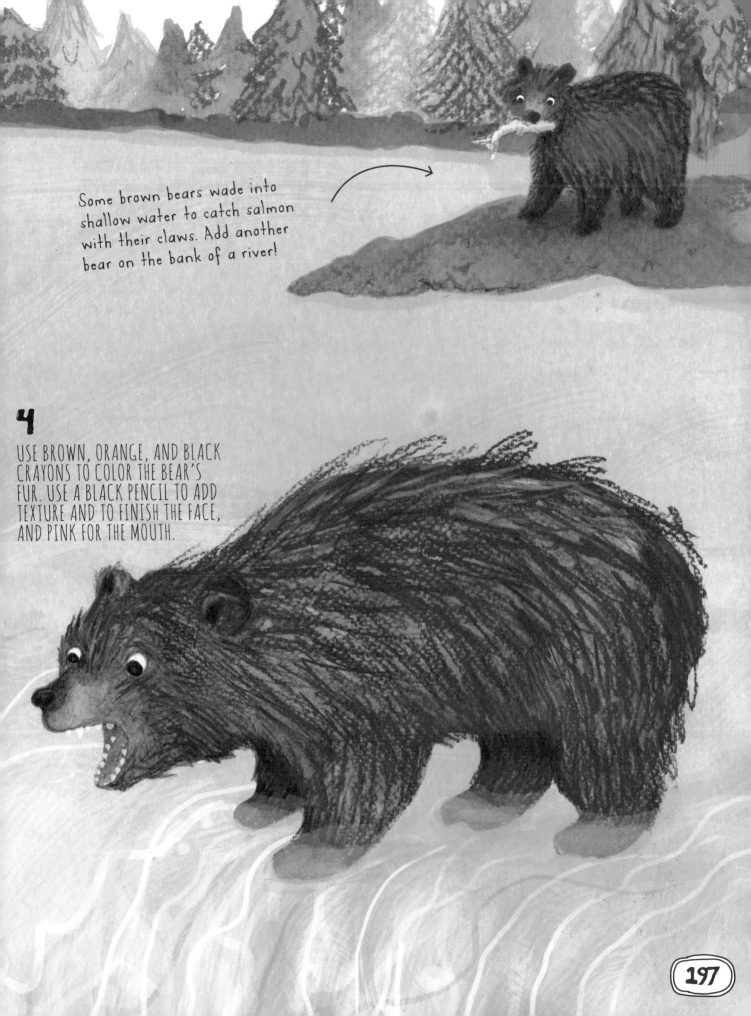

Some brown bears wade into shallow water to catch salmon with their claws. Add another bear on the bank of a river!

4

USE BROWN, ORANGE, AND BLACK CRAYONS TO COLOR THE BEAR'S FUR. USE A BLACK PENCIL TO ADD TEXTURE AND TO FINISH THE FACE, AND PINK FOR THE MOUTH.

EGYPT

LEARN TO DRAW
THE ELEMENTS OF
ANCIENT EGYPT
AND DRAW LIKE AN
EGYPTIAN!

HIEROGLYPHICS: Ancient Egyptians used pictures of objects, people, and animals as a writing system. Draw bold, black lines and curves to create your own hieroglyphs.

ANCIENT EGYPTIAN WOMAN: Try drawing this figure with long, smooth lines. Use a limited color palette of bright yellows, oranges, and blues to give your painting authenticity.

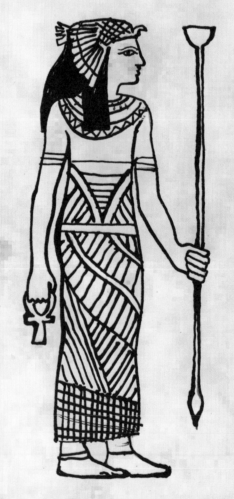
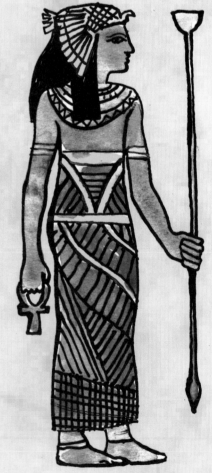

SPHINX: Draw this human-lion hybrid statue in bold, simple lines. Keep the facial features simple, using curved lines for the eyes, nose, and mouth.

Color your sphinx with a mix of yellow watercolor and yellow ocher for a sandy, desertlike wash. Add a little brown shading to give your picture more depth.

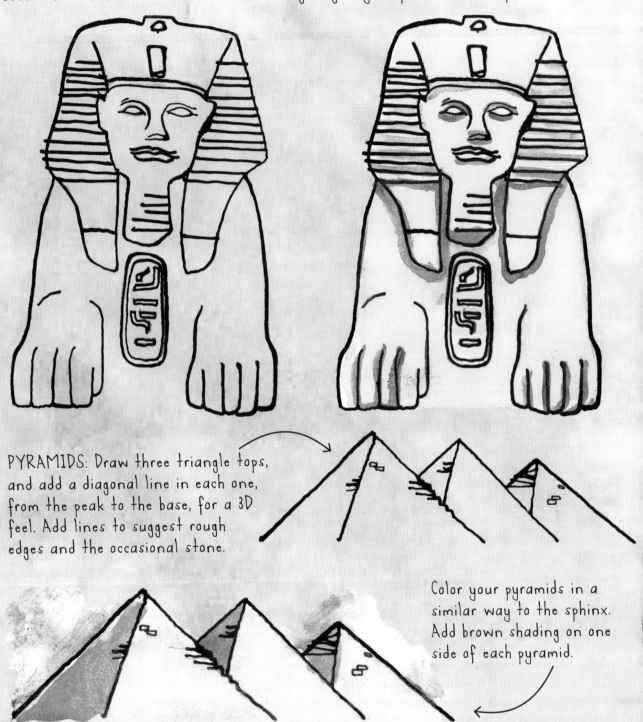

PYRAMIDS: Draw three triangle tops, and add a diagonal line in each one, from the peak to the base, for a 3D feel. Add lines to suggest rough edges and the occasional stone.

Color your pyramids in a similar way to the sphinx. Add brown shading on one side of each pyramid.

Find photos of Egyptology online or in books to help inspire your drawings!

URBAN BRIDGE

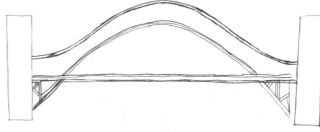

1 DRAW A WIDE TRIANGLE SHAPE WITH THE TOP POINT ROUNDED OFF. ADD AN OVERLAPPING RECTANGLE SHAPE AT BOTH ENDS.

2 DRAW MORE CURVES ABOVE AND BELOW YOUR GUIDE ARCH. LEVEL OFF THE TOP CURVE ENDS. ADD MORE HORIZONTAL LINES ALONG THE BOTTOM OF THE TRIANGLE FOR THE ROAD, AND ADD SETS OF DIAGONAL LINES FOR THE FRAMEWORK BELOW. ERASE ANY UNWANTED GUIDELINES.

Use dark lines and shadows to make some elements of your drawing fade into the background. Here, the blackened bars help the red ones in the foreground to stand out.

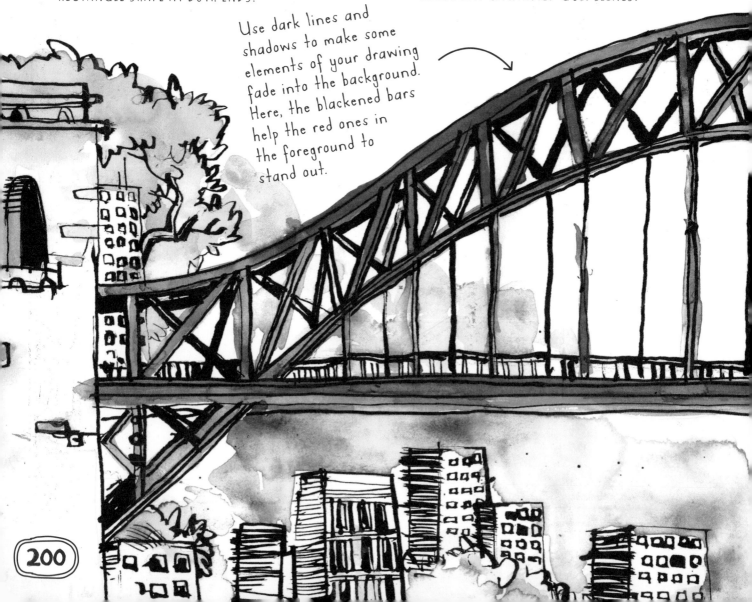

3 DRAW A SEQUENCE OF CRISSCROSSING BARS TO FILL THE GAP BETWEEN THE TWO CURVED SHAPES. ADD A LITTLE SHADING HERE AND THERE TO CREATE A 3D EFFECT.

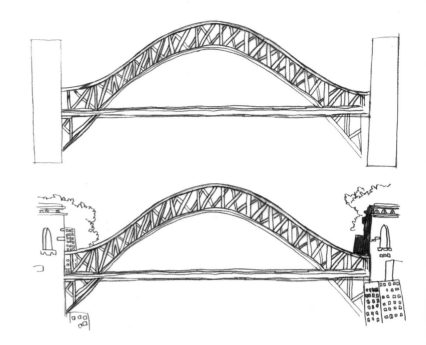

4 TURN THE RECTANGLES INTO BUILDINGS BY ADDING WINDOWS AND STONEWORK DETAIL. SKETCH ROUGH OUTLINES OF A COUPLE OF TREES BEHIND. ADD SOME APARTMENT BUILDINGS BELOW BY DRAWING A FEW VERTICAL RECTANGLES. THEN ADD ROUGH SQUARE SHAPES FOR WINDOWS.

Draw a few leaves here and there, then paint a yellowy-green wash. Draw some jaggedy, inky lines for leafless branches.

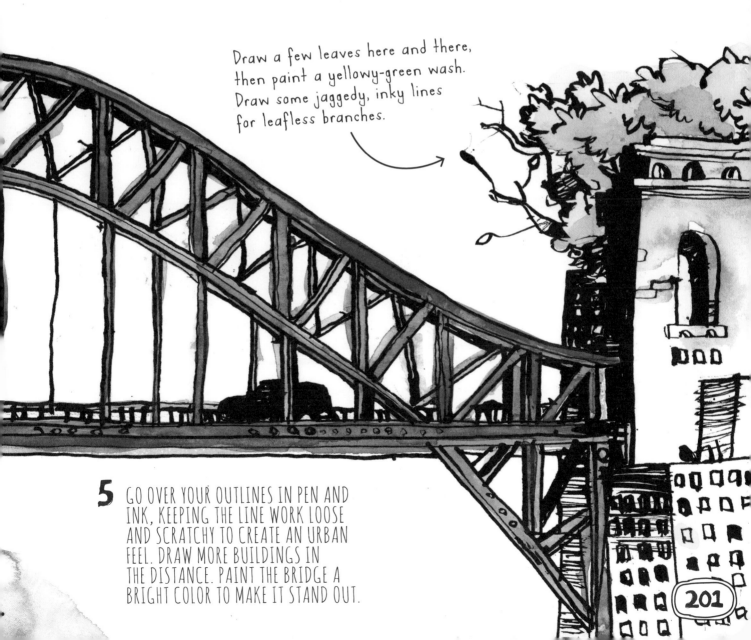

5 GO OVER YOUR OUTLINES IN PEN AND INK, KEEPING THE LINE WORK LOOSE AND SCRATCHY TO CREATE AN URBAN FEEL. DRAW MORE BUILDINGS IN THE DISTANCE. PAINT THE BRIDGE A BRIGHT COLOR TO MAKE IT STAND OUT.

GIRAFFE

EACH SPECIES OF GIRAFFE HAS A CHARACTERISTIC COLOR AND PATTERN. THIS ONE IS A WEST AFRICAN GIRAFFE, WHICH HAS LIGHT-COLORED SPOTS.

A neat pattern of large reddish-brown patches, with bright white borders.

Blotched pale brown spots with darker centers and off-white borders.

WEST AFRICAN

RETICULATED

SOUTH AFRICAN

1

USE ROUGH GUIDE SHAPES AND LINES TO CREATE THE BASIC GIRAFFE FRAME.

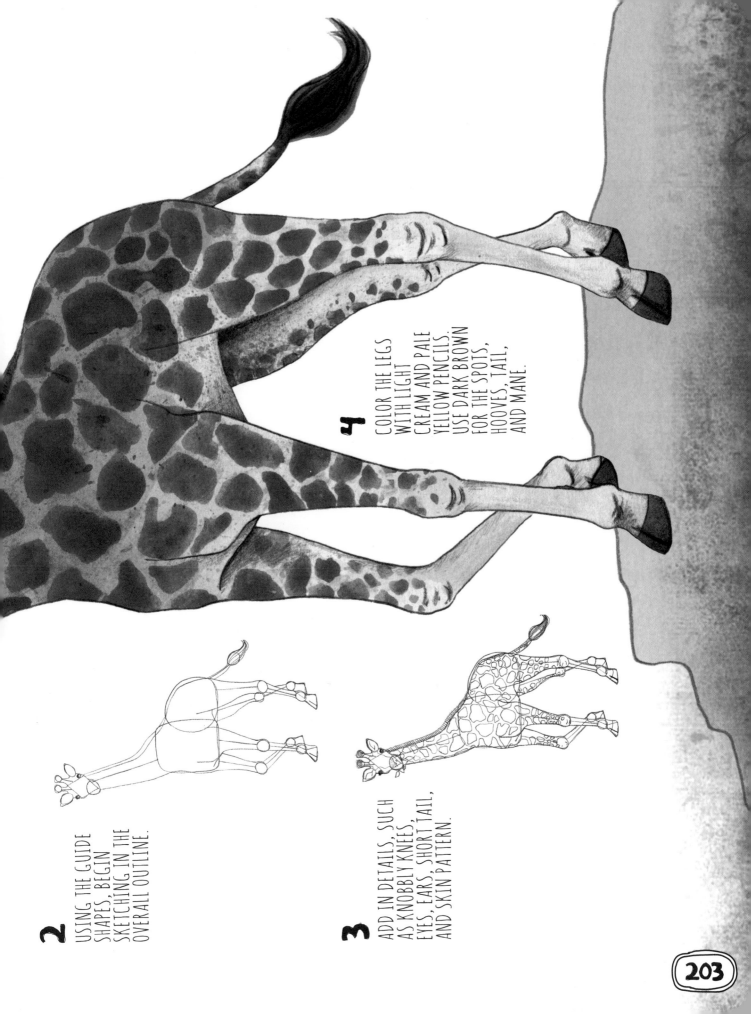

4

COLOR THE LEGS WITH LIGHT CREAM AND PALE YELLOW PENCILS. USE DARK BROWN FOR THE SPOTS, HOOVES, TAIL, AND MANE.

2

USING THE GUIDE SHAPES, BEGIN SKETCHING IN THE OVERALL OUTLINE.

3

ADD IN DETAILS, SUCH AS KNOBBLY KNEES, EYES, EARS, SHORT TAIL, AND SKIN PATTERN.

DESERT ISLAND

MIX DIFFERENT TECHNIQUES TO CREATE THIS FANTASY SCENE.

Start with simple outlines for the trunks and leaves of palm trees. Use a bristly brush when you paint the leaves.

Draw a pencil outline of a raft, then go over it in ink. Don't worry if your line work looks rough—that's authentic!

Find some reference images online to help you draw different kinds of fish.

 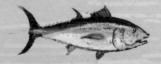

Use subtle blues and greens for the sea. Add white highlights on top to give the effect of light reflecting on the rippling water.

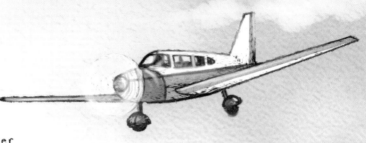

Draw a plane flying overhead to give the scene more of a story. What other vehicles or objects could you add?

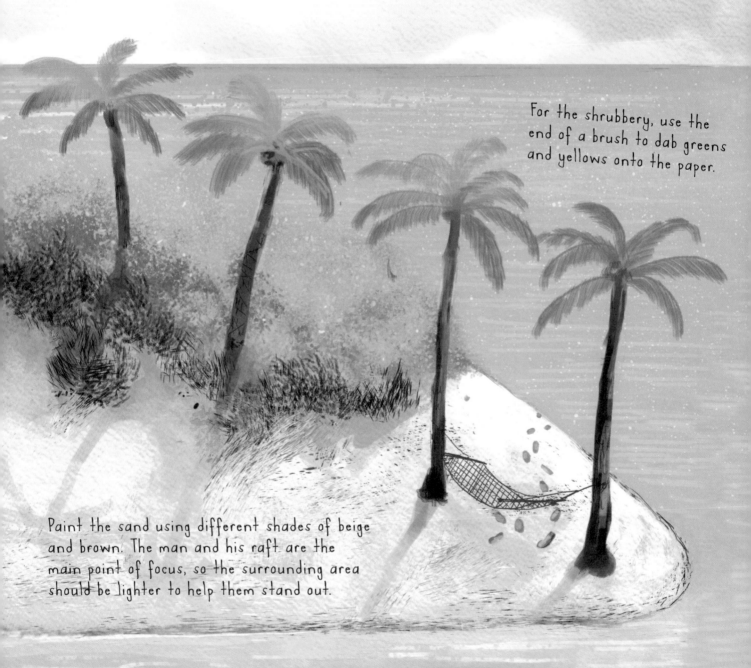

For the shrubbery, use the end of a brush to dab greens and yellows onto the paper.

Paint the sand using different shades of beige and brown. The man and his raft are the main point of focus, so the surrounding area should be lighter to help them stand out.

How about a message in a bottle in your scene? Add ink marks to make it look old, plus highlights to make the surface look like glass.

205

FRENCH CAFÉ

THIS CHIC FRENCH CAFÉ MIGHT LOOK A LITTLE COMPLICATED TO DRAW, BUT EACH OBJECT IN THE PICTURE IS ACTUALLY MADE UP OF RELATIVELY SIMPLE SHAPES. PRACTICE SKETCHING EACH ELEMENT ON ITS OWN, THEN BRING EVERYTHING TOGETHER TO CREATE A PERFECT PARISIAN SCENE!

Make the café look farther away than the people by positioning the building halfway up the page. Use a thick pencil outline for the building, picking out certain shapes in pen and ink.

For the umbrella, sketch a simple triangle, then draw a curved triangular shape on either side. Add curved lines beneath each segment. Draw a circle on top, then sketch the pole. Add more shapes to make the umbrella look 3D.

Sketch a big ellipse for the table top, then add a vertical line running through the center of two much smaller ellipses. Draw swirly supports on one side first before sketching their mirror image on the other.

Use different-sized ellipses and curved shapes to draw an ornate teapot and cup. Add swirly patterns to the sides to give them some old-fashioned charm!

To draw an elegant café chair, sketch an ellipse, adding another line at the bottom to make it look 3D. Draw two curved shapes for the back. Add a big U shape beneath the ellipse, then use more elegant curves for the legs.

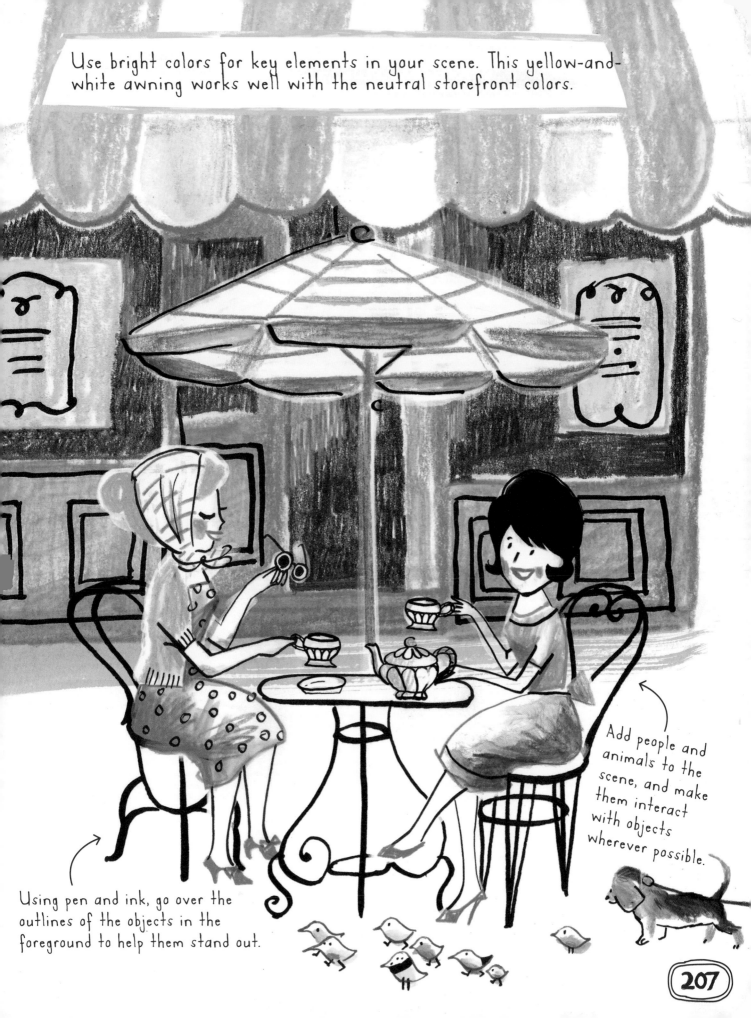

Use bright colors for key elements in your scene. This yellow-and-white awning works well with the neutral storefront colors.

Add people and animals to the scene, and make them interact with objects wherever possible.

Using pen and ink, go over the outlines of the objects in the foreground to help them stand out.

POSSUM

THE COMMON BRUSHTAIL POSSUM IS A SMALL NOCTURNAL ANIMAL THAT USES ITS LONG, BUSHY TAIL TO GRIP ONTO BRANCHES!

1

DRAW A CIRCLE FOR THE HEAD, FOLLOWED BY THREE SMALL CIRCLES FOR THE EYES AND NOSE. ADD U-SHAPED EARS AND AN ALMOND-SHAPED BODY.

2

SKETCH GUIDE SHAPES FOR THE LEGS, FEET, AND TAIL. PENCIL IN A ROUGH BRANCH SHAPE ABOVE THE POSSUM. WRAP ITS TAIL AROUND THE BRANCH.

3

USING THE GUIDES, DRAW THE OUTLINE OF YOUR POSSUM. ADD SMALL TOES TO EACH FOOT. TRY TO BREAK UP THE LINES TO SHOW THE FUR.

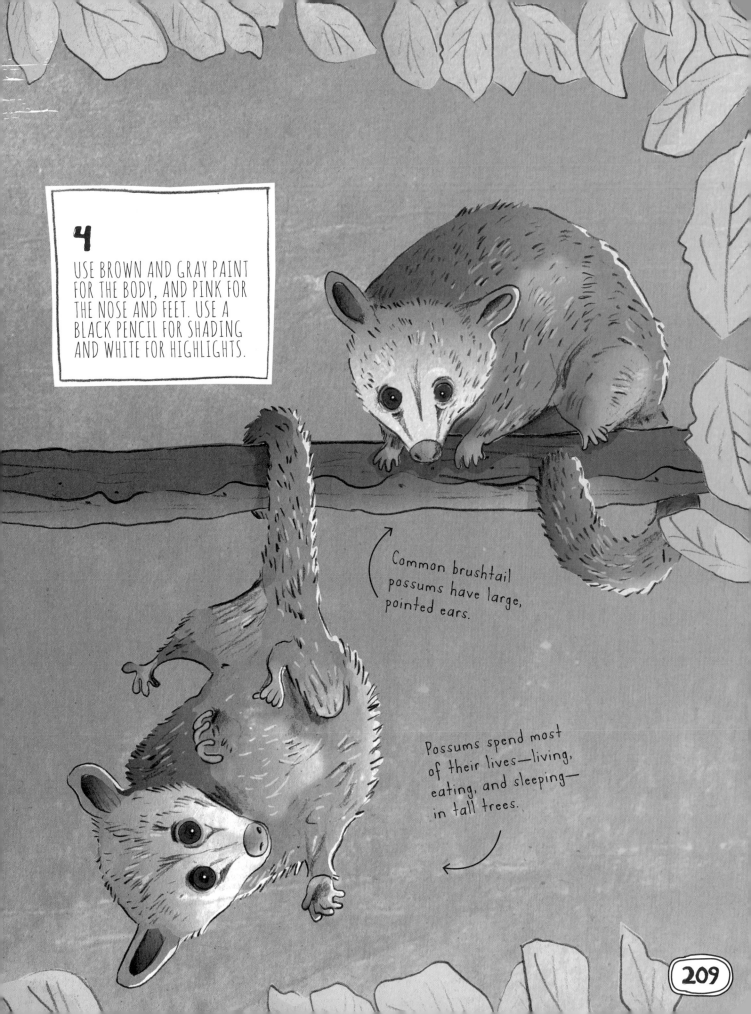

4

USE BROWN AND GRAY PAINT FOR THE BODY, AND PINK FOR THE NOSE AND FEET. USE A BLACK PENCIL FOR SHADING AND WHITE FOR HIGHLIGHTS.

Common brushtail possums have large, pointed ears.

Possums spend most of their lives—living, eating, and sleeping— in tall trees.

HELICOPTER

1

START WITH SIMPLE SHAPES. DRAW THREE ROUNDED RECTANGLES FOR THE CABIN, A LONG TUBE WITH A TRIANGLE AT THE END FOR THE TAIL, AND AN OVAL ON TOP FOR THE ROTOR BLADES.

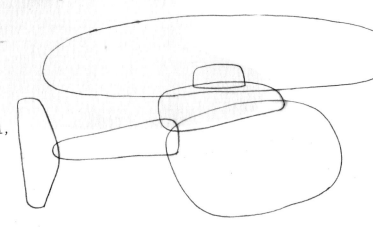

2

ADD MORE SIMPLE SHAPES TO THE TAIL AND ROTORS, AS SHOWN. DRAW ROUNDED WINDOWS AND SKETCH THE LANDING SKIDS.

3

REFINE YOUR OUTLINES, AND ERASE THE CONSTRUCTION SHAPES. ADD SMALLER DETAILS, SUCH AS AN OVAL FOR THE TAIL ROTOR AND SMALL CIRCLES FOR THE LIGHTS.

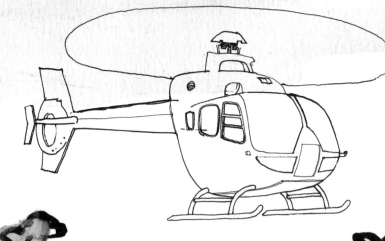

4

TRACE OVER YOUR DRAWING IN BLACK INK. USE WAVY LINES TO CREATE THE IMPRESSION OF FAST, SPINNING BLADES. ADD REFLECTIONS TO THE WINDOWS USING MORE WAVY LINES.

Enhance the sense of movement by coloring the wavy rotor lines in a bluey-gray shade.

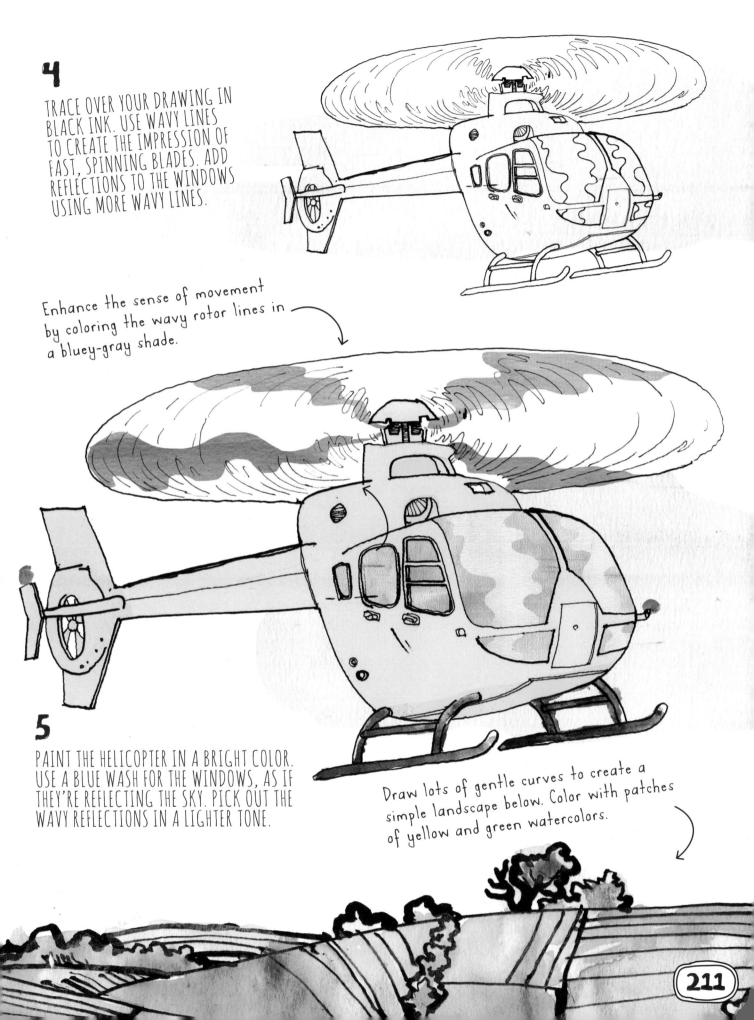

5

PAINT THE HELICOPTER IN A BRIGHT COLOR. USE A BLUE WASH FOR THE WINDOWS, AS IF THEY'RE REFLECTING THE SKY. PICK OUT THE WAVY REFLECTIONS IN A LIGHTER TONE.

Draw lots of gentle curves to create a simple landscape below. Color with patches of yellow and green watercolors.

FERRIS WHEEL

1

DRAW TWO OVAL SHAPES TO FORM THE MAIN STRUCTURE OF THE WHEEL. THIS DRAWING USES PERSPECTIVE, SO THE WHEEL WILL LOOK ELLIPTICAL RATHER THAN PERFECTLY ROUND.

2

DRAW TWO PARALLEL GUIDELINES THROUGH THE CENTER OF THE WHEEL. USE THEM TO POSITION TWO MORE ELLIPSES. THEN DRAW PERSPECTIVE LINES RADIATING OUT FROM THE LARGER ELLIPSE.

These parallel guidelines will also help form the central pivot of the Ferris wheel.

3

DRAW A TALL, A-SHAPED BASE IN FRONT OF THE WHEEL, WITH ANOTHER BEHIND IT. ADD A HORIZONTAL CROSSBAR.

Don't worry about wobbly lines or other imperfections. They'll add to the feeling of movement!

4

LIGHTLY SKETCH SPOKES RADIATING OUT FROM THE SMALLER ELLIPSE. ADD A CURVE TO THE LARGER ELLIPSE TO MAKE IT LOOK 3D. THEN USE SIMPLE ELLIPSES TO FORM THE SHAPES OF THE BASKETS AND PASSENGERS.

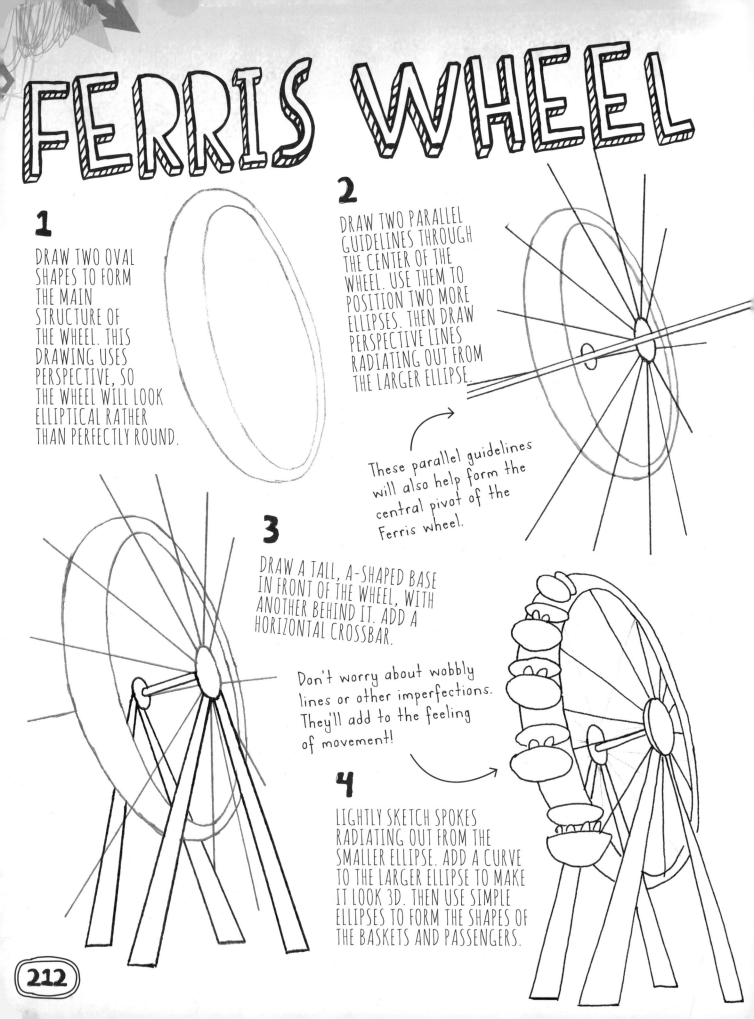

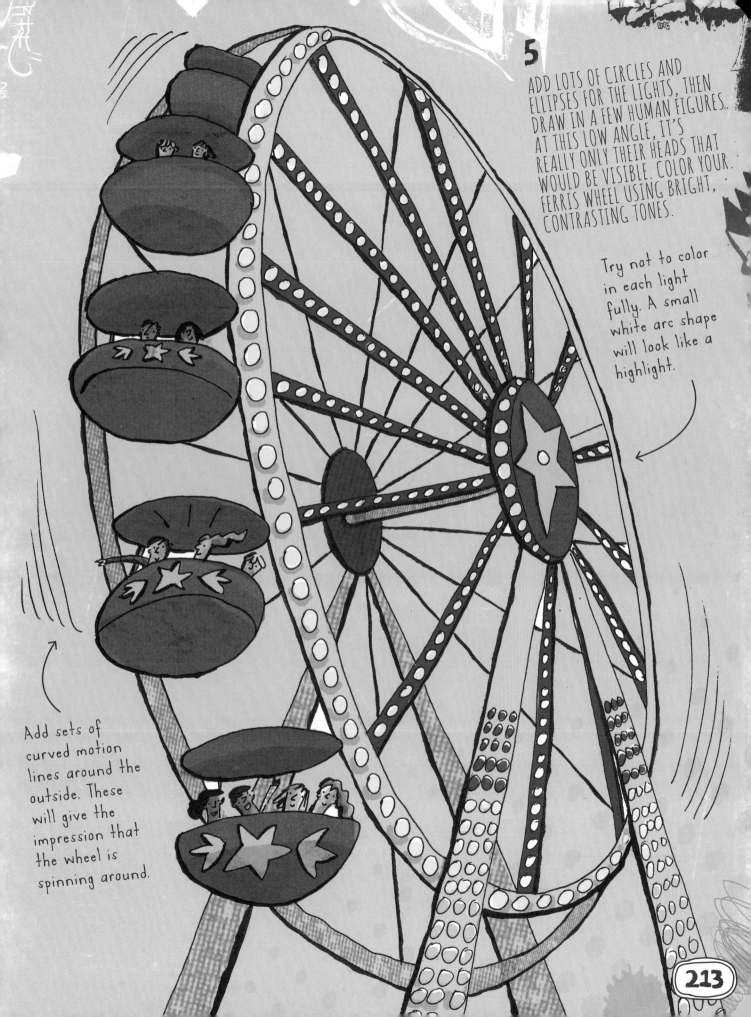

5

ADD LOTS OF CIRCLES AND ELLIPSES FOR THE LIGHTS, THEN DRAW IN A FEW HUMAN FIGURES. AT THIS LOW ANGLE, IT'S REALLY ONLY THEIR HEADS THAT WOULD BE VISIBLE. COLOR YOUR FERRIS WHEEL USING BRIGHT, CONTRASTING TONES.

Try not to color in each light fully. A small white arc shape will look like a highlight.

Add sets of curved motion lines around the outside. These will give the impression that the wheel is spinning around.

GECKO

THESE LIZARDS ARE FOUND IN WARM CLIMATES AROUND THE WORLD AND COME IN VARIOUS SHAPES AND COLORS. HERE ARE THREE FOR YOU TO DRAW!

NORTHLAND GREEN GECKO

Draw a sloping bean-shaped body with a large oval head and folded legs. Add a long tail, eye, and toes. Connect the shapes and paint green with yellow and gold freckles.

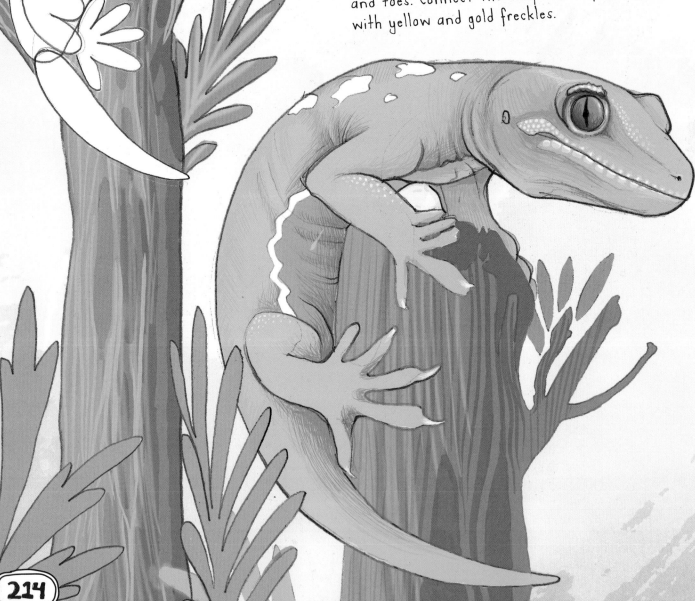

TOKAY GECKO

Draw a bean-shaped body and sausage-shaped tail. Add heart-shaped legs and circular feet. Add the head with an eye and a curved line for its mouth. Paint blue-gray with orange and white spots.

LEOPARD GECKO

Begin by drawing squashed ovals for the head and body. Add a curved tail and small ovals for the legs. Connect the shapes and add an eye and mouth. Paint yellow and orange, with black spots.

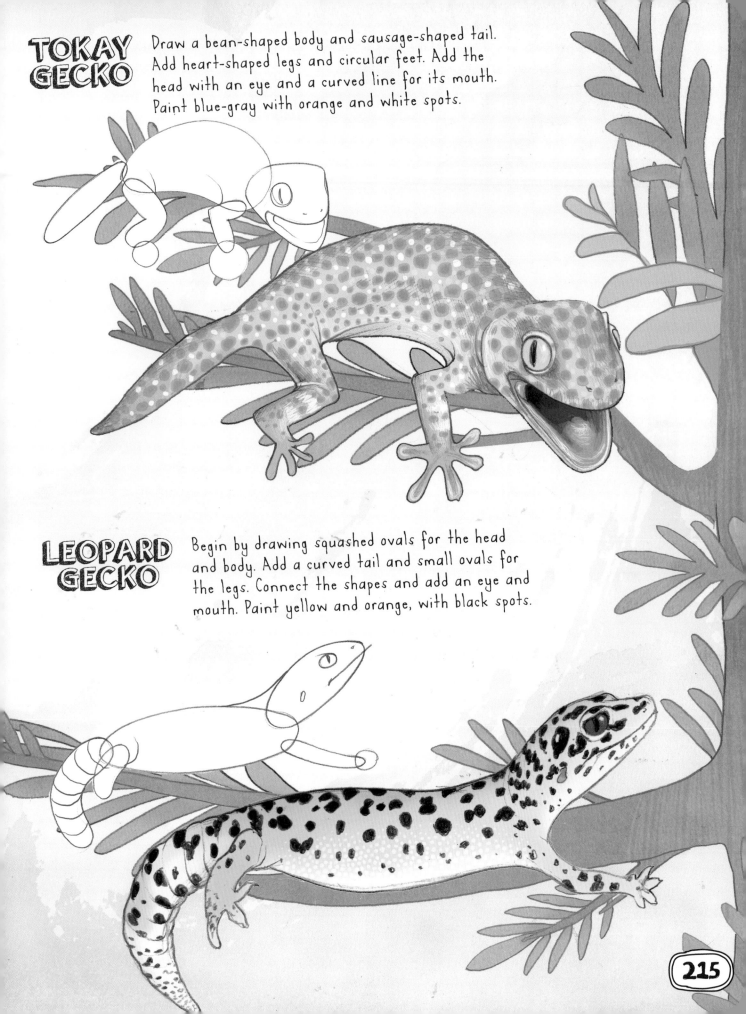

CLOTHES STORE

THIS STORE MIGHT LOOK TRICKY TO DRAW, BUT IT'S MADE UP OF LOTS OF SIMPLER SHAPES.

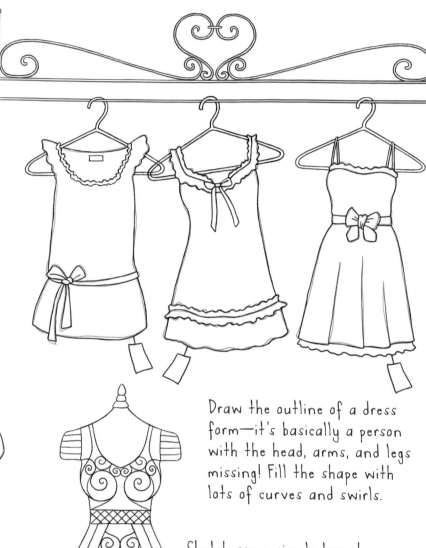

Draw a clothes rail and add a few hangers. Have fun drawing tops, dresses, or skirts—it's up to you!

Draw someone trying on a trendy outfit. Choose a fun, laidback pose.

Draw the outline of a dress form—it's basically a person with the head, arms, and legs missing! Fill the shape with lots of curves and swirls.

Sketch some simple box shapes with pairs of shoes perched on top. Take a look at fashion mags for inspiration!

Practice sketching each object on its own before drawing it in your scene.

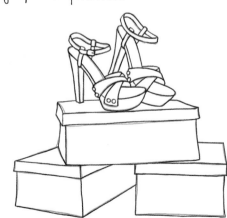

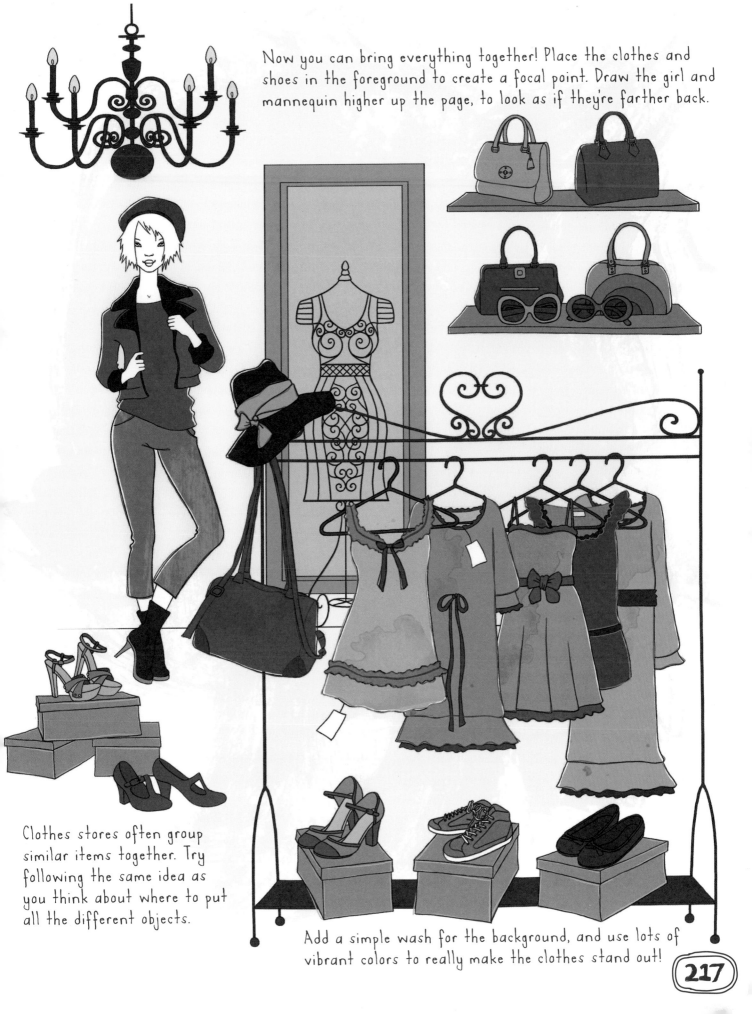

Now you can bring everything together! Place the clothes and shoes in the foreground to create a focal point. Draw the girl and mannequin higher up the page, to look as if they're farther back.

Clothes stores often group similar items together. Try following the same idea as you think about where to put all the different objects.

Add a simple wash for the background, and use lots of vibrant colors to really make the clothes stand out!

TWISTY TREE

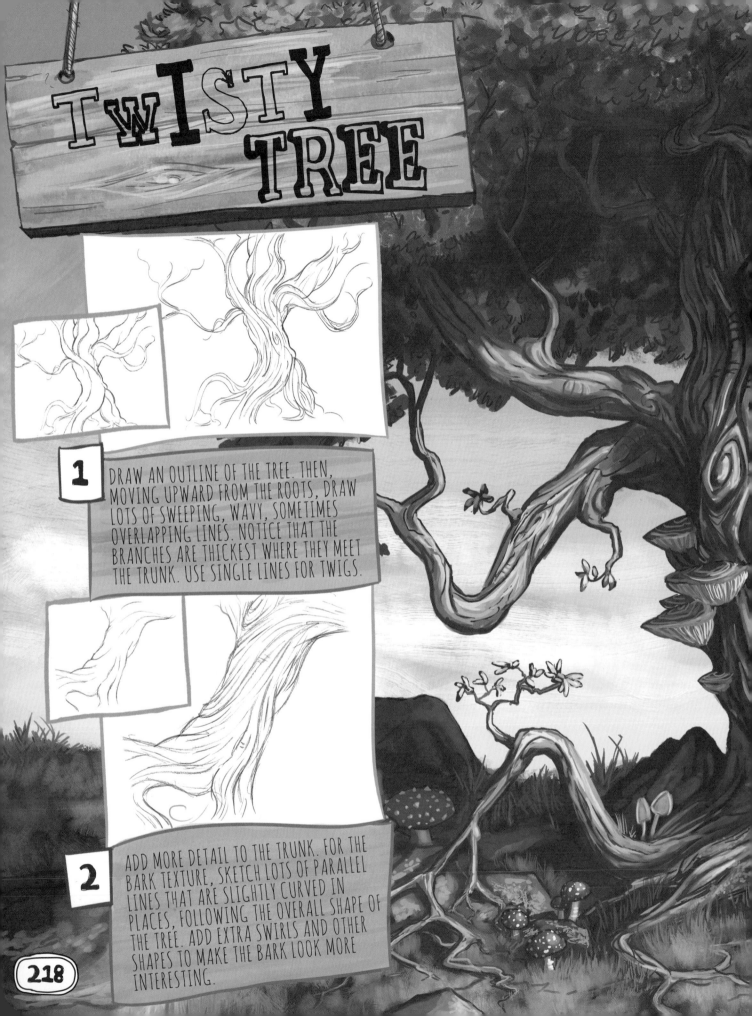

1 DRAW AN OUTLINE OF THE TREE. THEN, MOVING UPWARD FROM THE ROOTS, DRAW LOTS OF SWEEPING, WAVY, SOMETIMES OVERLAPPING LINES. NOTICE THAT THE BRANCHES ARE THICKEST WHERE THEY MEET THE TRUNK. USE SINGLE LINES FOR TWIGS.

2 ADD MORE DETAIL TO THE TRUNK. FOR THE BARK TEXTURE, SKETCH LOTS OF PARALLEL LINES THAT ARE SLIGHTLY CURVED IN PLACES, FOLLOWING THE OVERALL SHAPE OF THE TREE. ADD EXTRA SWIRLS AND OTHER SHAPES TO MAKE THE BARK LOOK MORE INTERESTING.

3 ADD MUSHROOMS AND FUNGI AROUND YOUR TREE. DRAW CYLINDER SHAPES FOR STALKS, WITH EITHER A CIRCULAR OR CONICAL SHAPE ON TOP. DECORATE WITH LITTLE LUMPS, AND USE SHADING LINES TO ADD DEPTH.

4 FOR A REALISTIC EFFECT, DRAW SOME OF YOUR BRANCHES SPLITTING OFF INTO TWO OR MORE SMALLER ONES. DON'T OVERDO THIS, THOUGH! USE THIN, CROOKED LINES.

5 ONLY DRAW THE INDIVIDUAL LEAF SHAPES THAT ARE CLOSE TO THE VIEWER. FOR LEAVES THAT ARE MORE DISTANT, SIMPLY DRAW THE OUTLINE OF A BIG CLUMP OF LEAVES, AND ADD A FEW VAGUE LEAF SHAPES HERE AND THERE FOR TEXTURE.

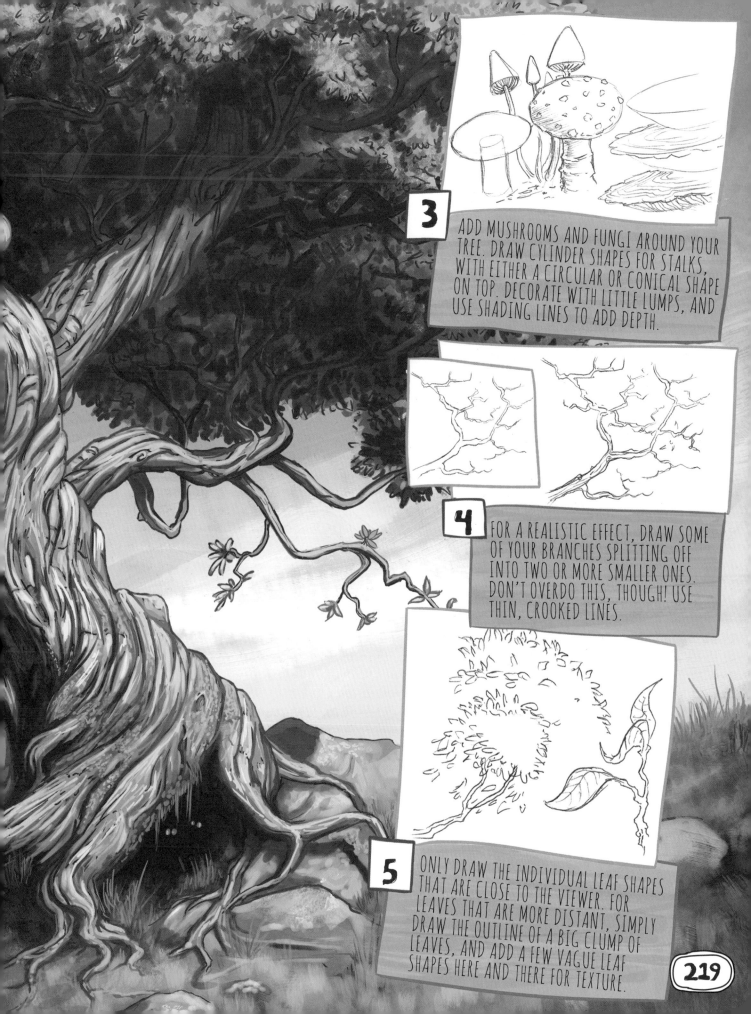

MOSAIC

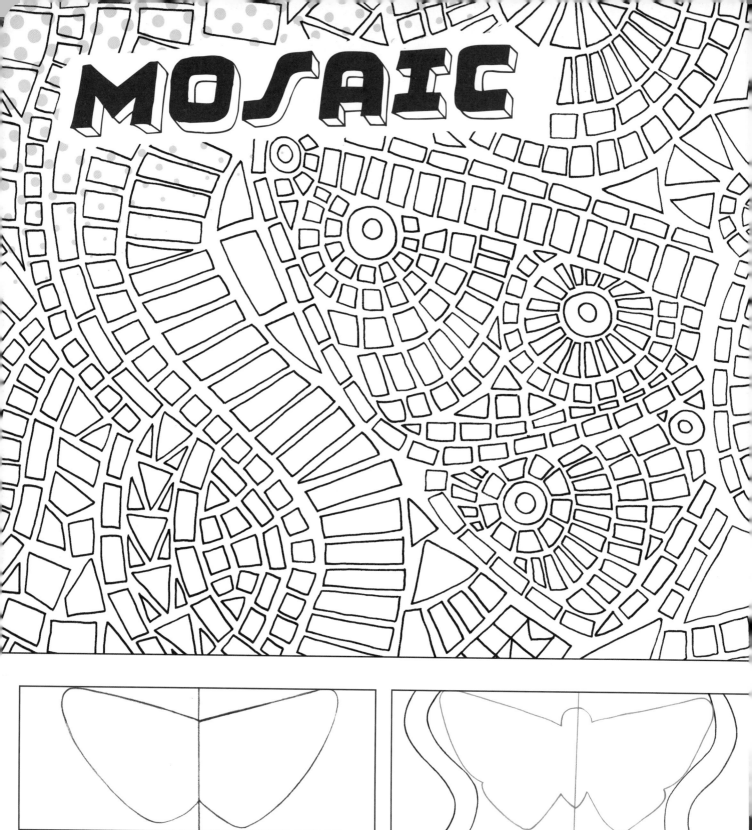

1 START WITH A BASIC SHAPE TO BUILD YOUR MOSAIC AROUND. FOR A BUTTERFLY, SKETCH A VERTICAL LINE, THEN DRAW A SIMPLE WING ON EACH SIDE.

2 DRAW WAVY LINES AROUND THE BUTTERFLY WINGS, READY FOR THE MOSAIC PATTERN LATER ON. ADD A SEMICIRCULAR HEAD AND A POINT FOR THE BODY.

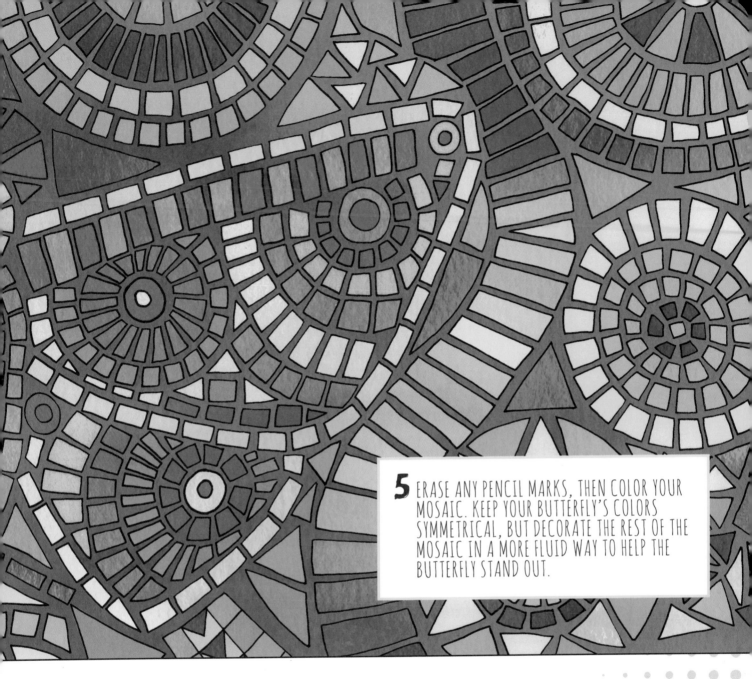

5 ERASE ANY PENCIL MARKS, THEN COLOR YOUR MOSAIC. KEEP YOUR BUTTERFLY'S COLORS SYMMETRICAL, BUT DECORATE THE REST OF THE MOSAIC IN A MORE FLUID WAY TO HELP THE BUTTERFLY STAND OUT.

3 SKETCH A SYMMETRICAL PATTERN ON THE WINGS AND A MIXTURE OF SHAPES AROUND THE BUTTERFLY. THESE DON'T NEED TO MIRROR EACH OTHER.

4 DRAW THE INDIVIDUAL MOSAIC PIECES USING TINY RECTANGLES, SQUARES, CIRCLES, AND TRIANGLES. GO OVER YOUR OUTLINES WITH AN INK PEN.

ABOUT THE ARTISTS

TALENTED ARTISTS FROM AROUND THE WORLD HAVE CONTRIBUTED THEIR SKILLS AND ILLUSTRATIONS TO THIS BOOK!

TOM MCGRATH'S work is inspired by artwork he has seen, books he has read, movies he has watched, and even occasionally by real life. He is obsessed with clouds, fish, and airships.

STEVE HORROCKS was born in Merseyside, England. He now lives in California with his wife, where he works at a major feature animation studio and continues to pursue his passion for creating art on a personal level, too.

SOPHIE BURROWS draws all sorts of things for children's books and greeting cards, and especially loves drawing silly animals and cute kids. Her favorite food is pizza and her favorite animals are kittens!

JULIE INGHAM is an illustrator and designer who lives and works by the sea in West Sussex, England. Her favorite things to draw are skyscrapers and all things decorative!

YASUKO YASUKO has developed a graphic illustration style, mixing ink work, brushstrokes, and digital textures. She loves Japanese fashion, and sometimes makes her own clothes. Yasuko lives and works in Paris and loves to spend time drawing in the Louvre art museum.

ALEX HEDWORTH works as an illustrator for an animation studio. He has been drawing for as long as he can remember—his first drawings were copies of comic books, and he is now working on a graphic novel of his own.

JESSICA KNIGHT enjoys working with mixed media and especially loves drawing tigers and anything to do with the sea. When not doodling, daydreaming, or dancing around her studio, she likes walking by the river with Chekhov, her imaginary pet dachshund.

PAULA FRANCO is a children's book illustrator and graphic designer from Argentina. She loves to spend her spare time wandering around libraries.

DAVID SHEPHARD is a children's book illustrator and designer. He lives in the shadow of a Norman castle in Sussex, England, with his wife, children, and several pets. He loves drawing people and faces, and works best in his attic, where his family slides his supper under the door!

LUCIANO LOCENZO got an MA in Illustration in Barcelona, Spain, and now lives in that same city. He works as a professional illustrator on books, newspapers, and magazines.

STEVE STONE is an illustrator from the northeast of England who loves to capture the character of animals. He gets lots of help from his orange cat, Vincent van Mog.

MADDY MCCLELLAN lives in Sussex, England, and works as an illustrator and printmaker. She has illustrated many children's books, including some that she has written herself. She is happiest drawing with a lively, inky line in her studio in the yard, visited by an assortment of animals.

SI CLARK is an illustrator and animator. He grew up in the countryside but now lives in London, England. He started drawing at a very early age and has pretty much been drawing every day since then. Si is obsessed with drawing trees and cities, as well as finding strange textures to scan into his drawings!

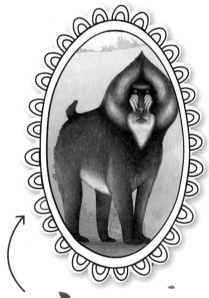

ADAM FISHER has always been fascinated by wildlife. He began drawing animals at a young age and still keeps a book of patterns and shapes found in nature. He uses the textures of fur, feathers, and scales in his work.